TITANIC
IN PHOTOGRAPHS

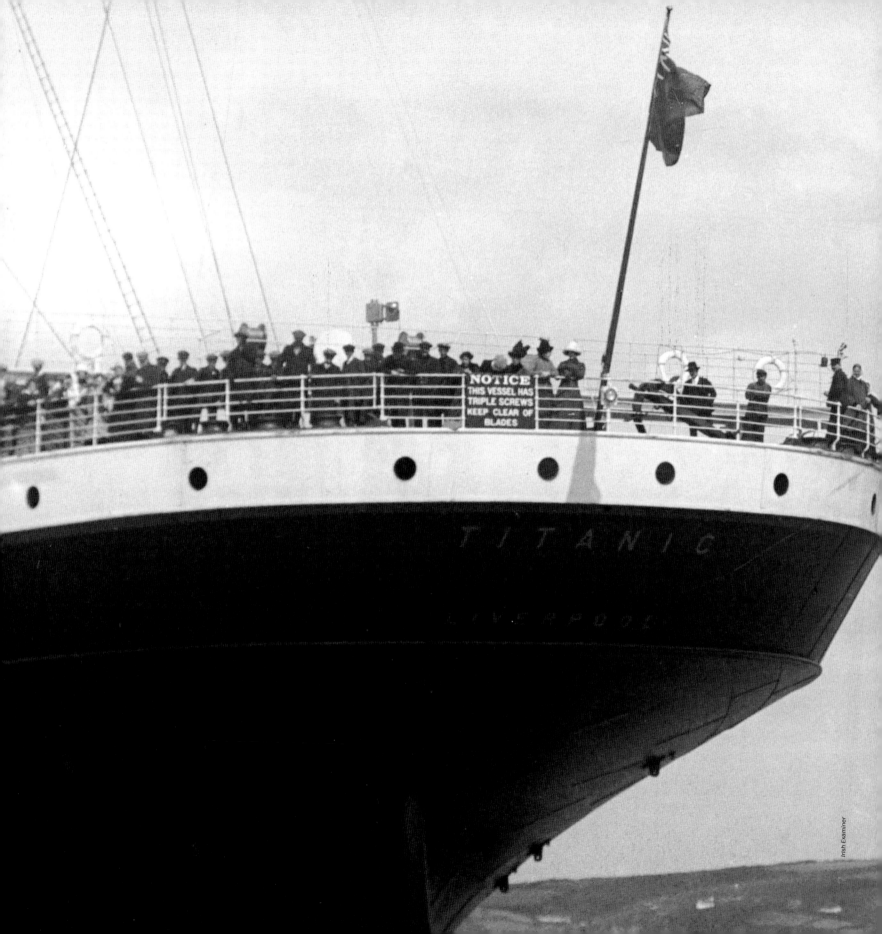

NOTICE
THIS VESSEL HAS
TRIPLE SCREWS
KEEP CLEAR OF
BLADES

TITANIC

LIVERPOOL

TITANIC
IN PHOTOGRAPHS

DANIEL KLISTORNER, STEVE HALL

BRUCE BEVERIDGE, ART BRAUNSCHWEIGER & SCOTT ANDREWS

FOREWORD BY KEN MARSCHALL

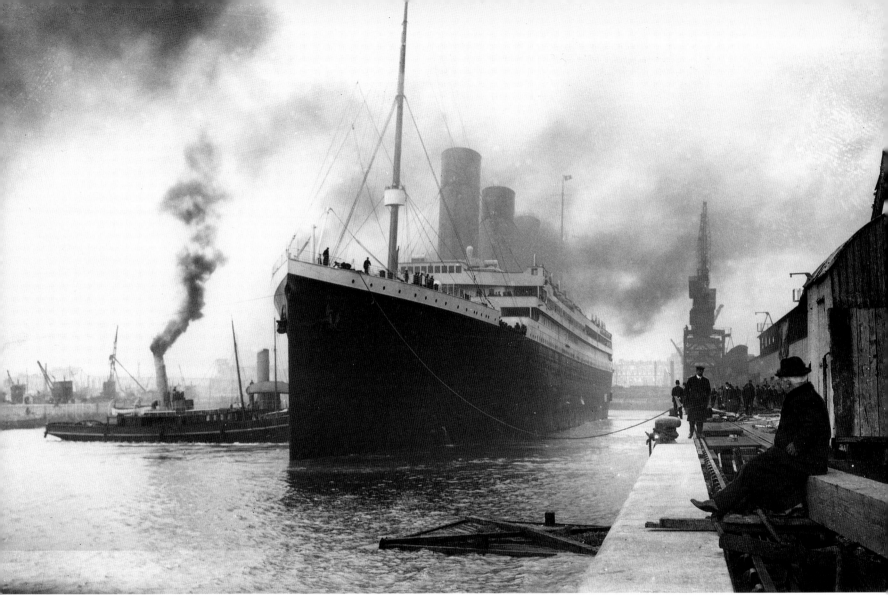

Authors' Collection

First published 2011
The History Press
The Mill, Brimscombe Port
Stroud, Gloucestershire, gl5 2qg
www.thehistorypress.co.uk

© Daniel Klistorner, Steve Hall, Bruce Beveridge,
Art Braunschweiger & Scott Andrews, 2011

The rights of Daniel Klistorner, Steve Hall, Bruce Beveridge, Art Braunschweiger
& Scott Andrews to be identified as the Authors of this work has been asserted in
accordance with the Copyrights, Designs and Patents Act 1988.

British Library Cataloguing in Publication Data.
A catalogue record for this book is available from the British Library.

ISBN 978 0 7524 5896 0

Typesetting and origination by The History Press
Design by Katie Beard
Printed in Malta

Above: This is perhaps one of the most iconic and striking images of *Titanic* moving away from the pier as she departs on her first and only voyage. It is no wonder that this photo, taken by H.G. Lloyd of Southampton, won a prize in a *Southampton Pictorial* competition. The man sitting down in the foreground is believed to be Benjamin Steele, marine superintendent at Southampton for the White Star Line.

Frontispiece: Crowding *Titanic*'s stern at Queenstown are hundreds of emigrants, anxious but hopeful as they embark on a journey in search of a better life in the New World. As *Titanic*'s stern slipped beneath the waters of the freezing North Atlantic, many of the people seen here would perish.

Cover: A London press photographer standing at the rail of the steamer *Beacon Grange* gets ready to take a picture of *Titanic* departing Southampton.

Rear cover: *Titanic* steams up the Victoria Channel toward Belfast Lough for her sea trials on 2 April 1912.

Inside jacket, back: *Olympic* is drawn into the Thompson Graving Dock for the first time, 1 April 1911. Two Harland & Wolff photographers are on the scene to record the event.

For all those who have captured important moments in history, and for those who preserve them for future generations.

CONTENTS

FOREWORD

It's like Christmas. There's something magical and indescribably evocative, for me, about seeing a new photograph of *Titanic* for the first time, or even more thrilling, holding a first-generation print in my hands. It's a window to the ship itself.

Her brief life makes the photographs all the more rare and significant. If it weren't for two enterprising shutterbugs – Kate Odell and Frank Browne – we would have absolutely *no* pictures showing what it was like to be on board when *Titanic* was in motion. Browne's photos were published at the time, but Odell's were quietly secreted away. I remember my excitement in 1987 when I first learned of the Odell pictures. I was working on the book *The Discovery of the Titanic*, by Robert Ballard, and it was only weeks before it was scheduled to go to press. The owner of the photographs agreed to several of them being published, and, at great expense, a whole section of the book was completely redesigned at the last minute to accommodate and showcase the stunning new images. That's how important they were, how immeasurably they added to the meagre *Titanic* photographic canon.

As an artist with a photorealistic, perfectionist bent, I'm all about accuracy, detail, and lighting – attributes that, to me, also happen to define the very essence of photography. Not surprisingly, photographs of *Titanic* have been my primary research tool since my first commission to paint the liner in the late 1960s. All these years later I'm still asked to paint the ship, and my work finds me going through files and checking images almost daily. Historical (or as I call them, 'archival') photographs are invaluable to a serious artist such as myself, no less than to any dedicated modeller. They are the final word. A photograph cannot be wrong. It doesn't lie, exaggerate, purposely omit information or have a faulty memory. Even original plans of the ship drawn by the builders themselves should not be taken literally without careful comparison with the photographic record, where subtle – and sometimes gross – differences quickly become apparent. My mantra? Always study the photographs.

If it were not for photography we would never know about the subtle changes made to *Titanic*'s appearance between Belfast and Southampton, in the few hours between Southampton and Cherbourg, and even between Cherbourg and Queenstown. In doing the research for a painting showing *Titanic* departing the site of her final anchorage, it was interesting to notice the starboard anchor raised a little bit higher in each successive photograph and how people moved about on deck. Comparing *Titanic*'s configuration from one day to the next, or even one *minute* to the next, is a fascinating game of discovery and surprise, all made possible because of the photographic record.

Titanic photos range from the finest, highest-resolution glass-plate negatives taken by Robert Welch at Harland & Wolff or by Frank Beken from a small boat off the Isle of Wight, to the coarse half-toned pictures found in newspapers of the time. For these low-quality newsprint reproductions it is the original, clear prints or negatives that are all important and sadly, in too many cases, lost to history. The search for them will forever be ongoing. Only through finding them can the full resolution of the original photographs be revealed.

Stereo photography was old hat by 1912, but even though 3-D views were taken of other contemporary liners, none has surfaced for *Titanic*. At least, none that was intentional. A few wonderful stereo views of the ship can be created if one combines two photographs that happen to have been taken adjacent to each other and moments apart.

I often hear the cynical sentiment that *Titanic* has been 'beaten to death', that not only have we learned all we can possibly learn about the ship, her people and the wreck, but that surely we have seen the last photograph of her. Never mind that dedicated sleuths continually uncover new information about her history,

The last photo of *Titanic* taken by Kate Odell, departing Queenstown on 11 April 1912.

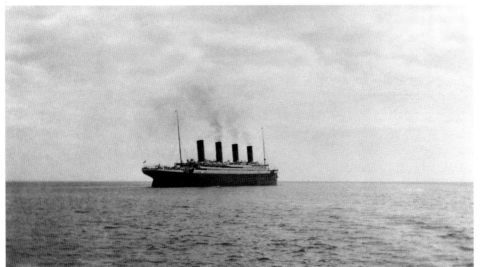

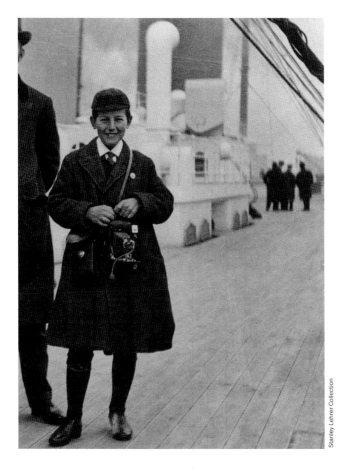

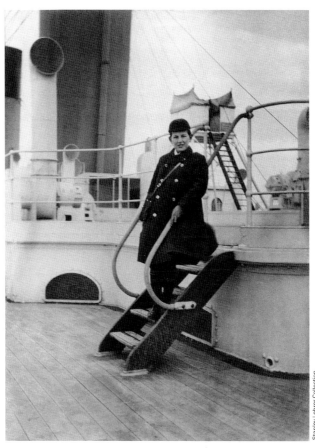

Eleven-year-old Jack Odell aboard *Titanic*, with his Kodak Folding Pocket Camera slung across his shoulder.

passengers and crew, and every exploration of the wreckage invariably reveals fresh, previously unknown details about her structure and fittings. But what about the vintage photographs? Have we seen the last of them?

Some forty years ago I held the notion that, unlike with other liners, at least gathering together all *Titanic* pictures should be a manageable goal. Her short life, I thought, allowed for only a finite number of images, and in time I would actually attain the 'complete set'. Today I can only chuckle at my youthful naiveté. New photographs surface and surprise us almost yearly, and there is no reason to believe that more won't continue to be discovered long into the future. A fantastic hoard of priceless Autochrome images could easily turn up one day, giving us history's first known colour photos of *Titanic*. Or perhaps it will be a set of black-and-white negatives taken inside, say, the first-class smoking room, each shot from the same spot through a different, deeply coloured red, blue or yellow filter. When combined, as was commonly done for published still lifes at the time, they would create a stunning full-colour view of this iconic room for which, at present, no known photograph exists at all.

A comprehensive book dedicated to *Titanic*'s photographic record is something I've thought about compiling myself for many years. The authors have risen to the challenge and tackled the job admirably, filling a conspicuous void in the libraries of every *Titanic* buff.

There can be no more appropriate time for such a volume to debut than on the eve of the centennial of history's most well-known maiden voyage. May these photographic detectives continue their quest for ever clearer prints of these important images, to find long-lost original negatives, or even better, all-new pictures that will inform and inspire generations of *Titanic* researchers and devotees to come. ★

Ken Marschall
Redondo Beach, California
July 2011

ACKNOWLEDGEMENTS

The authors would like to thank the following individuals for their contributions, in no particular order:

Ken Marschall for always being available to help with images and information, and for allowing us the use of images from his collection.

Stanley Lehrer for kindly giving permission to use photos taken by Kate Odell, which are among the very few surviving images ever taken by passengers aboard *Titanic*.

Mark Chirnside for allowing us to use images from his collection and for always being more than willing to share his extensive knowledge of the *Olympic*-class liners.

J. Kent Layton for providing the stunning colour illustrations from *The Railway & Travel Monthly*.

Anne Kearney of the *Irish Examiner* who assisted with researching the photos taken by Thomas Barker for the *Cork Examiner*.

John Balean of 'The Press Photo History Project' who provided invaluable insight into the practice of photography by press agencies at the turn of the twentieth century, and for assisting with information on *Central News*.

Tom Cunliffe, who provided valuable information on the pilot boats used at Southampton.

George Behe for sharing some rare images from his extensive *Titanic* collection.

Andrew Aldridge for allowing us to use some rare and previously unpublished images.

Jonathan Smith for allowing the use of images from his collection and providing information he has researched over the years on *Titanic*'s anchors.

Ralph Currell, whose tireless research always uncovers new photos and new information.

The late Josha Inglis for granting us the use of images from his collection.

R. Terrell-Wright for allowing the use of his rare photographs.

The authors would like to extend particular thanks to Ioannis Georgiou who granted access to his extensive collection of images, and whose meticulous attention to detail assisted in identification of some of the images. Ioannis' extensive contribution to the 'Tragedy & Rescue' chapter is tremendously appreciated and sheds some new light on the events and several previously unidentified lifeboat photographs.

Particular thanks also go to Günter Bäbler of the Swiss *Titanic* Society. Günter very generously shared his knowledge and extremely rare images from his collection, many of them not available anywhere else and some of which he obtained for the express purpose of supplying them for this book.

And finally, we would like to thank our dedicated team at The History Press: Amy Rigg, Emily Locke, Katie Beard and Martin Latham.

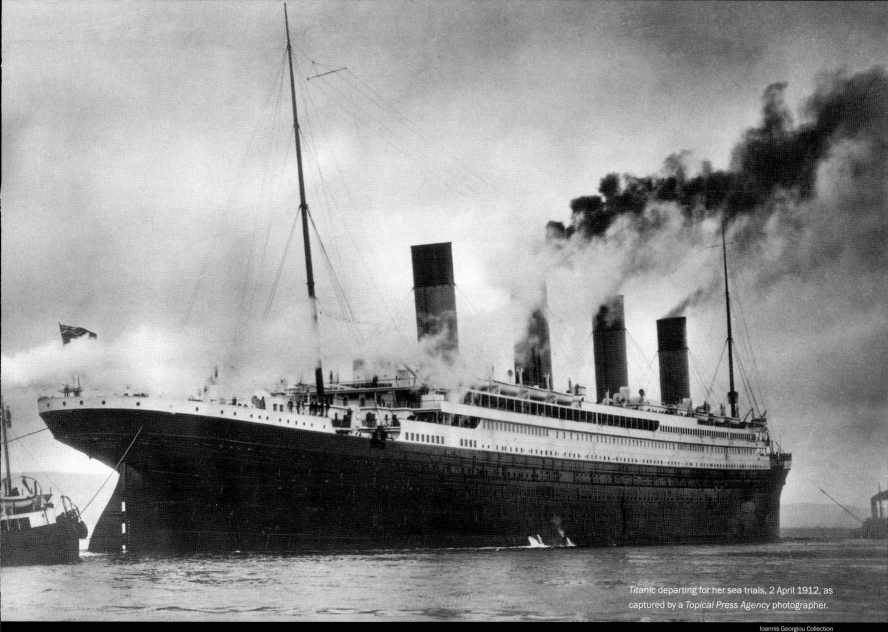

Titanic departing for her sea trials, 2 April 1912, as captured by a *Topical Press Agency* photographer.

Images have the power to captivate us, to thrill us and to freeze a moment in time and, on occasion, allow us to experience it as if we were there. There is an image of *Titanic* on her sea trials: a thick wreath of smoke is seen emanating from one of her tugs, blowing across *Titanic*'s stern as the tug strains to lead the leviathan into the open waters of Belfast Lough. Little imagination is required to feel the pride and anticipation of the day as ship and crew head out to put the largest and newest passenger liner through her paces.

Titanic continues to generate interest and no other ship in history has ever commanded such attention. Yet far fewer photos were taken of her than her sister *Olympic* and today all we have is a limited collection of black-and-white images taken by a few individuals lucky enough to have captured photographs of the ship that would later become so famous.

Being the first of her class, *Titanic*'s sister *Olympic* was extensively photographed. At the time, *Titanic* received less attention and was not as widely photographed, as she was considered 'almost the same' and it is for this reason that countless views of *Olympic* are often misidentified or misrepresented as her younger sister. Photography was also a relative novelty at the time, cameras being largely in the hands of professional studio photographers and press agencies. Nonetheless, a surprising number of *Titanic* images can still be enjoyed today.

We owe much of our knowledge of *Titanic*'s construction to the visual record compiled by a small group of photographers operating at Harland & Wolff. Foremost among these is Robert John Welch, the official Harland & Wolff photographer at the time. His initials can be seen on many glass-plate photographs of *Titanic*. Welch often had James Glass working alongside him, and some photographs were taken by Glass himself. Other photographers working around Harland & Wolff at the time were William Alfred Green and brothers Alex and David Hogg.

Welch only took ten photographs of *Titanic*'s interiors, but other photographs were taken at Southampton by three London press photographers. Their names are lost to history, but we are indebted to them for the images they captured. They were aboard on 9 and 10 April 1912 prior to departure and had the opportunity to roam the ship for several hours.

We have a rich insight into life aboard *Titanic* thanks to a young candidate for the Jesuit priesthood, Frank Browne. An accomplished amateur photographer, Browne sailed from Southampton and disembarked at Queenstown. And finally, throughout *Titanic*'s short life, a number of other photographers – onlookers and passengers, professional and amateur – stood in awe at the sight of *Titanic* and released their camera shutters, unaware that they were capturing significant moments in history. Despite the relative paucity of *Titanic* photographs appearing in books about the ship, in fact many were taken and the total number may be surprising. There were likely over 300 photographs taken with either the ship itself featuring as the principle subject or seen as a partial glimpse off to the side in a photograph of something else. Every now and then a previously unknown and unpublished photograph surfaces; we are fortunate enough to be able to include a number of these here.

In the 100 years since *Titanic*'s sinking, a time period which spans two world wars, many photographs have been lost to the ravages of time and history. The fragile glass plates that were used to capture images of *Titanic* were no match for the bombs that fell on Belfast, London and Southampton during the Second World War. History also has a habit of fading into insignificance when the historic value of photographs is not recognised at the time, with records irretrievably lost when interest re-emerges decades later. There are also pleasant surprises that continue to delight historians. Photographic prints once made and circulated around the world – either privately or to illustrate the news – are rediscovered in archives or private collections and from these we can reproduce images that were once captured on glass plates since lost or broken.

Many of *Titanic*'s photographs were also sold as postcards and were reproduced by license from original photographers. 'Real photo' postcards were professionally printed and are particularly striking, revealing the most amount of detail. The numbers produced are speculative, but postcards actually showing *Titanic* (rather than her sister ship *Olympic*) were primarily sold throughout the United Kingdom in the weeks and months following the disaster. Some cards were produced quickly and were available while the ship was still at Southampton – local studios having taken photographs and making them available for purchase before the ship's departure. Today these original cards are rare and highly collectable.

Some photographs of *Titanic* were also converted to 'lantern slides'. These were similar in design and function to the slide projector. At the time there were public viewing theatres and studios. The slides were placed into a back-lit projection device and the operator would usually present a brief narration to each image. Unfortunately, *Titanic* lantern slides were not produced in large numbers and today there remain only a few examples.

Whatever the medium or however the photographs have come to survive, we hope you enjoy this rich visual record as *Titanic*'s story is told through photographs. ★

Daniel Klistorner & Steve Hall

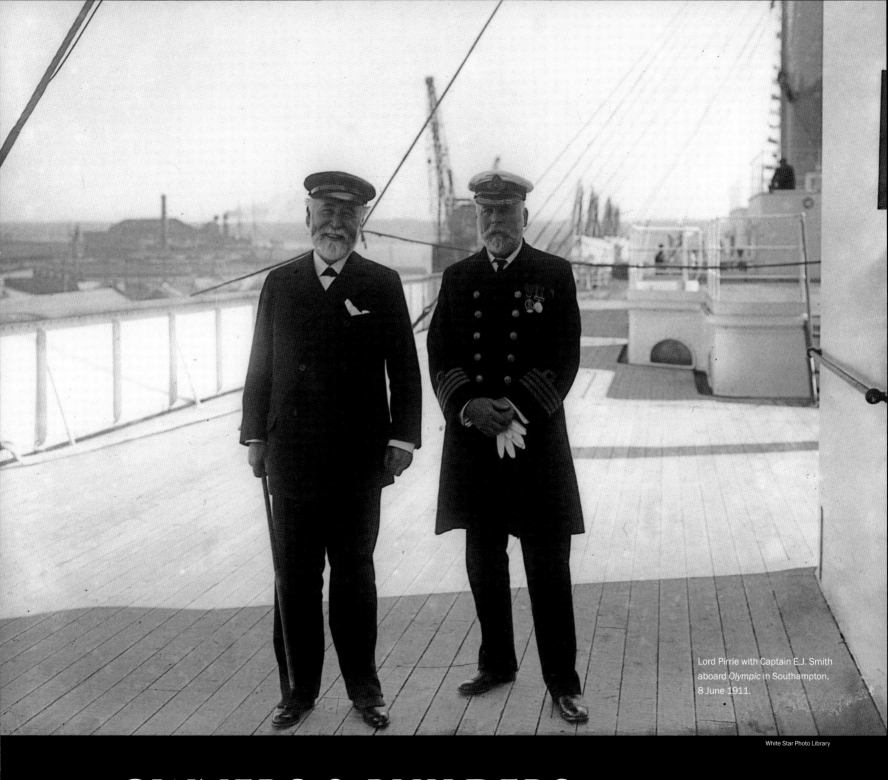

Lord Pirrie with Captain E.J. Smith aboard *Olympic* in Southampton, 8 June 1911.

1 ★ OWNERS & BUILDERS

An advertisement from 1911 proudly announces Harland & Wolff's achievements and shows that the firm had even expanded to have a small shipyard in Southampton, primarily used for carrying out repairs.

HARLAND & WOLFF, LIMITED.

Builders of the "OLYMPIC" and "TITANIC," the largest steamers in the World, 45,000 tons each.

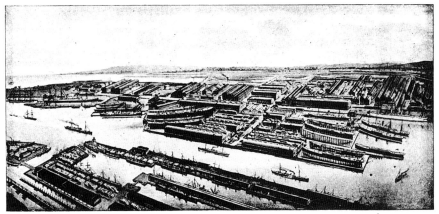

BELFAST WORKS.

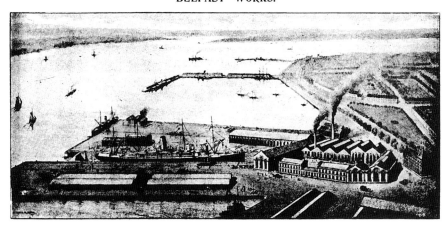

SOUTHAMPTON WORKS.

Harland & Wolff, Ltd., have headed the returns for Shipbuilding twelve times in the last twenty years. They have often exceeded 80,000 and 90,000 tons in the year, and thrice their output has been over 100,000, viz.:—

1903	8 vessels	110,463 tons,	100,400 I.H.P.		
1908	8 ,,	106,528 ,,	65,840 ,,		
1910	8 ,,	115,861 ,,	100,130 ,,		

Authors' Collection/The Shipbuilder

Thomas Henry Ismay had the vision of establishing first-class passenger service across the Atlantic, with a fleet of ships in every way superior to anything then in existence. Ismay was no stranger to the business, having been apprenticed at age sixteen to the shipping firm of Imrie and Tomlinson of Liverpool and partnering with a former sea captain to form their own ship brokering firm three years later. Then at age twenty-five Ismay went off on his own, establishing T.H. Ismay & Company, the 'company' in the name being no one other than himself. Ismay proved to be an astute businessman and shrewd investor, and quickly prospered. In 1867 he seized the opportunity to purchase the White Star Line, a financially insolvent company providing clipper ship service to Australia, finally concluding the deal for the sum of £1,000 on New Year's Day, 1868. He quickly turned the company's fortunes around by selling off the unprofitable clipper ships and chartering steamships in their place for use on the North Atlantic. One year later, Ismay formed the Oceanic Steam Navigation Company (OSNC), which would become the parent company of the White Star Line.

When Thomas Henry Ismay envisioned a new fleet of transatlantic passenger ships unrivalled by any other, his timing was well chosen. A voyage across the Atlantic was a long journey, often uncomfortable and reaching one's destination was by no means assured. The travelling public, he knew, would readily book passage with any company that could provide safe ships in

Thomas Henry Ismay.

Authors' Collection/The Shipbuilder

which one could travel with sufficient luxury as to forget being at sea. Given the radical improvements in hull design and interior arrangements being achieved by shipbuilders, this was well within Ismay's capabilities to provide. All that he required was a shipyard to deliver what he needed.

Meanwhile, a fellow apprentice of Ismay's had also struck out on his own. William Imrie had inherited a small shipping company from his father, initially managing it on his own but partnering with Ismay soon after. The new company was called Ismay, Imrie & Company, and was made a subsidiary of the OSNC. Ismay ran the steamship side of the business under the White Star flag, and Imrie ran the sailing vessels under a separate flag (sailing ships were still profitable on certain routes). The company prospered and soon began attracting interest from outside investors. Two such shareholders were Edward J. Harland and Gustav Wolff.

In 1858 the twenty-seven-year-old Harland, then working as a shipyard manager, acquired ownership of his employer's firm on Queen's Island in Northern Ireland. He took on his former assistant, Gustav Wolff, and the firm of Edward J. Harland & Company was born. Three years later they changed the name to Harland & Wolff to reflect the growing partnership. Over the decades that followed, a period of technological progress and explosive growth in the steamship trade would result in the company expanding at an astonishing rate. By the time *Titanic* was built, Harland & Wolff would advertise itself as leading the world in shipbuilding tonnage construction for twelve of the previous twenty years.

Shortly after establishing the new White Star Line headquarters in Liverpool, Ismay was approached by Gustav Schwabe, a prominent Liverpool merchant. Schwabe was accompanied by his shipbuilding nephew, Gustav Wolff. Schwabe offered to finance the new line if Ismay had his ships built by Wolff's company. Ismay agreed to the proposal and a partnership with Harland & Wolff was established in 1869 that would ultimately catapult the White Star Line to a position as a dominant force in the North Atlantic steamship trade. Ismay then entered into negotiations to set the terms on which ships would be built for the White Star Line. By the time Ismay's company was ready to order their first new ship, Harland & Wolff had already expanded and upgraded their yard facilities to handle the increased volume.

The first ship ordered by the White Star Line was the *Oceanic*, which was quickly followed by five sister ships. The launch of the *Oceanic* occurred on 27 August 1870. She was 3,707 Gross Registered Tons, 420ft long, and had a beam of 41ft. The *Oceanic* was arguably the culmination of those improvements which

Sir Edward J. Harland. Authors' Collection/*The Shipbuilder* Gustav Wolff. Authors' Collection

made transatlantic travel a comfortable experience rather than an ordeal to be endured. A notable 'first' incorporated into *Oceanic* was a significant improvement in the relative proportions of length, breadth and depth of hull. This increased the efficiency of the hull through the water, resulting in less motion and less fuel being consumed, and also made her more stable. During the construction of the vessel, Ismay also took every opportunity to improve his passengers' comfort and accommodations. The saloon and passenger accommodations were moved amidships (the area where the motion of the sea would be felt the least), separate chairs rather than benches were provided in the dining saloons, electric call bells were added and the lighting was improved. Initially clean-burning sperm oil lamps were installed in place of the traditional but dim illumination provided by candles, later to be followed by an elaborate but unsuccessful attempt to introduce gas lighting. Safety was enhanced by self-acting watertight doors and an improved bulkhead division.

Before the *Oceanic* was even launched, rival companies had already dismissed her design as not worthy of serious consideration. To the surprise of her detractors, but perhaps not her builders, she

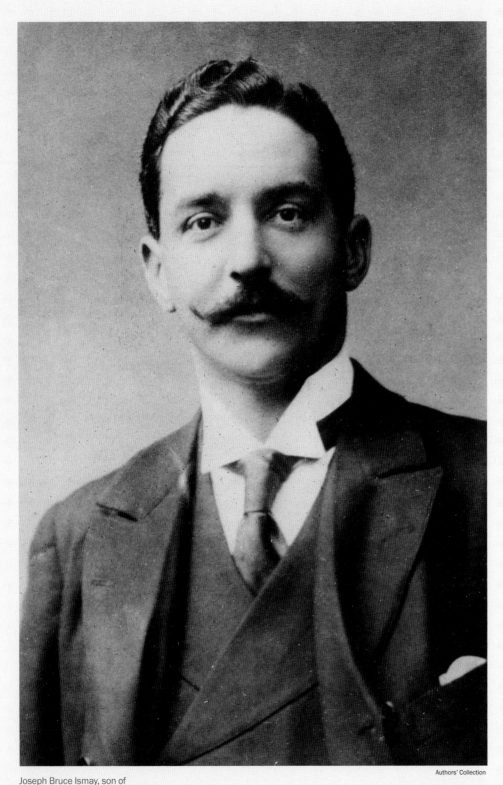

Authors' Collection

Joseph Bruce Ismay, son of
Thomas Henry Ismay, founder of
the Oceanic Steam Navigation
Company. Bruce Ismay started out
as an office boy at his father's firm.

was a true greyhound of the ocean. She was at least a knot faster than any of the ships that had come before her and the motion of the vessel was easy, without any indication of weakness or straining even in the heaviest weather. Her first appearance in Liverpool was a celebrated event. Ismay himself accompanied the vessel on her first voyage to New York in March 1871. The transatlantic trade of the company was thus started with the *Oceanic*, the house flag of the White Star Line flying proudly at the main mast.

By the late 1870s the company was so successful that it commanded a large share of the passengers and cargo passing between Liverpool and New York. From 1877 onward the White Star Line had also been regularly employed under contract with the British government to carry the American mails from Liverpool and Queenstown to New York. Carrying the Royal Mails was not only profitable but prestigious, and such ships were permitted to fly the Royal Mail pennant and carry the designation 'RMS' (for Royal Mail Steamer) before their names.

During the years of White Star Line's rapid growth, ownership had not changed. The well-known names of Thomas Henry Ismay and William Imrie – joined by W.S. Graves in 1881 and the two sons of Ismay in 1891 – still continued to run the company. At Harland & Wolff, though, 1895 saw the death of Sir Edward Harland. Taking his place as chairman of the company was William J. Pirrie, who had joined the firm in 1868 as a young apprentice. Rising quickly through the firm, he later became yard manager and was offered a partnership in 1875. In 1906 Pirrie was created Baron Pirrie of the City of Belfast and would thereafter be known as Lord Pirrie.

In 1897, the Stettin Vulcan Company turned out the *Kaiser Wilhelm der Grosse* for the North German-Lloyd (Norddeutscher Lloyd) Company. This new arrival on the scene averaged a speed of 22.8 knots across the Atlantic, thus breaking the previous British-held record and taking the coveted Blue Riband, the prize awarded to the ship achieving the fastest Atlantic crossing. Speed was not the only issue at stake, however, for a new and faster ship often meant a larger ship with bigger and better appointments as well. White Star Line's answer to the German vessel was to order a new vessel from Harland & Wolff. With the original *Oceanic* decommissioned in 1896, White Star Line once again chose that name for their new flagship. Making her maiden voyage in September of 1899, *Oceanic* had the distinction of being the first vessel launched since the *Great Eastern* to exceed that ship's length. (The *Oceanic*, though, was of less registered tonnage.) However, although the *Oceanic* was the largest vessel that had ever been built to date, her intended speed was never attained and the Blue Riband still remained with

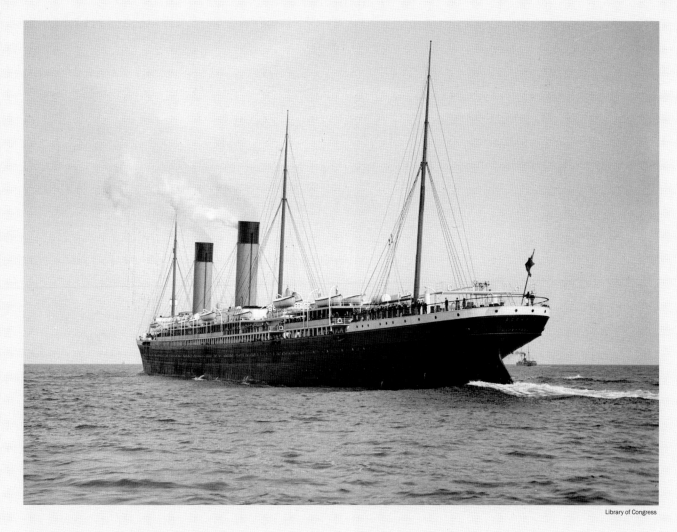

Oceanic (II) in 1899 was the largest vessel ever built and the first to exceed the length of the *Great Eastern* of 1858.

Library of Congress

a foreign flag. For a considerable period after this, both Cunard and White Star Line contented themselves with building ships which, although they were increasingly large, came nowhere near the German ships for speed.

All this changed, however, with the invention of the steam turbine. The steam turbine was a revolutionary device that could extract thermal energy from pressurised steam and convert it into rotary motion with far greater efficiency than the reciprocating engines used to date. It was eminently suited to marine propulsion but up to 1890 had not yet been adopted for this purpose. It would take a confident and daring innovator named Charles Parsons to design a turbine engine that was practical enough to be adopted for purposes of steam navigation. In 1894, Parsons financed and fitted his technology into the little *Turbinia*, which created a sensation and no little displeasure from the Royal Navy when it dashed in and among the assembled ships at Queen Victoria's Diamond Jubilee naval review at Spithead on 26 June 1897. With sparks and

smoke pouring from its funnel, she easily eluded all pursuers. Once the navy got over their fit of pique at being embarrassed in such a manner, it employed Parson's technology for two new destroyers launched in 1899 and six years later the first steamship company followed suit.

As the twentieth century dawned, two enormous White Star Line steamers were launched, the *Celtic* in 1901 and the *Cedric* in 1902, each establishing a record for size. These were the last vessels built for the White Star Line as an independent company, for in 1902 the White Star Line was purchased by and absorbed into an American-owned shipping conglomerate. This consisted of a group of American capitalists under financier J. Pierpont Morgan who were interested in expanding American business interests in the North Atlantic. By this time the top position at the White Star Line was held by J. Bruce Ismay, eldest son of Thomas Henry Ismay who had died in 1899. As Morgan and his associates were already familiar with William Pirrie – managing director and controlling

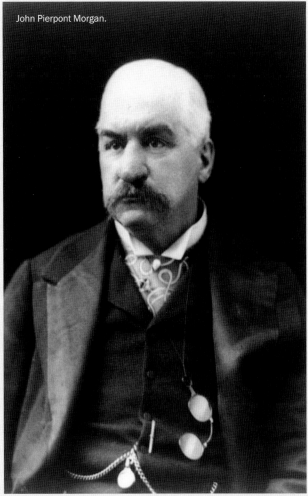

John Pierpont Morgan.

Lusitania (below right) was launched on 7 June 1906, while *Mauretania* (below left) was launched on 20 September of the same year. They were completed and ready for speed trials in July and September of the following year, respectively. *Mauretania* had 175 watertight compartments including those in her double bottom, and the shipbuilding trade publications stated that she was as unsinkable as a ship could be. The phrase 'practically unsinkable' was not unique to *Olympic* and *Titanic*, but had been used before their construction. The term was frequently used when describing the new liners fitted with extensive watertight subdivisions. This safety feature had been found to be successful, and helped create the false pretence of the unsinkable ship.

chairman of Harland & Wolff, which built many of their ships – it was through him that the White Star Line was approached. Pirrie also had a financial interest in the latter company, so it would potentially benefit him as well.

The offer for the purchase of the White Star Line was put forward in 1901. The Norddeutscher Lloyd and the Hamburg-American companies were similarly approached by Morgan, but though a working agreement was initially arranged, the German lines ultimately decided to preserve their separate existence. Managers of the White Star Line considered what many business experts believed to be a good offer, and accepted. In a separate Builder's Agreement, the Morgan group pledged to give H&W all orders for new vessels as well as all heavy repairs of their ships. In return, H&W agreed not to build ships for any other companies except the Hamburg-American Line, providing that the Morgan group kept H&W's shipyards fully and continuously employed. Furthermore, H&W would build ships on a 'cost-plus' basis: the shipyard would simply take their costs and add a commission of 5 per cent for new ships, 10 per cent for new machinery fitted into old ships, and 15 per cent for repairs.

The Morgan combination was eventually incorporated at the end of September 1902 in New Jersey as 'The International Mercantile Marine Company' (IMM) with a capital of $120,000,000. The formation of this conglomerate would later be regarded by Harvard University's Business History Review as 'one of the boldest acts in American business history.' It would effectively create a single corporation that would own, overnight, five leading American and British steamship lines. This was not without controversy. The British were dismayed at the prospect of losing such a significant percentage of shipping to American control. Concerned over this, the British government stepped forward and reached an agreement with IMM by which the British character of the British ships would

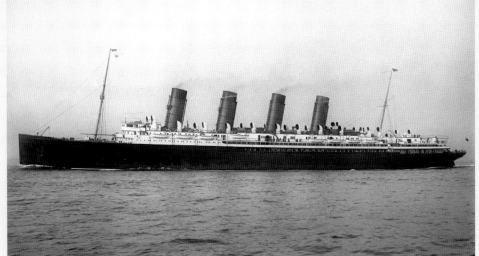

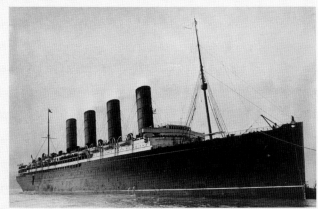

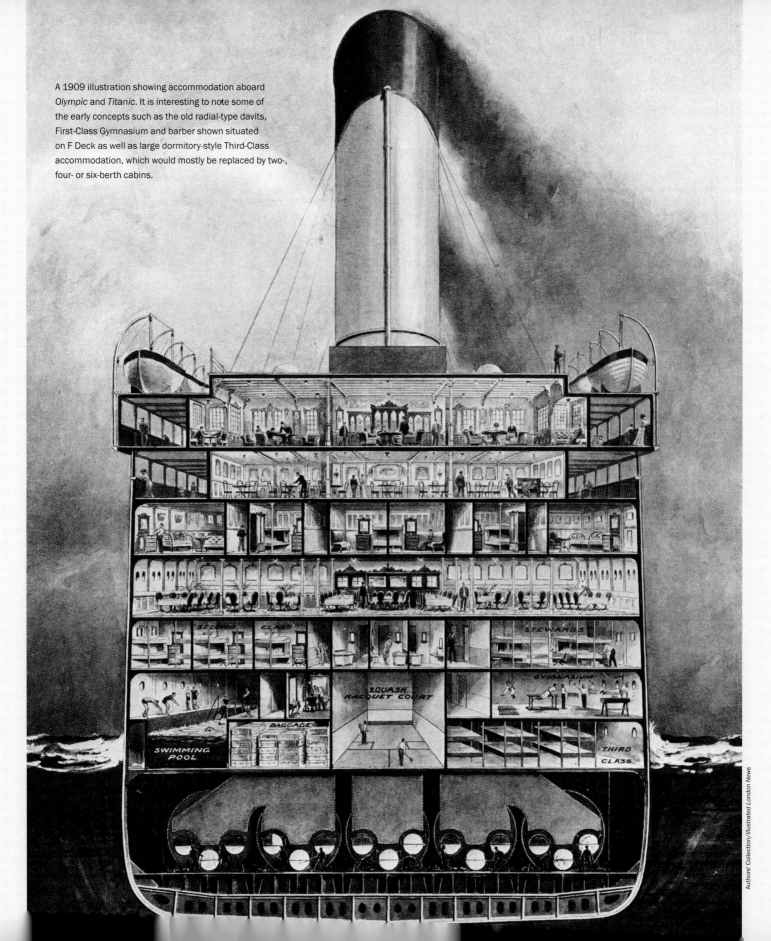

A 1909 illustration showing accommodation aboard *Olympic* and *Titanic*. It is interesting to note some of the early concepts such as the old radial-type davits, First-Class Gymnasium and barber shown situated on F Deck as well as large dormitory-style Third-Class accommodation, which would mostly be replaced by two-, four- or six-berth cabins.

Captain Edward Smith was accustomed to commanding the company's flagships, which included *Majestic*, *Adriatic*, *Olympic* and *Titanic*.

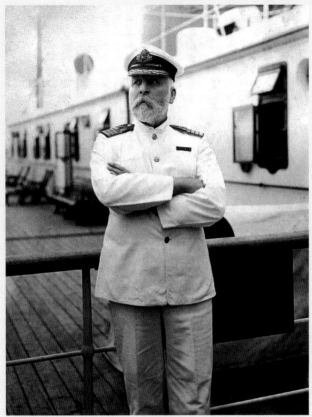

White Star Photo Library

be preserved. Thus, on the surface at least, British ships would remain British.

Bruce Ismay was made the president and managing director of the IMM in 1904 and over the next few years a few significant events took place. The mail steamers of the White Star Line changed their port of departure from Liverpool to Southampton in June 1907 and started calling at Cherbourg on their way to and from New York. As a result of the formation of the Morgan Shipping Trust, the British government arranged to loan the Cunard Line the necessary capital for the building of two new fast steamers as well as a yearly subsidy of £150,000 for twenty years. In exchange, these vessels would be available as Royal Naval auxiliaries in times of war. Cunard had found the *Carmania*'s turbine engines to be a success, so they adopted this principle in 1905 when commissioning their two new express steamers *Lusitania* and *Mauretania*. The design requirements imposed were such as to ensure their surpassing anything the world had ever seen in relation to size and speed.

Lusitania and *Mauretania* were powered exclusively by steam turbines which gave them speed but at the cost of large amounts of coal and vibration throughout the passenger accommodations. The White Star Line chose not to follow this path, as by this time it was no secret that it had chosen luxury over speed as a selling point for its ships. However, White Star Line was naturally interested in as much speed for their ships as could be achieved economically. Three months after *Lusitania* was launched, Harland & Wolff launched the *Adriatic*, the largest White Star Line vessel to date. The *Adriatic* was 709ft 2in in length, 75ft 6in beam, and 52ft deep, with a displacement of over 40,000 tons. She entered transatlantic service in the spring of 1908 and was in every way an improved version of all her great predecessors. She had an electric passenger lift between the various decks, a gymnasium, a full suite of Turkish and electric baths and – first for any ship – a 'plunge bath'. Her hull was divided into twelve watertight compartments, the bulkheads being fitted with watertight doors which could be closed from the Bridge if desired, and there were no fewer than nine steel decks. She was under the command of White Star's senior captain, Edward J. Smith. Although *Adriatic* proved to be a popular ship, White Star Line needed an answer to Cunard's latest transatlantic greyhounds.

Progress and friendly rivalry between the shipping lines continued and it is in this context that the stage for two new great steamships was set. They would be 50 per cent larger than *Mauretania* and *Lusitania* and would offer passengers the utmost in comfort. Before the ships were completed the press fantasised about the appointments, calling the two ships 'The Riviera on the Ocean.' They wrote of lavish public rooms and cafés fashioned to represent those of the Riviera, swimming pools 'sufficiently deep' to afford diving, a children's playroom with panels depicting fairytales, an extensive ballroom and even an ice-skating rink – 'in a sentence, passengers may skate, dance, smoke, swim, dive, and practice the arts of physical culture at their will'. Some of the more outlandish reports suggested there would be an old-fashioned 'Cheshire Cheese Chop House' that would be open day and night. Other reports spoke of sumptuous gardens on the upper decks, with beds of blooming roses and carnations, arbours skilfully contrived by the most expert of gardeners, an avenue of palms, and, ensuring that no detail would be overlooked, revealing that in the winter months all these were to be protected by glass roofs.

Although some of these concepts would never be realised, *Olympic* and *Titanic*'s great size did afford many improvements such as larger staterooms, vast amounts of promenade space, a restaurant which was in addition to the regular dining saloon, a larger swimming pool (rather than a 'plunge' bath) and even an elevator in Second Class. In the decades that passed larger ships would come and go, but for the time being *Olympic* and *Titanic* held the spotlight and captivated the world. ★

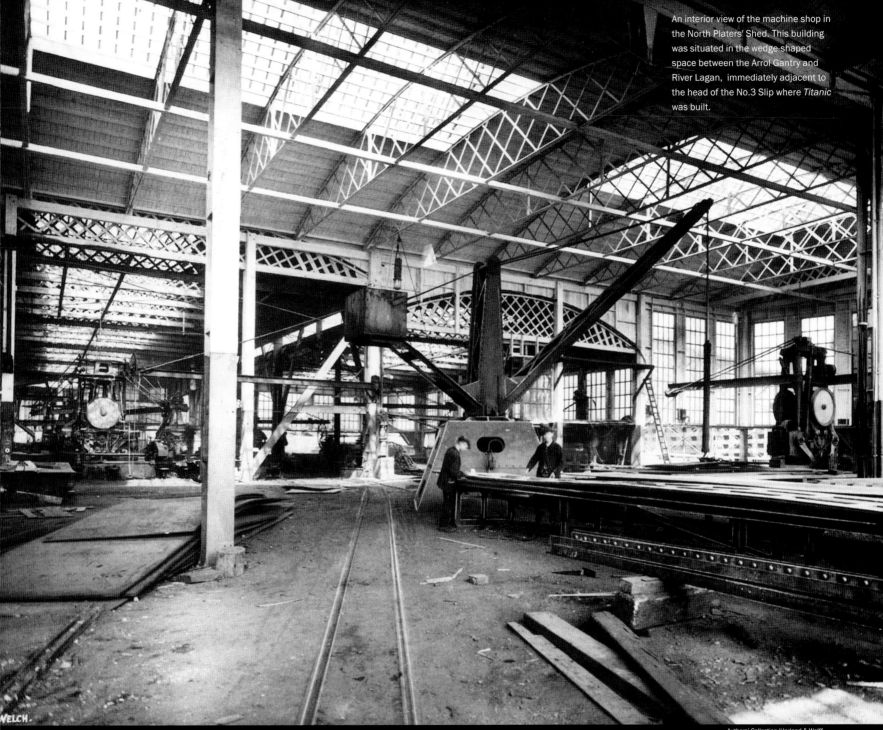

An interior view of the machine shop in the North Platers' Shed. This building was situated in the wedge-shaped space between the Arrol Gantry and River Lagan, immediately adjacent to the head of the No.3 Slip where *Titanic* was built.

2 ★ CONSTRUCTION & LAUNCH

According to popular legend, in 1907 a dinner was held at the Belgrave Square mansion of Lord Pirrie with Joseph Bruce Ismay as a guest, and it was at this dinner where plans were conceived for the construction of three huge liners that would be White Star Line's response to Cunard Line's new greyhounds. Although the new White Star ships would not compete with the Cunarders in terms of speed, they would be fast enough to offer a weekly service in each direction between England and America while providing unparalleled comfort and luxury.

The task of designing the vessels fell under the supervision of Harland & Wolff's principal architect, the Right Honourable Alexander Carlisle. On 29 July 1908, a meeting was held between White Star Line officials and the shipyard engineers. It was here that the owners saw the scale concept drawings of the proposed *Olympic*-class ships. On 31 July 1908 the contract was signed, making a formal agreement between the Oceanic Steam Navigation Company and Harland & Wolff. The order to commence construction was now official.

There would be three ships in all. *Olympic* would be the first of the class with *Titanic* to follow shortly thereafter. A third ship, yet to be named, would be built later. The ships would be true sisters, built from the same set of plans and nearly identical in all aspects from exterior to interior. The commencement of the construction of *Olympic* and *Titanic* would be staggered so as to not overtax the shipyard fabrication shops and off-site suppliers.

Olympic's keel was laid on 16 December 1908 and a little over three months later the laying of *Titanic*'s keel began on 22 March 1909, with the placement and positioning of the keel blocks on the newly cleared slipway. Over a week later, on Wednesday 31 March 1909, the first piece of keel plate was placed on the blocks – construction work on SS 401 officially began. Work on *Titanic* proceeded rapidly and it was often reported at this early stage that *Olympic*'s progress was in a 'slightly more advanced stage of construction'. Newspapers began to speculate that the ships would be ready almost simultaneously and enter service in the summer or autumn of 1911. *Titanic* was fully plated to her double bottom by 15 May of the same year but thereafter progress of her construction began to lag and the various stages of construction were accomplished at a slower pace than those of her sister. These were by far the largest liners ever attempted and despite the ambitious step forward in shipbuilding, efforts may have been shifted to *Olympic* in order to complete her and bring her into service as soon as possible.

By late November 1909 all but the last of *Olympic*'s frames had been raised into position and the framing of *Titanic* had progressed sufficiently that on 21 December an interesting event in the history of shipbuilding was marked at Harland & Wolff by the delivery of a number of record castings, at that time the largest and heaviest ever produced for any ship. These included the stern frame and two brackets for *Titanic* as well as the rudder for *Olympic*. These were sent on Sunday 12 December from the Darlington Forge Company and special railway arrangements had to be made as one of the castings extended 14ft beyond the side of the railway wagon and heavy balance weights were placed on the opposite side. The operation was carried out with great care and the train, which never travelled faster than 4mph, eventually delivered the castings to Hartlepool where they were placed aboard the cargo ship *Glenravel* for delivery to Belfast. Finally, by early March 1910 once the stern frame and brackets were assembled at Harland & Wolff, *Titanic*'s stern frame was in position.

On Wednesday 23 March 1910, Joseph Bruce Ismay visited Harland & Wolff and inspected the building of *Olympic* and *Titanic*. By this stage, *Olympic* was almost fully plated and *Titanic* was only two weeks away from having her last frame put into position. This is the only time that Ismay is known to have visited Harland & Wolff to inspect the ships' construction, except for when they were launched. However, the rare visit was of an official capacity and it was on this occasion that an important conference took place between Ismay, Lord Pirrie, Alexander Carlisle, Harold

The main drawing office at Harland & Wolff around 1908 where the main structural plans for *Olympic* and *Titanic* were created. In the back can be seen a half model of the *Olympic*-class prototype. A second drawing office was attached to the Engine Works.

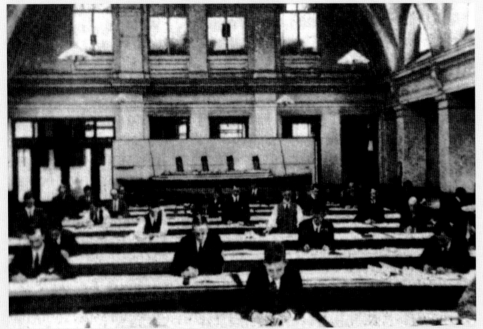

Authors' Collection/*The Engineer*

Sanderson and other leading officials of the White Star Line. The group no doubt discussed many aspects of the ships' construction, design and decoration of passenger accommodations as in the ensuing months orders for fittings not being produced by Harland & Wolff would need to be placed. Discussions also briefly included safety provisions for the two ships, where Alexander Carlisle's proposal of boats for all on board was turned down.

And so progress of the two ships continued. By 15 April 1910 *Olympic* was fully plated and by early July significant progress was being made in the plating of *Titanic*. *Olympic*'s launch was announced to take place on 20 October and preparations for the launch were well in hand when on Monday 8 August 1910 Alexander Carlisle suddenly announced his early retirement due to ill health. With the impending launch and the expected completion of *Olympic* by the summer of 1911, a new dock was being constructed in Southampton as no other dock was large enough for the berthing of the two giants at that port. Meanwhile, in New York, arguments with the Harbor Commission continued regarding the extension of the Chelsea Piers into the Hudson River, while additional dredging of both the Ambrose Channel and around the Chelsea Piers continued to increase the depth of water in order to permit the passage of the new class of ships at all tides. In Cherbourg, there was no pier large enough or quay with water deep enough to allow the berthing of the new liners so in October 1910 the White Star Line placed an order for two new tenders, *Nomadic* and *Traffic*, which would be used to ferry passengers, baggage and mails to the liners anchored outside the breakwater.

On 19 October 1910, *Titanic*'s hull was fully plated, just in time for *Olympic*'s launch the following day from the adjacent slip. No sooner had *Olympic* taken to the water and been moved to the Fitting-Out Wharf than work resumed on both ships. With *Titanic*'s hull fully plated, work continued with the plating of her decks, installation of transverse bulkheads and other internal work. On Monday morning, 5 December 1910, an accident occurred at Harland & Wolff when the pin holding one of the small travelling cranes to the large gantry above *Titanic* gave way. A large iron plate was being lifted at the time, but as it was only a few feet from the ground, there was little danger to any of the workers in the vicinity and no damage was done to *Titanic*; only the craneman sustained slight bruising. By February 1911 as the first of *Olympic*'s funnels were being fitted, it was becoming apparent that *Titanic* would soon be ready for launch. On 27 February *Titanic*'s huge 101¼-ton rudder (which had been cast as six separate pieces) arrived at Harland & Wolff, having been dispatched by the Darlington Forge Company. The rudder arrived on the Antrim Iron Ore Company's steamer *Glenravel*, much like *Titanic*'s stern frame and *Olympic*'s rudder had in December of 1909.

While *Titanic*'s intended launch date of 31 May 1911 was already being circulated as early as December 1910, Harland & Wolff did not officially announce this date until 7 March 1911. On Sunday 30 April 1911, *Titanic*'s centre anchor and two bower anchors, manufactured by Noah Hingley & Sons, were dispatched to Dudley where they were loaded onto a special train and made their way to the Fleetwood shipping docks. Although *Olympic*'s anchor received twelve horses for the occasion, twenty horses were supplied to haul *Titanic*'s anchor to Dudley. Other equipment such as chains, cables and attachments were delivered to Fleetwood in the following days and everything was finally delivered to Harland & Wolff on Friday

Drawing of *Titanic*'s profile. The *Olympic*-class ships were designed with an appealing yacht-like appearance as the old island superstructure design with separated deckhouses was replaced with a continuous superstructure. In contrast to ships of the Cunard Line, Harland & Wolff made every attempt to limit the number of cowl vents on the upper decks through the extensive use of electric ventilation blowers. The result was a ship with a streamlined appearance and whose lines suggested speed and grace. The overall length of *Olympic* and *Titanic* would be 882ft 9in; the extreme breadth 92ft 6in; and from keel to Navigating Bridge the total height would be 104ft. Both vessels would have a gross registered tonnage of around 45,000.

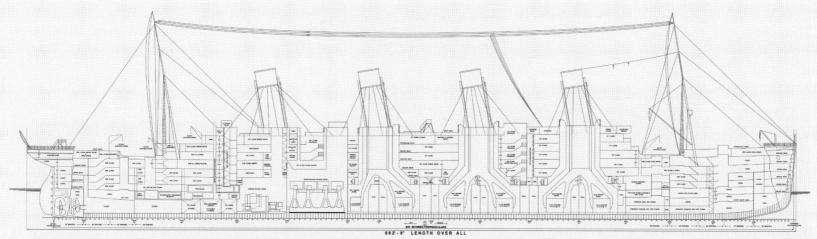

882'-9" LENGTH OVER ALL

Illustration by Bruce Beveridge

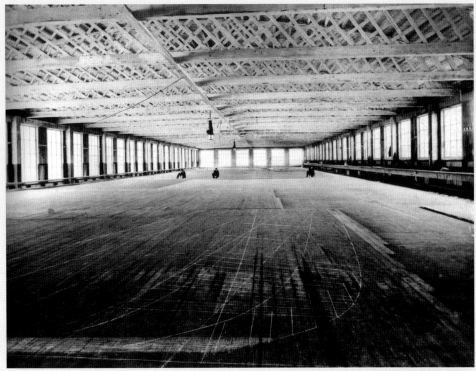

Authors' Collection/*The Shipbuilder*

The Mold Loft at Harland & Wolff. Here, on an uninterrupted floor as large as a football pitch, the preliminary hull lines laid out in the Drawing Office were reproduced full scale in height by one-quarter scale in length. After doing so, the loftsmen, as they were called, then performed a thorough job of 'fairing' the ship's lines to eliminate any slight variances and imperfections in the smoothness of these graceful curves. Once the basic lines had been faired, the loftsmen then set about the business of determining the exact shape, size and position of every frame, deck beam and shell plate strake.

5 May aboard the *Duke of Albany*. At some point later in May, *Titanic*'s hull was painted in preparation for the big day and the anchors were fitted shortly thereafter.

As the sun dawned on Belfast on the beautiful and warm Wednesday morning of 31 May 1911, the day was a cause for many celebrations. The White Star Line's newest and the world's largest ship, the *Olympic*, was complete and ready to be handed over to her owners. Her sister ship, *Titanic*, was ready for launch and Lord and Lady Pirrie were both celebrating their birthdays. Reporting on the launch, numerous newspapers found it irresistible to draw attention to the coincidence – the *Sunday Independent* wrote:

It is by many accepted as a happy augury for the career of both the great ships that the successful launching of the one and the first extended trial trip of the other synchronised with the natal day of both the head of the building firm and his amiable wife.

Titanic's launch was set for 12.15p.m. sharp and throughout Harland & Wolff the day was observed as a holiday, except for a small crew of workers who assisted with the launch. Wearing a blue serge jacket suit and his signature yachting cap, Lord Pirrie arrived at the yard early in the morning to direct the preliminary launching preparations. Throughout the morning, thousands of

people flocked to the shipyard from every direction to witness the launch. By water, the specially chartered *Duke of Argyll* brought some special guests to Belfast from Liverpool and other pleasure steamers crowded with sightseers lay off in the river. By land, those nearby walked, while cars, taxi-cabs and trams – all crowded – conveyed spectators to the yard. To accommodate those fortunate enough to witness the event, Harland & Wolff provided a number of vantage points. On the opposite side of the river from where *Titanic* patiently stood in her slipway, a section of grounds had been railed off, for which a charge of admission was made. The proceeds would be given to various Belfast hospitals. A significant number of guests and representatives from the press were accommodated on a large stand directly facing *Titanic*'s stern while the best seats for special guests of the owners and builders were on a stand constructed near the port bow.

About 11.30a.m. the carpenters wielding heavy mauls began to knock away the few remaining keel blocks and shoring timbers, and by noon final preparations were all but complete. Lord Pirrie and Bruce Ismay made a final inspection and a small party of special guests finally took their places at 12.05p.m. on the platform by the port bow of the ship. Accompanying Lord and Lady Pirrie, Bruce Ismay and some of his family members were J. Pierpont Morgan, head of the International Mercantile Marine; his business partner Mr E.C. Grenfell; Mr Harold Sanderson, the General Manager of the White Star Line; Mr P.E. Curry, White Star's Southampton Manager; Mr Charles F. Torrey, Managing Director of the Atlantic Transport Line; Charles Payne, Director of Harland & Wolff; the Lord Mayor of Belfast and numerous other prominent members of society and the shipping industry.

Among the dignitaries and thousands of onlookers were approximately 100 journalists from Ireland, England, Scotland and Wales. Some were fortunate enough to secure a seat on the viewing stand at *Titanic*'s bow which afforded the best view of the launch. A journalist from *The Manchester Guardian* was one such individual and recorded a striking account:

This is the 401st vessel launched by Messrs. Harland and Wolff. The number appeared in neatly painted figures on one of the launching planks at the ship's bow as she lay on the stocks. On the upraised bow, towering nearly 100 feet from the ground, was the name *Titanic*, like an exclamation flung up to heaven and suggesting in one word the pride and glory of her owners.

Messrs. Harland and Wolff have an unostentatious way of launching even their greatest productions. The only thing about

their yard to betoken the event of the year was the flying of half-a-dozen flags above the gantry where the new ship lay ... There was no naming ceremony, and there were no cheering masses of workmen, though the yard seemed to be keeping holiday. Everything was solid and workmanlike, and the great task of launching a hull weighing between 24,000 and 25,000 tons was carried through with no more display than the launching many years ago of the yard's ship No.1 – a diminutive craft of only 24½ tons and a length of 71 feet, which could be lifted at the davits of a monster like the *Titanic*.

Everything was in readiness at an early hour. No staging remained about the ship's sides, but occasionally the clanging of hammers was heard from underneath the hull where the remaining shores were being knocked down in batches. Only a few were left on either side at the hour of noon when Lord Pirrie made his final inspection of the arrangements. A minute later a whistle sounded a shrill summons, and a little regiment of men armed with long-handled hammers attacked the last of the shores. They fell like saplings before an axe, and other men lifting them shoulder high, carried them off.

The hammers ceased, and everywhere among workmen and spectators there was a tense silence. It was broken by the discharge of a rocket. By the time the rocket had burst somewhere out of sight in the glare of the sun the workmen had moved to new stations or jumped aside as not wanted. A second rocket was fired to signal the launch. It rose and burst, and what seemed at first an echo of the explosion came from the ground. It was the crackling of massive timbers strained almost to breaking point. The bow of the ship at the same time moved, but so slightly that doubt could be excused. It took a perceptible moment to tell that the ship was actually sliding down the ways. There was a short glad shout of 'she's off', followed by what seemed a long silence, while the big mass glided noiselessly to the water.

From the stand near the bow we soon caught sight of the curl of the wave flung back by the vessel's stern, and the perspective through the gantry gradually drew out to its full length. Suddenly we saw the gleam of the sky beyond and the bow of the ship dipping a graceful curtsey and baptizing itself in far-flung spray. Then there was indeed a shout, and a hoarse chorus of sirens, in which one imagined there came the deep note of the twin ship waiting for the news off Bangor. The launch had seemed to last a comparatively long while, yet the official time from the depression of the 'triggers' which were the last hold on

Authors' Collection/The Engineer

the ship to its floating was sixty-two seconds, and the speed of the launch was twelve knots.

In a minute and a half and almost within her own length, *Titanic* came to a complete stop. A number of tugboats immediately surrounded her and in a short time, she was successfully moored at the Fitting-Out Wharf. With the excitement over, the crowds slowly dispersed and Harland & Wolff officials escorted a large group of their guests to the shipyard's dining hall where they were entertained for lunch. Likewise, the White Star Line entertained another large party of guests for lunch at the Grand Central Hotel. By the afternoon, *Olympic* was officially handed over to the White Star Line and a group of dignitaries were ferried to her aboard the *Nomadic*, which along with the *Traffic* was also handed over on the same day and thereafter proceeded to Cherbourg. Although on Wednesday 31 May 1911 a triumphant achievement was celebrated in Belfast, there was still much work to be done on *Titanic* and it would resume promptly the very next day. ★

The Platers' Sheds. On average, the shell plates used on these ships were 6ft wide and 30ft long and weighed between 2½ and 3 tons each. The largest shell plate used on *Titanic* was 36ft long and weighed 4¼ tons. The thickness of the plates averaged about 1in amidships and thinned toward the ends but was thicker in other areas depending on the need for extra strength.

When construction commenced on *Olympic* (yard number 400) and shortly after on *Titanic* (yard number 401), Harland & Wolff was considered a full-service shipbuilding company in the most complete sense of the term. They employed over 14,000 men including sub-contractors as well as on-site personnel. With an Engine Works, Joiners' Shop and a vast array of other shops and departments, Harland & Wolff could build and fit out ships from the keel on up. At the height of *Olympic* and *Titanic*'s construction, approximately 6,000 men alone were involved with the building of the two ships, about one-sixth of whom worked on night shifts.

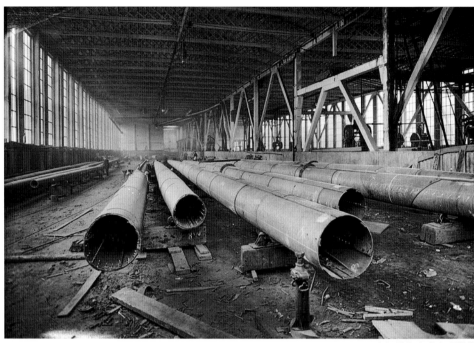

Authors' Collection/Harland & Wolff

Steel Mast Shed. *Olympic* and *Titanic* were each fitted with two masts which towered to a height of 205ft above the water. The foremast was fitted with a derrick for lifting heavy cargo such as automobiles into the forward holds. All but the top sections of both masts were made of rounded steel plates. The ladder to the crow's-nest was located inside the foremast, and was accessed on C Deck.

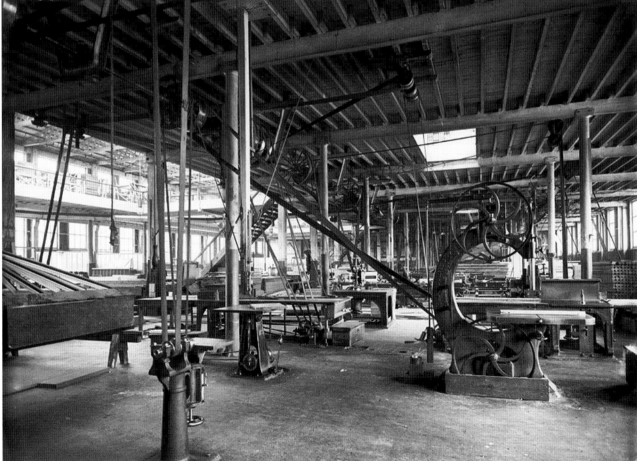

One of the machinery bays on the ground floor of the North Yard Joiners' Shop. A large band saw is seen in the immediate right foreground, while various table saws, jointers, shapers, planers and other heavy woodworking equipment appear along the length of this bay.

Authors' Collection/Harland & Wolff

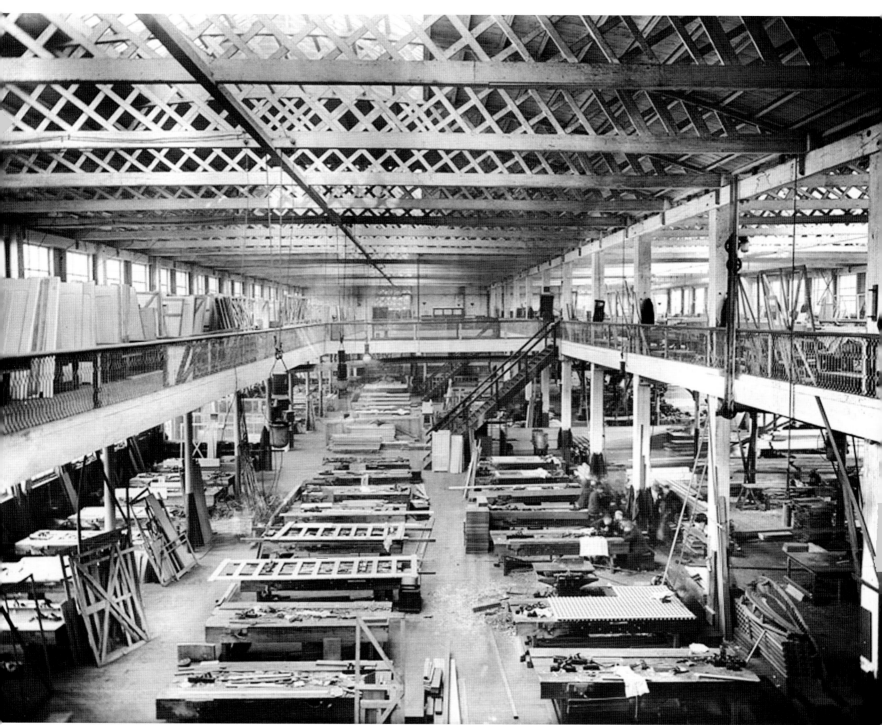

An overall view showing both the ground and upper floors of the North Yard Joiners' Shop. The ground floor was used largely to produce the more ordinary types of interior bulkheads, doors and other joinery which were used in the construction of the lower classes of passenger staterooms and cabins as well as similar joinery for the crew's quarters and the 'working areas' of the ship. The ground-floor shop also produced joinery as diverse as plugs by the thousands for filling in the bolt holes in deck planks and handrails. The upper floor was devoted entirely to the finishing work of interior joinery and the making of cabinetry and furniture. Note the row of finished stateroom bulkheads awaiting removal to the storage area.

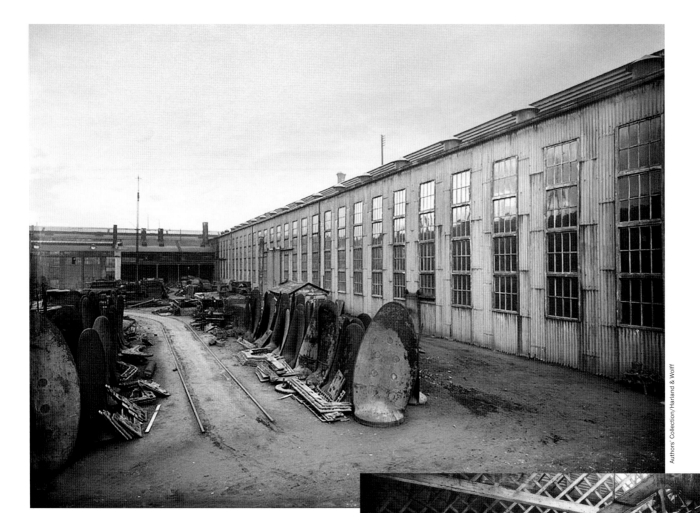

This photo shows part of the outside storage yard of the brass and iron foundries. The yard is filled with a veritable garden of raw propeller blades cast in bronze, steel or iron. Propeller blades were selected from this storage yard and then sent off to be machined, drilled and scraped to final shape, after which they were mated to a hub for final finishing and balancing as a matched set.

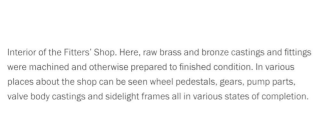

Interior of the Fitters' Shop. Here, raw brass and bronze castings and fittings were machined and otherwise prepared to finished condition. In various places about the shop can be seen wheel pedestals, gears, pump parts, valve body castings and sidelight frames all in various states of completion.

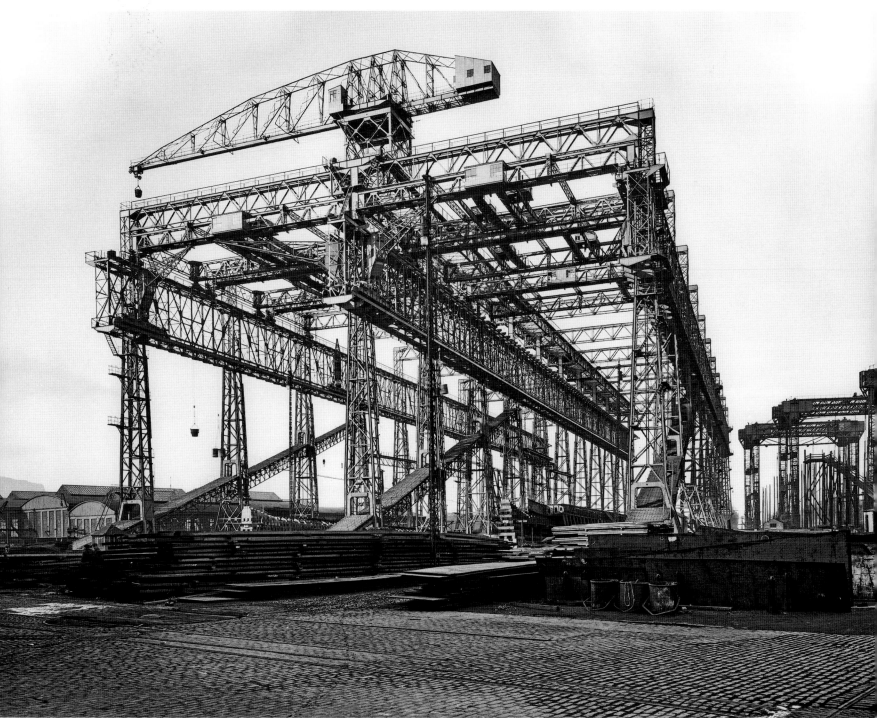

This photo, taken on Wednesday 31 March 1909, captures an historic moment – the day *Titanic*'s first keel plate was laid. To facilitate the construction of these colossal vessels, Harland & Wolff was required to undertake a major expansion to its Queen's Island facilities. When completed, the yard had no less than eight building slips, all capable of taking large vessels. Two new slips numbered 2 and 3 were specially laid out for the construction of the huge *Olympic*-class ships in a space previously occupied by three slips. Two huge gantries with overhead cranes were required for these new slips, and the William Arrol Company was contracted to construct them. For years the Arrol gantry dominated the Belfast skyline as *Olympic*, *Titanic*, *Britannic* and other ships rose within them.

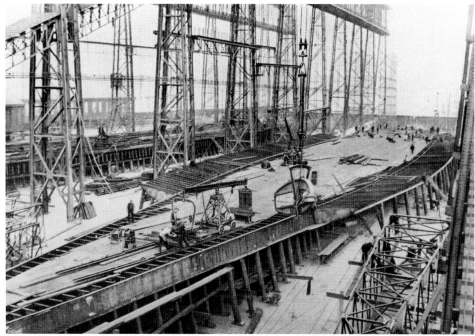

Authors' Collection/*The Engineer*

These photos, taken in July 1909, show work underway on *Olympic*'s double bottom with *Titanic*'s double bottom seen in the adjoining slip to the left in a slightly less advanced state of construction. This part of the ship was divided into forty-four separate compartments and contrary to popular belief was not designed solely for protection against collision or grounding. In fact, the double bottom was integral to both the structural strength and the functioning of the ship. The compartments within were used for the storage of fresh water, for makeup boiler feed water, domestic use and to hold water ballast for trimming the ship.

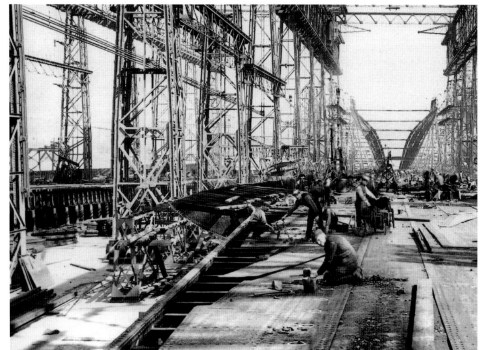

Authors' Collection

Titanic's stern frame being lifted into position. At the time, it was one of the largest castings produced for any ship, weighing 70 tons. So that it could be transported by rail, the frame had to be made in two sections. Even so, it still overhung the side of the railway wagon by 14ft. The two sections were put together at Harland & Wolff and once combined, reached a height of 68ft 3in.

Günter Bäbler Collection

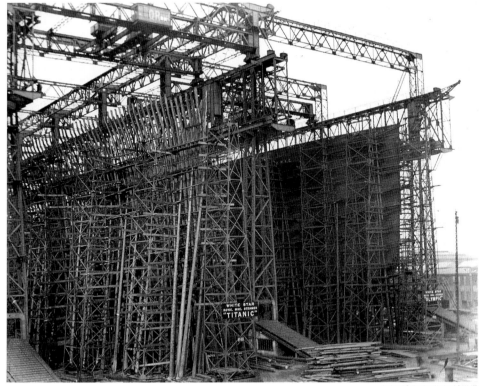

On Wednesday 6 April 1910, *Titanic*'s last frame was lifted into position. These photos, taken on 7 April, record this stage of her construction for posterity. Plating of some of the fully framed areas had already begun at the stern.

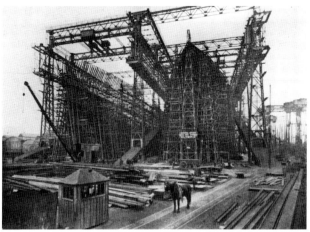

Authors' Collection/Harland & Wolff

Authors' Collection/*The Shipbuilder*

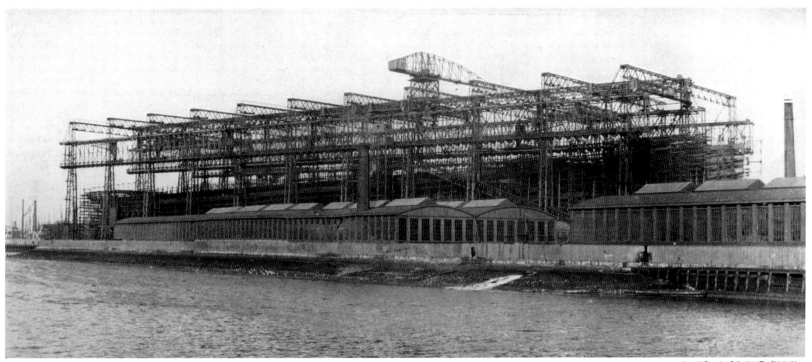

Ioannis Georgiou Collection/*The Shipbuilder*

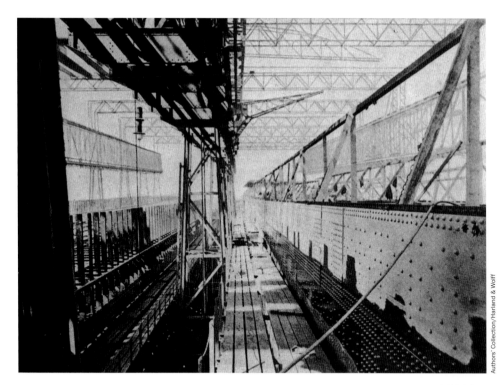

In this July 1910 photograph, *Olympic*'s plated hull is seen to the right, with *Titanic*'s frames seen to the left in the adjacent slip. One observer remarked that 'the symmetrical appearance of the rivet heads catches the eye and gives the impression of exceptional strength'.

Authors' Collection/Harland & Wolff

This photo was taken around mid-August 1910. The plating of *Titanic*'s hull is well advanced and *Olympic*'s hull is in the early stages of preparation for her launch some two months hence.

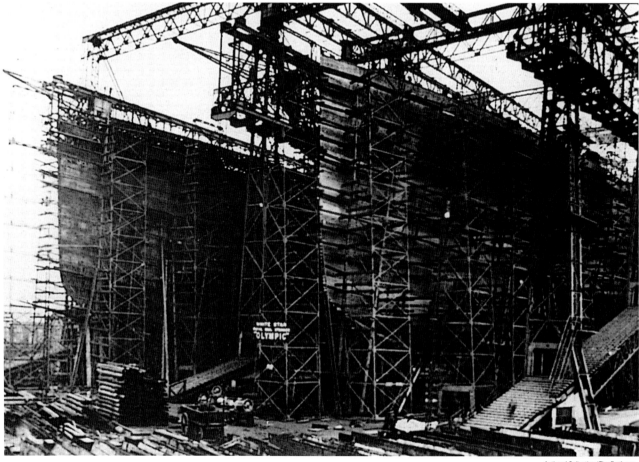

Authors' Collection/*The Engineer*

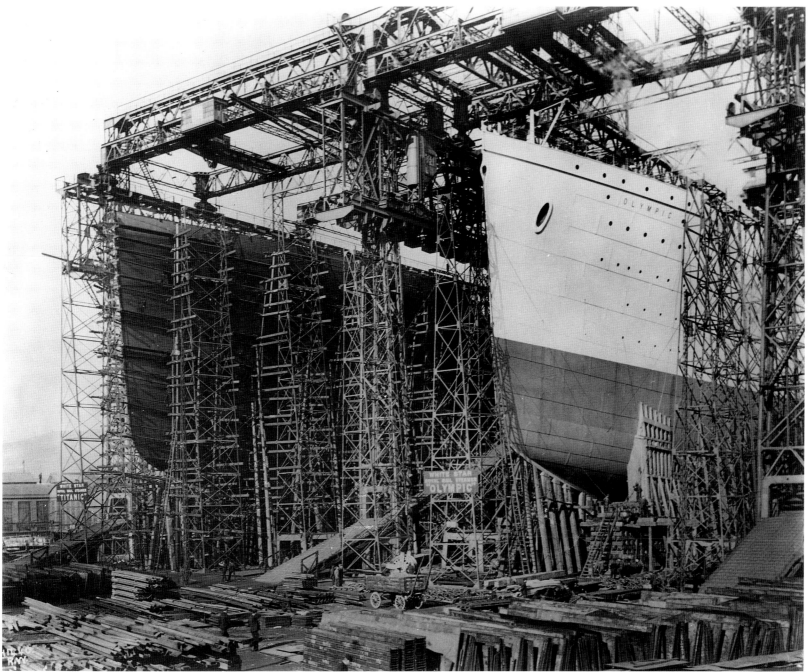

Olympic's hull is freshly painted as seen here a week or two before her launch. Lord Pirrie had directed *Olympic*'s hull to be painted in a light gray to improve her appearance while she glided down the slipway into the River Lagan. The light paint would better show her overwhelming size and allow photographers and cinematographers to capture striking images of what was to be the world's largest ship. This also served as free publicity as the photographs were circulated worldwide.

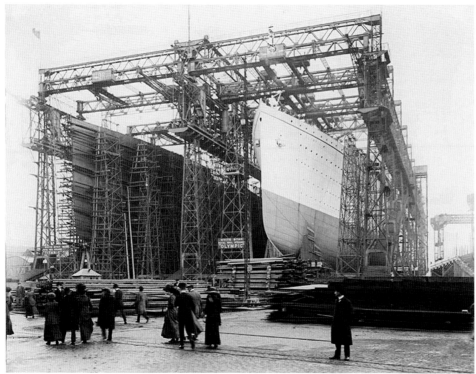

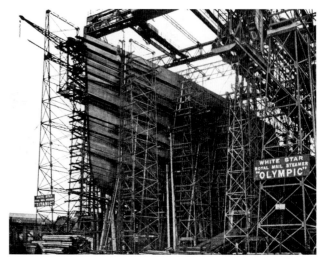

Günter Bäbler Collection

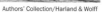

Authors' Collection/Harland & Wolff

Crowds gathering in the morning of 20 October 1910 to witness *Olympic*'s launch [left], while *Titanic* stands proudly in the adjoining slip, her hull having been fully plated only the day prior [above].

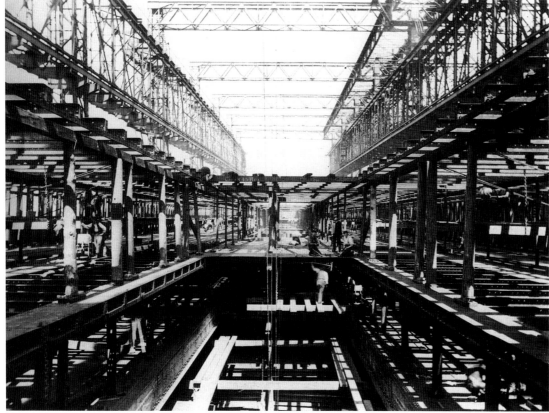

Authors' Collection/Harland & Wolff

For the last seven months of *Titanic*'s time under the gantry, interior work proceeded with the laying of deck plating, the installation of transverse bulkheads, plumbing, electrical work, and the fitting of much of the auxiliary equipment. The ship's heavy machinery such as boilers, engines and condensers would be lowered into the hull through openings in the decks after the ship had been launched.

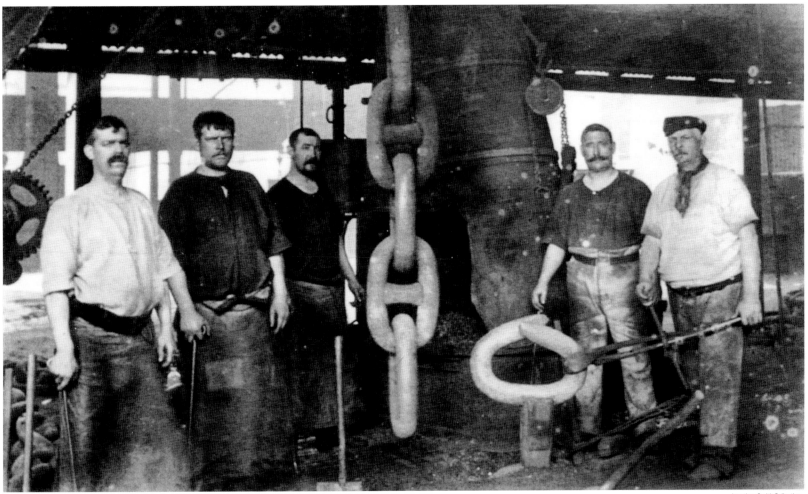

Part of the chain workshop at Noah Hingley & Sons Ltd of Netherton, Dudley. This photo shows a section of anchor chain for *Titanic*'s two side anchors. Each link started life as a length of straight-cut round bar which was heated and bent into a semi-circular shape. Using hammers, the 'chain gang' would hammer the link into its closed state making sure that both ends meet. The stud would then be inserted and hammer-closed into position. Almost 1,200ft of chain was crafted for *Titanic*.

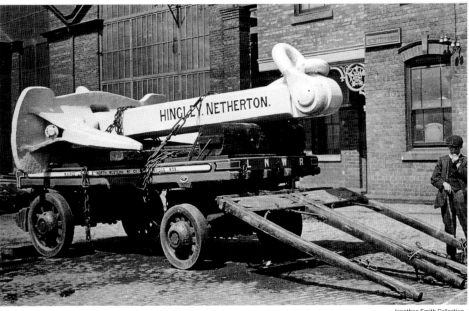

This photograph was taken by local photographer Edwin Beech on Saturday 29 April 1911 and shows *Titanic*'s newly painted 15.16-ton centre anchor as it sits atop of the dray outside the Lloyds Proving House, which was situated on the opposite side of the Hingley works. Of all the anchors made for the *Olympic*-class ships, *Titanic*'s centre anchor was the only one with 'Hingley. Netherton.' painted on it. (This was a result of Hingley's dissatisfaction with the lack of publicity from White Star Line for the mammoth anchors supplied by Hingley's for the new fleet.) Following delivery to Harland & Wolff, the anchor was painted black.

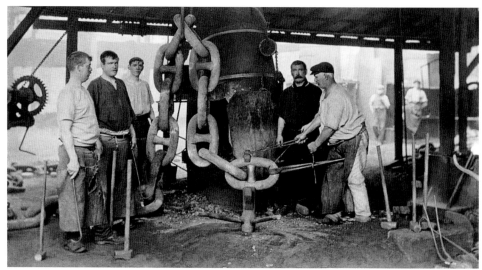

This photograph, also taken by Edwin Beech, shows some of the 'chain gang' at Hingley's. The king of the chain makers, Ben Hodgetts, is to the far right and then from right to left are Theopholus Dunn, Albert Hodgetts (Ben's son), George Bridgewater and Ben Woodhouse.

Jonathan Smith Collection

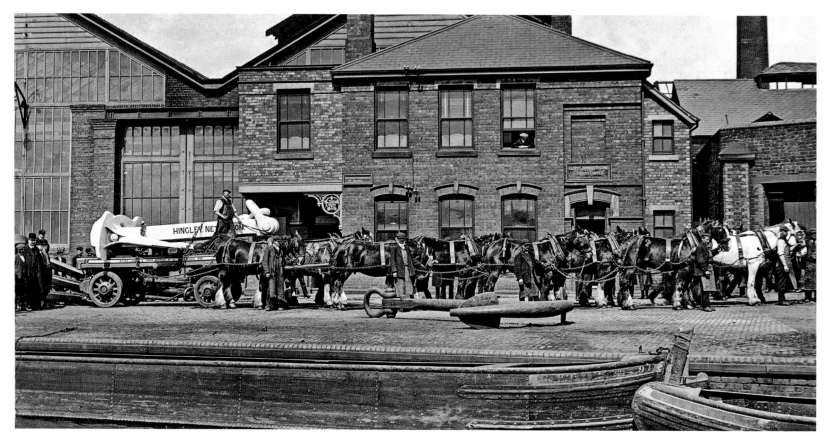

White Star Photo Library

Sunday morning 30 April 1911, Beech was back at Hingley's to photograph *Titanic*'s anchor leaving the works. The original line-up of eight shire horses can clearly be seen along with their guides. With a 2-mile journey ahead of them, which included a steep incline leading up to the town of Dudley and the railway station, a further six horses were supplied to help assist with the journey ahead. The London & North Western Railway yards at Dudley station sent down a further six horses of their own in case any fell or were needed to take the extra strain during the haul to the goods yards. A worker from the Hingley works joked to the men as they entered the Proving House grounds with the L&NWR horses, saying 'you can take them poor specimens back', indicating the Hingley horses could easily do the job better.

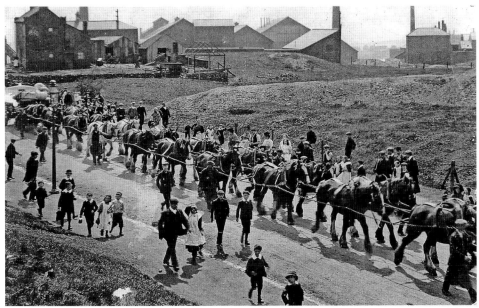

Jonathan Smith Collection

After a slight delay in leaving the Proving House, Edwin Beech captured these scenes around midday as the procession headed towards Northfield Road and then on towards the town of Dudley. As the journey begins, men and women, along with their children dressed in their Sunday best, can be seen following ahead and alongside the procession. The children can be seen still carrying their hymn books. In these iconic images, the spirit of excitement and enthusiasm is captured in an instant.

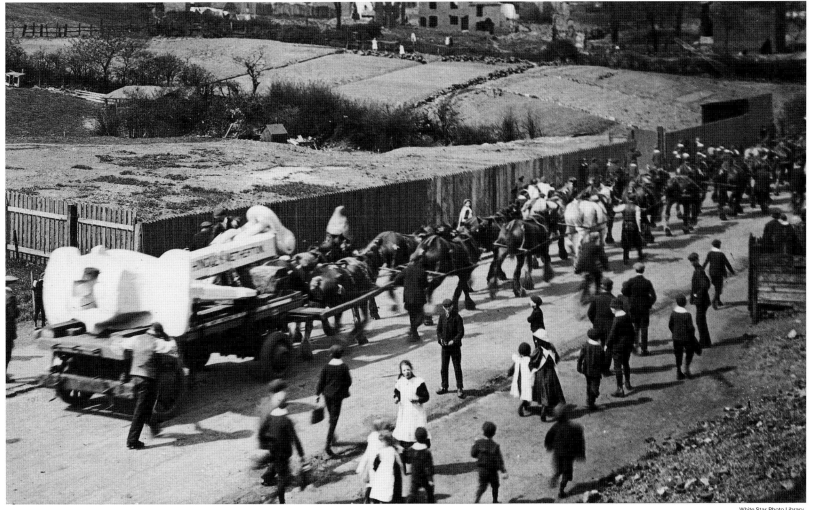

White Star Photo Library

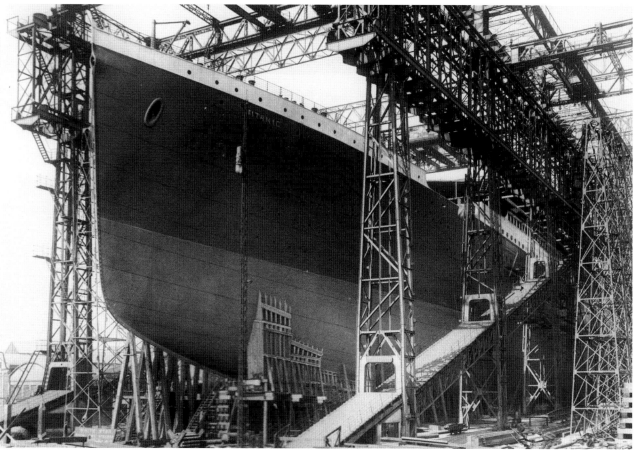

The freshly painted *Titanic* as seen here a week or two before her launch.

The starboard tail shaft being fitted on *Titanic* as she lay in her construction slip in May 1911, prior to launch. The rudder is clamped to prevent movement during launch. The *Olympic*-class liners were each fitted with a cast-steel rudder weighing 101¼ tons and with an overall length of 78ft 8in and a width of 15ft 3in.

Authors' Collection/Harland & Wolff

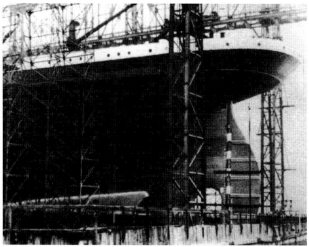

Authors' Collection/*Belfast Telegraph*

Titanic's stern prior to launch in a rare image showing the cofferdam at the end of the slipway prior to removal. As the day of the launch neared, the end of the slipway was flooded to the level of the river. The cofferdam was then removed by the use of a barge, thereby allowing clear passage of the hull to slide into the river.

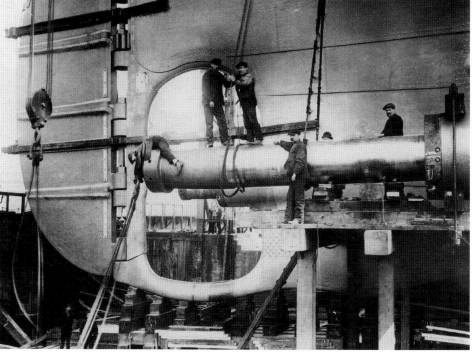

Authors' Collection/Harland & Wolff

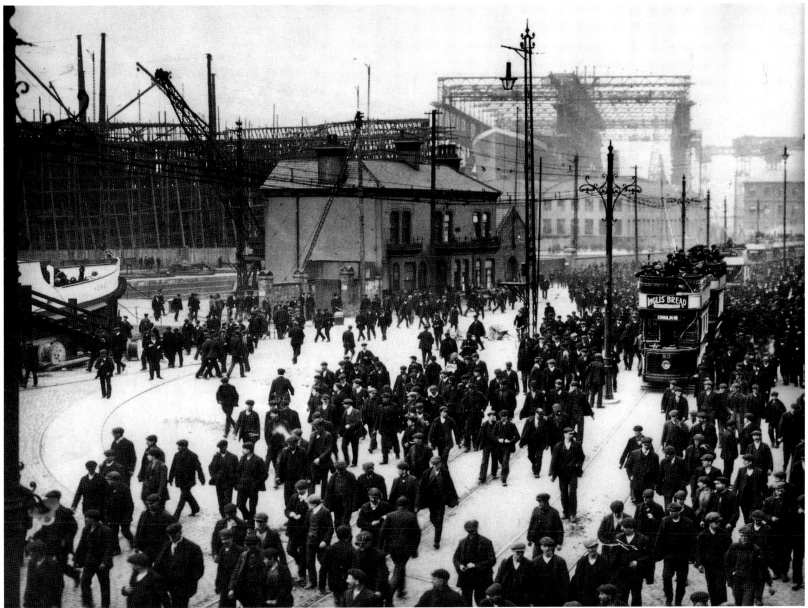

With the great gantries of Harland & Wolff dominating the Belfast skyline, the end of a work day at the yard presents a noteworthy scene, as the *Southern Star* observed: 'When the horn known as the Buzzer sounds at 5.30p.m. ... along the broad road, a mile or so long, are 40 to 50 electric cars [awaiting to commute workers], and in less than 5 minutes the whole road is black with men who pour out of different gates of the works like a swarm of bees.'

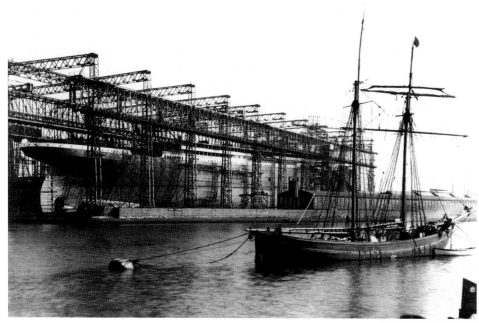

These photos were taken on 29 May 1911 from the *Olympic*. The image above was taken from her stern as she lay at the Fitting-Out Wharf, while the image below was taken a little later as *Olympic* was hauled off the Wharf by tugs at 10.30a.m. in preparation for her sea trials departure. In both images, *Titanic* is seen in her slip under the great gantry in the distance.

(Above) *Titanic* stands ready under the gantry a few days before her launch, the cofferdam at the end of her slip not yet removed.

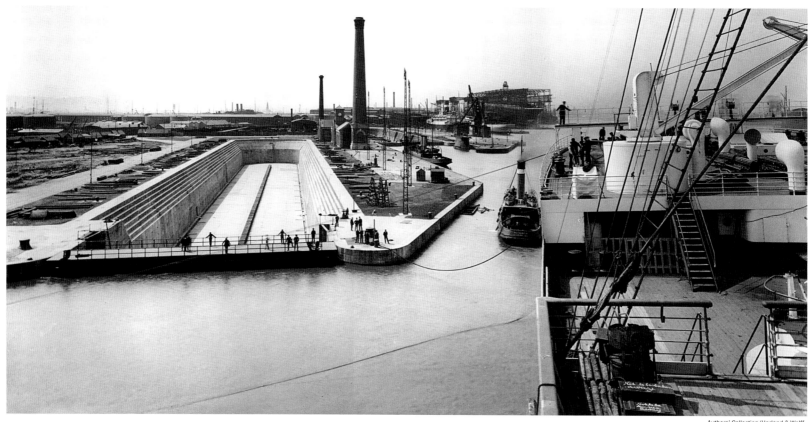

Irish Examiner

With the warm sun shining brightly, it was a perfect day in Belfast on Wednesday 31 May 1911. With *Titanic* towering over Harland & Wolff, this *Cork Examiner* photo was taken by Thomas Barker, the only full-time photographer working for the newspaper, on his way to attend the launch.

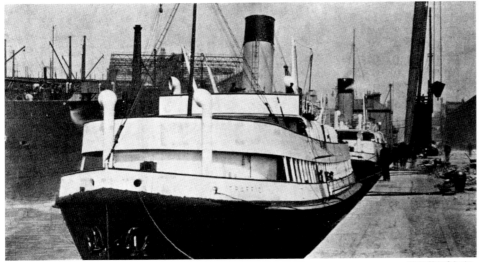

Günter Bäbler Collection

While work on *Olympic* and *Titanic* was in progress, construction was also underway on the new White Star Line tenders *Traffic* and *Nomadic*. Construction began at the end of 1910 and both were launched at the end of April 1911. It only took a month to fit out both tenders. This photo, taken on 31 May 1911, shows both tenders completed and ready awaiting their afternoon departure. The tip of *Titanic*'s bow can be seen under the gantry in the background.

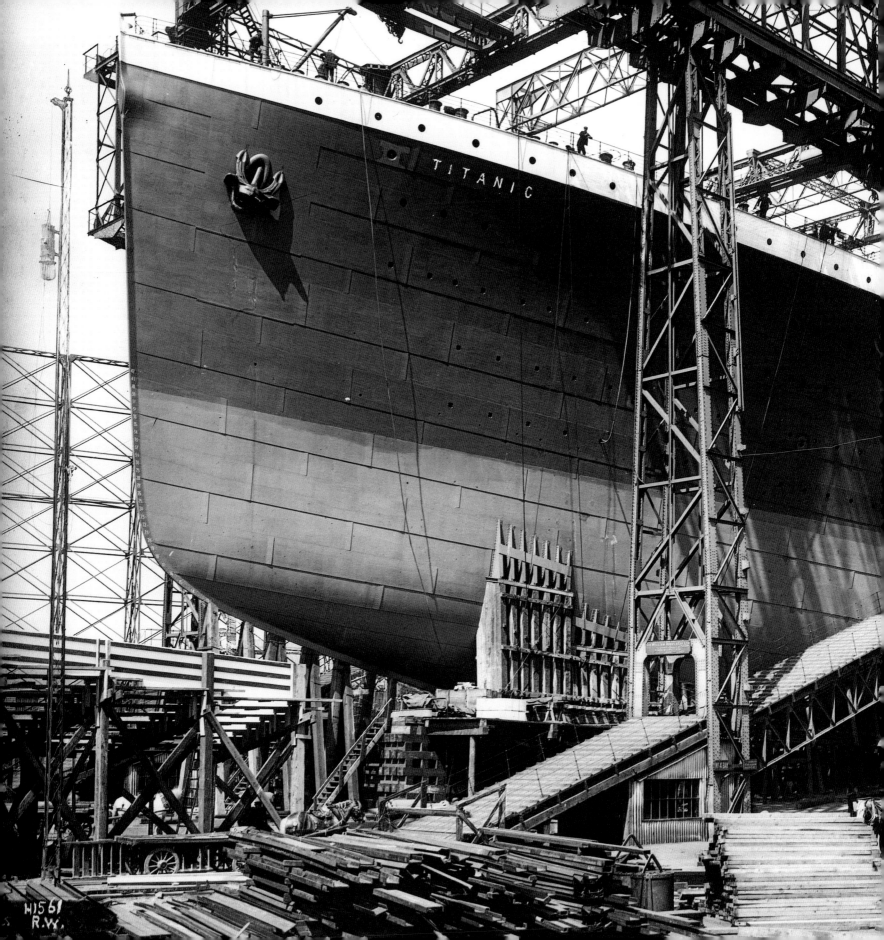

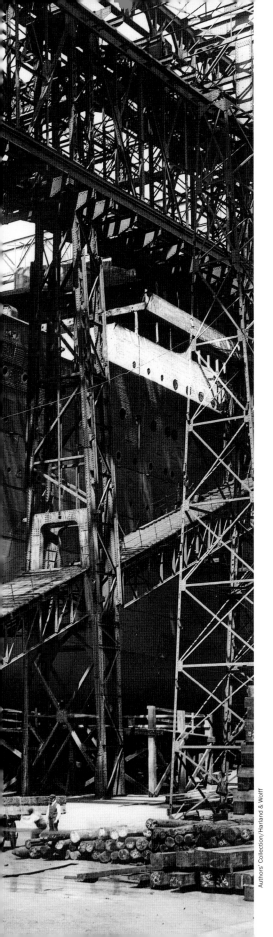

Titanic stands proudly awaiting her launch. The observation stands have been constructed for those privileged enough to receive a special invitation. Soon over 100,000 people will be gathered around the yard to watch her take to the water for the first time.

Authors' Collection/Harland & Wolff

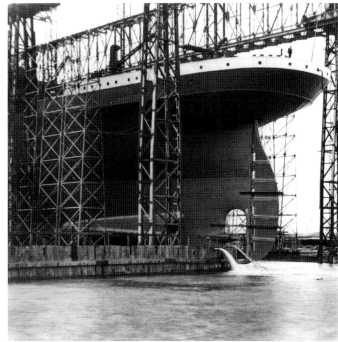

Ioannis Georgiou Collection/Harland & Wolff

Titanic's stern prior to launch with caisson removed.

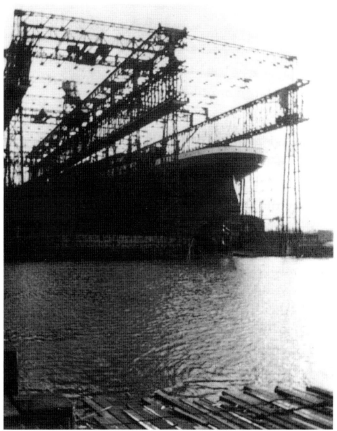

Jonathan Smith Collection

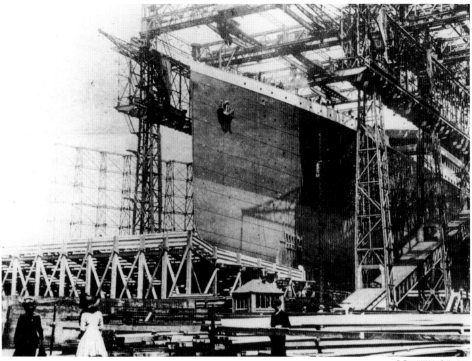

R. Terrell-Wright Collection

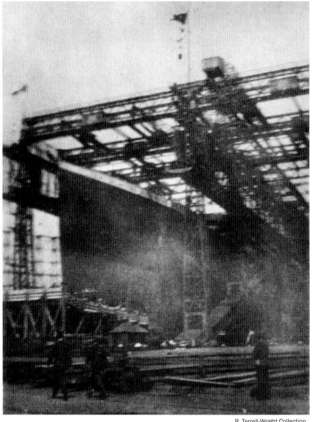

R. Terrell-Wright Collection

From an early hour, large numbers of people began to gather in the yard and about noon, all vacant spaces around *Titanic* were occupied by crowds of spectators.

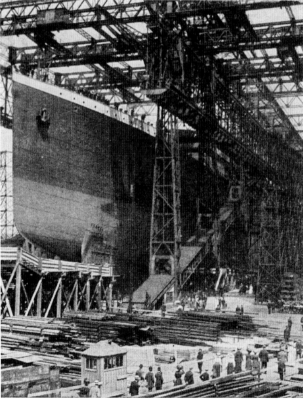

Authors' Collection/*Illustrated London News*

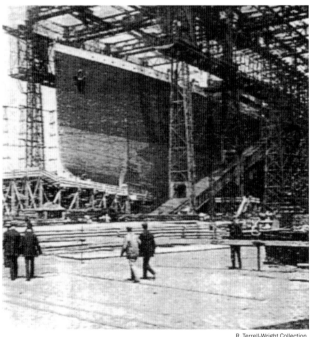

R. Terrell-Wright Collection

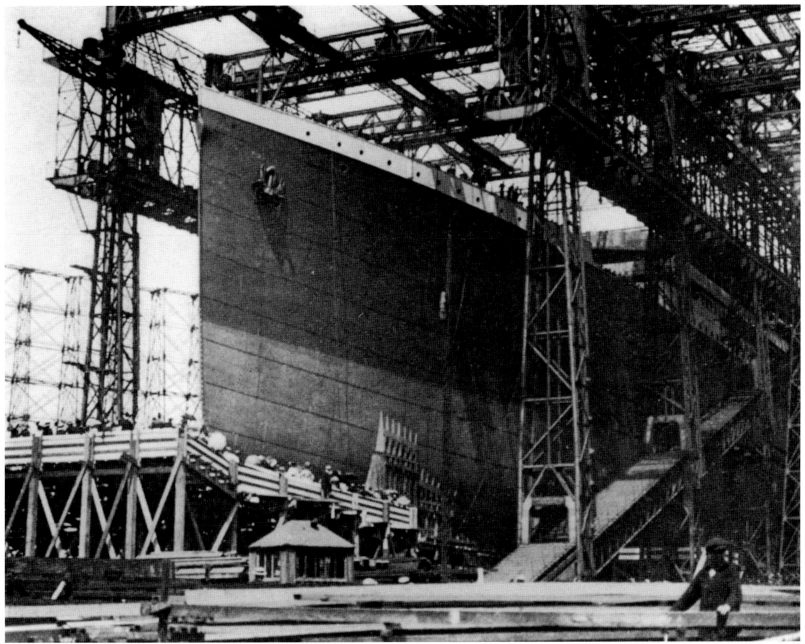

This photo was taken moments before 12.15p.m., the privileged guests having taken their place only a short time prior. The *Glasgow Herald* reported that 'the weather was magnificent, the sun shining brightly all day and the many bright dresses of the ladies on the decorated platforms combined with the fine appearance of the ship ... formed a magnificent picture'.

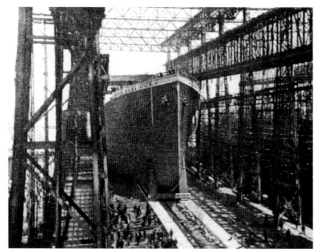

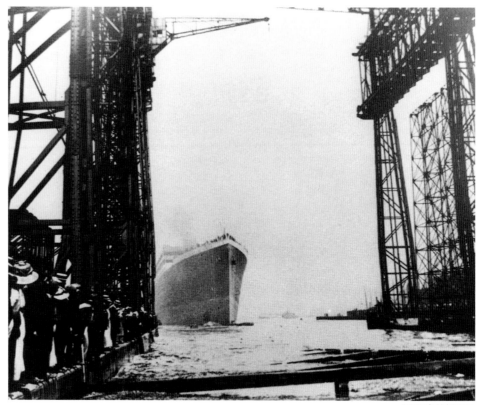

R. Terrell-Wright Collection

Jonathan Smith Collection

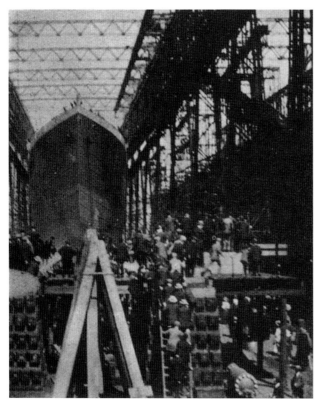

Library of Congress/*Shipping World*

As was customary for White Star Line ships, there was no launch ceremony with the usual bottle of Champagne broken over the bow. (In an apocryphal quote, a worker is reported to have said, 'They just builds 'em and shoves 'em in.') Harland & Wolff simply fired a few rockets to give warning for boats in the river to stand clear and, with the release of the launching triggers, a huge hydraulic ram initiated a push to begin the hull's slide down the ways and into the water.

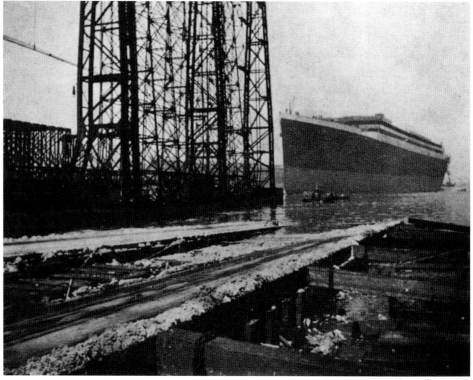

Library of Congress/*Shipping World*

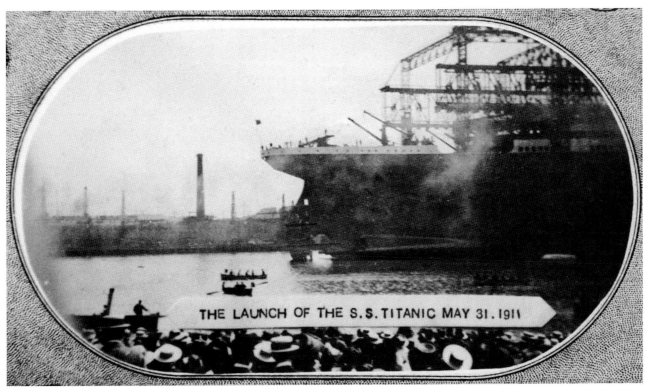

THE LAUNCH OF THE S.S. TITANIC MAY 31. 1911

George Behe Collection

These photographs were taken from across the river as spectators observe *Titanic* taking to the water for the first time.

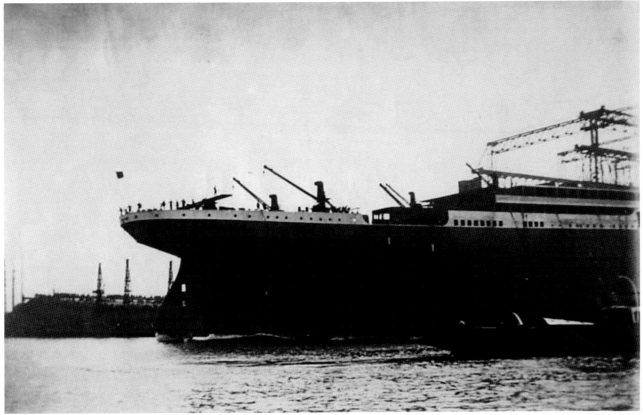

R. Terrell-Wright Collection

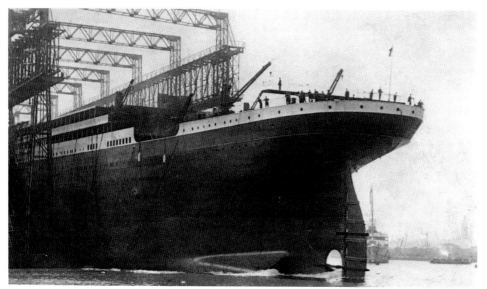

R. Terrell-Wright Collection

A succession of images showing *Titanic* as she slid into the water stern-first. Celebratory whistles echoed through the Belfast air from ships witnessing the event as the vessel settled gracefully into the water of the River Lagan. Anchored in Belfast Lough in the distance, *Olympic* also blew her whistles.

Authors' Collection/*Belfast Telegraph*

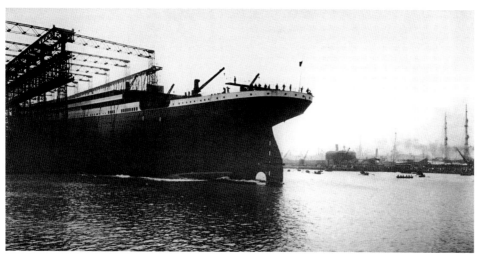

Authors' Collection/Harland & Wolff

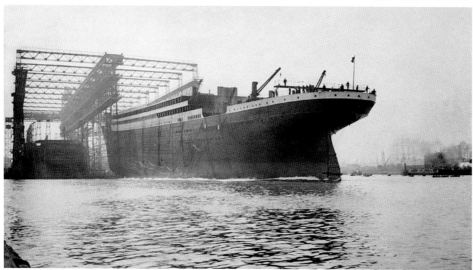

Authors' Collection/Harland & Wolff

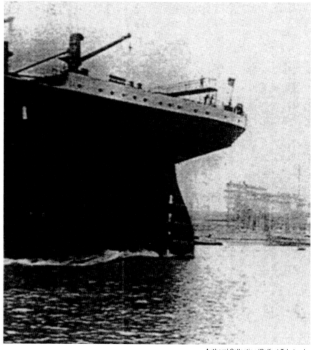

Authors' Collection/*Belfast Telegraph*

By 12.16p.m. *Titanic* was afloat. Her launch had taken sixty-two seconds, exactly the same as *Olympic*. Drag chains, steel hawsers and anchors had been used to arrest the backward movement of the massive hull and bring it to a standstill once afloat.

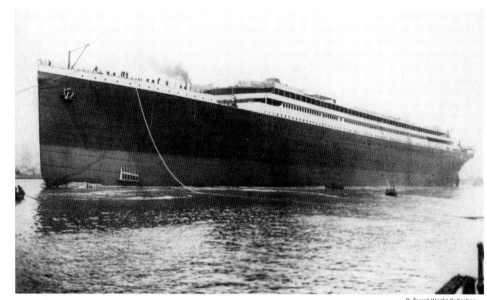

R. Terrell-Wright Collection

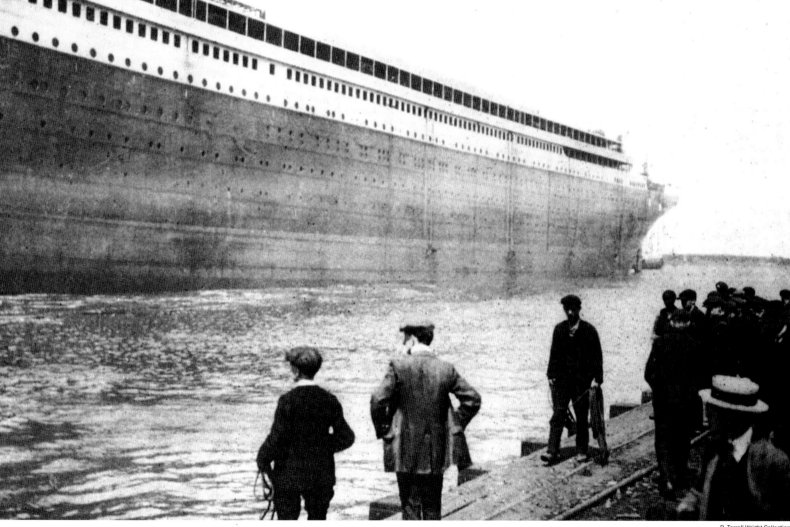

R. Terrell-Wright Collection

The photograph on the right is a rare snapshot, capturing Harland & Wolff's photographers at work. They can be seen at the extreme right of the image. James Glass is holding his camera and tripod as he relocates to another vantage point, moments later capturing the image seen here, below left. One of the Hogg brothers can be seen behind Glass with a drape over him and the camera as he waits for the perfect shot. Some minutes later, he captured the image seen here, below right, showing one of the boats detailed to pick up floating launch debris.

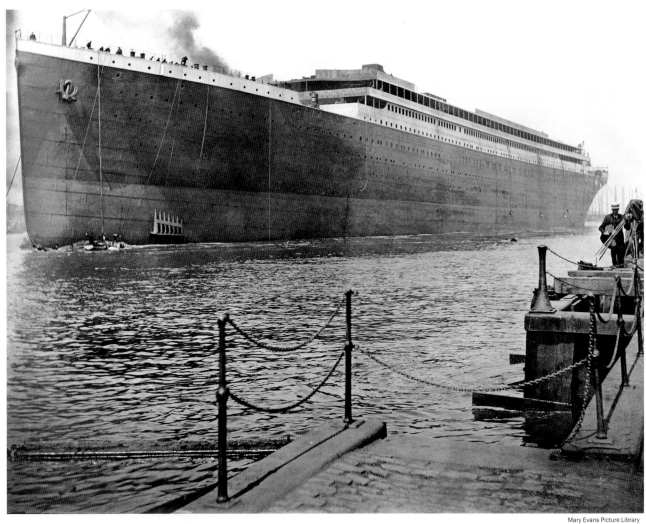

Mary Evans Picture Library

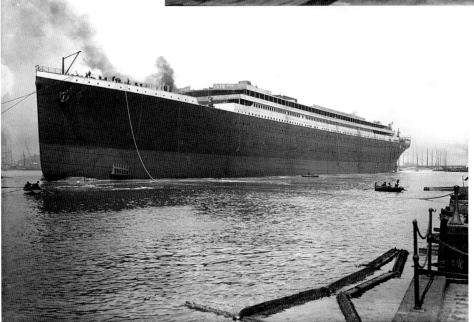

Authors' Collection/Harland & Wolff

Authors' Collection/Harland & Wolff

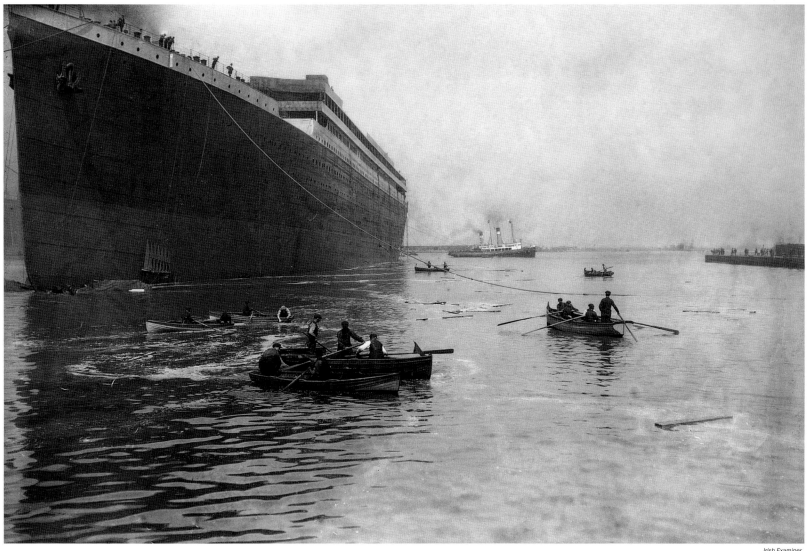

Irish Examiner

As soon as *Titanic* came to a stop, boats and tugs surrounded the waters around the ship. The smaller boats were mainly craft from the shipyard charged with collecting the flotsam from the launch cradles.

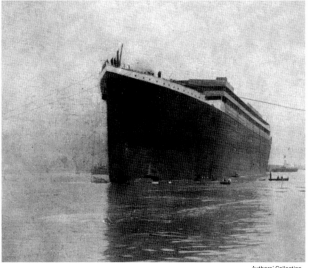

Authors' Collection

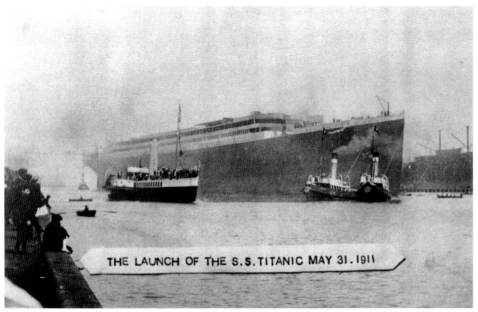

THE LAUNCH OF THE S.S. TITANIC MAY 31. 1911

R. Terrell-Wright Collection

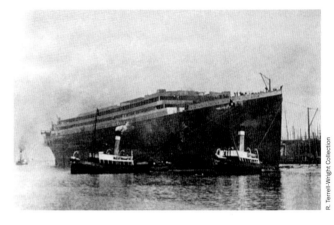

R. Terrell-Wright Collection

Once the yard workers aboard *Titanic* detached the hawsers and drag chains from the hull, she was taken in tow by five tugs. In addition to Harland & Wolff's tug *Hercules*, four tugs from Liverpool's Alexandra Towing Company – *Alexandra*, *Hornby*, *Herculaneum* and *Wallasey* – moved the vessel to her berth at the Fitting-Out Wharf. Here *Titanic* would spend the majority of her remaining time at Harland & Wolff where all her heavy propulsion machinery, funnels and other equipment along with her interiors would be fitted.

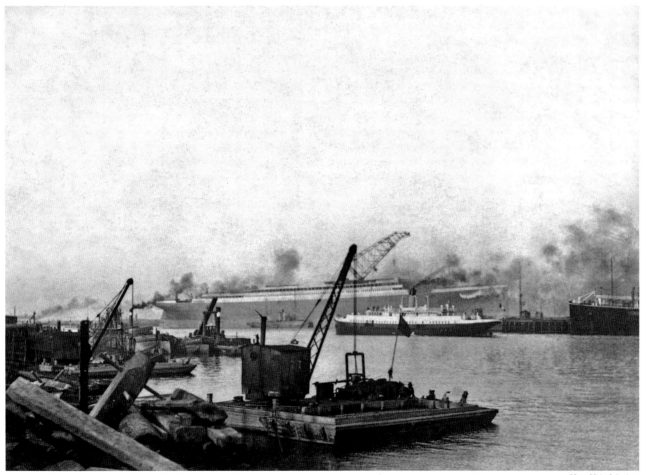

Günter Bäbler Collection

This extremely rare photo shows *Titanic* at the Fitting-Out Wharf some three hours after her launch. Once lunch and festivities following the launch were over, the dignitaries and their guests were taken aboard the new tender *Nomadic* (seen here passing *Titanic*) to *Olympic* which departed at 4.15p.m. for Liverpool. *Nomadic* and her running mate *Traffic* were specially constructed to service all White Star Line steamers calling at Cherbourg. As the huge new *Olympic*-class ships were too large to be moored at quayside, the tenders would ferry mail, passengers and baggage between ship and shore.

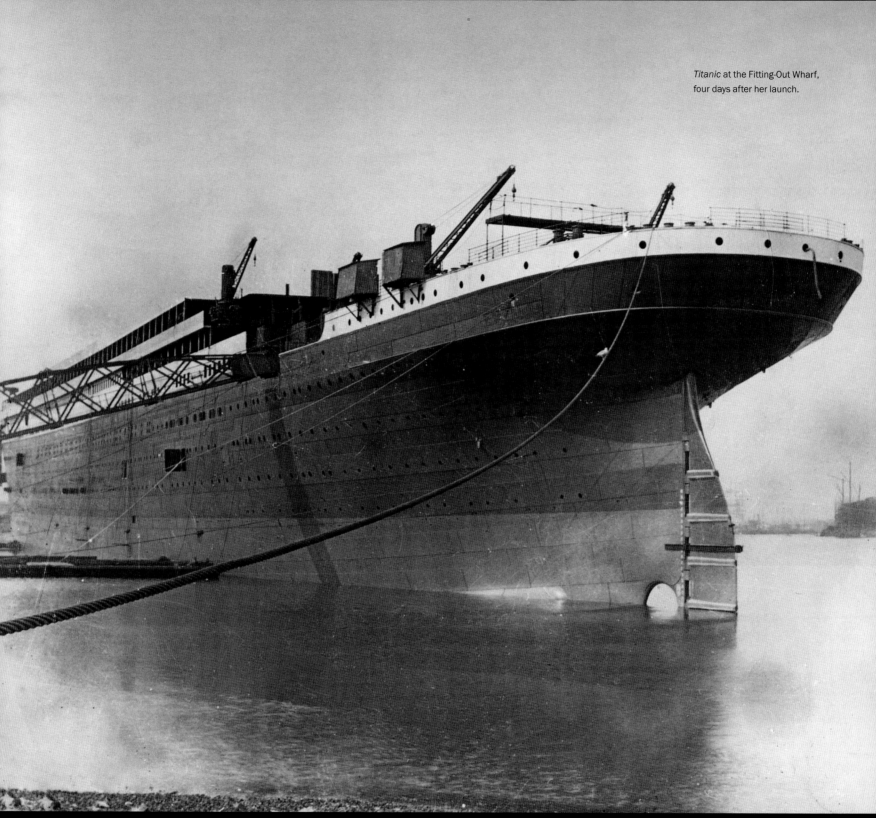

3 ★ FITTING OUT & SEA TRIALS

1912

R. WAYGOOD & CO., Ltd.,

Lift Makers
By Royal Warrant

To His Majesty
King George V.

ALSO SUPPLIERS TO

Cunard Line, Nord-Deutsche Line, Hamburg-Amerika Line, Holland-Amerika Line, R.M.S. Packet Co., White Star Line.

WAYGOOD

Three of the eight Waygood Lifts on White Star Liner
s.s. "OLYMPIC,"
the largest vessel in service.

LIFTS ON LINERS

R. WAYGOOD & CO., Ltd.,
ESTABLISHED 1833.

FALMOUTH ROAD, LONDON, S.E.

White Star Photo Library

When *Titanic* and *Olympic* were launched they were virtually empty shells and the next task was to fit them out and transform them into functional floating palaces. This was no mean feat and preparations for fitting out began well in advance. While *Titanic* was just a skeleton of frames, Harland & Wolff's own workshops were busily manufacturing much of the machinery, such as boilers and engines. These would have to be ready around the time of *Titanic*'s launch as they would be the first to be installed in the bowels of the ship before other work could commence. Likewise, Harland & Wolff's cabinet makers, carpenters and upholsters were busily manufacturing frames, panelling and furniture.

Most of the ship's fittings, furniture and machinery were manufactured in-house by Harland & Wolff. However, a quantity of this work was contracted to outside firms and orders were being placed throughout 1910 and 1911. As the ships were so much larger than anything seen before, thus requiring larger quantities, placing orders so far in advance was also done so as not to overtax manufacturing at the independent suppliers. Although the firms being contracted at this time are too numerous to list completely, some are worth noting. H.P. Mutters & Zoon, a Dutch manufacturer of exquisite panelling and furniture, would fit out twelve luxurious staterooms aboard *Titanic* as well as supply furniture and upholstery for numerous public rooms. Perry & Co. would supply many chandeliers and light fittings for public rooms and suites while N. Burt & Co. was also contracted to supply light fittings as well as most of the door handles and decorative push plates, door hooks, drawer pulls and handles, various baskets and holders for washbasins and bathrooms – and even toilet-paper holders. Rossel, Schwarz & Co. would supply the latest exercise equipment for the Gymnasium while Doulton & Co. would supply many of the washbasins and other sanitary appliances. One company particularly proud of being contracted to supply fittings for the *Titanic* was R. Waygood & Co. Having been recently conferred as 'Lift makers to his Majesty King George V', Waygood had an impressive list of clients past and present, including both the late Queen Victoria and King Edward VII, the Bank of England, the British Museum and an array of other prominent hotels and banks, as well as His Royal Majesty the King of Siam. Waygood would fit three elevators in First Class, one in Second Class and four hoists in crew areas.

As fittings for *Titanic* were being sourced throughout Europe and Britain, at the beginning of August 1910 it was proudly announced that Hoskins & Sewell, a prominent Birmingham firm manufacturing brass beds, won a contract in 'open competition'

for the fitting of beds aboard *Olympic* and *Titanic*. This was one of the largest contracts for ships' berths ever placed in England at that time and amounted to several thousand pounds. The contract with Hoskins & Sewell also included the manufacture of special panelling which would be supplied for portable Third-Class cabins. By the end of September 1910, the White Star Line also placed an order for 50,000 pieces of china from another 'well-known Birmingham firm' and about a month later, White Star's chandler, Stonier & Co., were in discussions with Royal Crown Derby regarding a special set of china for use in the exclusive *à la carte* Restaurant. By 31 January 1911, the pattern was finalised and an order confirmed, with delivery to *Olympic* by the end of April 1911 and a delivery to *Titanic* in December 1911 – at least a month or so before it was intended the ships would be completed in Belfast. In March 1911, four Steinway pianos were ordered for *Titanic* and on 16 May 1911, the day *Olympic*'s pianos were delivered for fitting, an order was placed for one more for *Titanic*.

As *Titanic*'s launch day approached, some of the equipment and machinery manufactured by off-site suppliers also neared completion. In March 1911, Thermo and Pressure Instruments Ltd, of Salusbury Road, Kilburn, announced that they would be fitting *Titanic* with a large number of Fournier instruments 'for the purpose of showing the various temperatures required by the engineers. More than 12,000 ft of tubing will be used on the vessel ... to centralise the various dials on the starting platform of the engine-room'. By 26 May 1911, the lighting plant for *Titanic* (manufactured by W.H. Allen, Sons & Co., located at Bedford) was also complete and on its way to Harland & Wolff via Heysham. The lighting plant consisted of four 400-kilowatt engines and dynamos.

Following *Titanic*'s launch she was moved to the Fitting-Out Wharf and work began the very next day. The following two months would be spent lowering the heavy machinery into her hull, beginning with the boilers. The building of the world's largest liners often attracted attention and, as Harland & Wolff held such a prominent position in shipbuilding, the yards were never short of official visits – which were always welcomed as they often brought publicity or new business from a varied clientele. On 12 July 1911, Admiral Togo, Chief of the Naval General Staff of Japan, made a tour of numerous shipyards, observing the construction going on in various yards and departments. While visiting the engine works, he paid particular attention to the huge engines that would be fitted aboard *Titanic*.

With *Titanic*'s construction making steady progress and using the experience gained with *Olympic*'s fitting out (the latter took

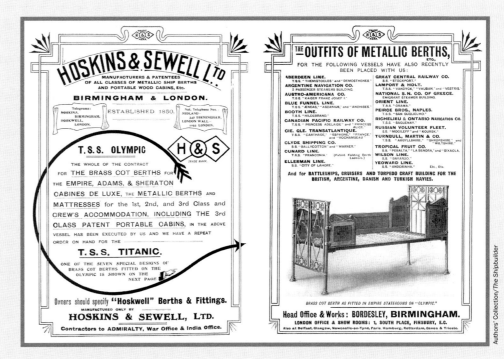

Authors' Collection/The Shipbuilder

about seven and a half months) it was anticipated that *Titanic* would be ready to enter service by the end of January 1912. Orders for fittings required late in the fitting-out process were instructed to be delivered in November or December 1911. In June 1911, newspapers also began announcing *Titanic*'s potential entry into service at the beginning of 1912. It wasn't long before that thinking would be altered as by early July 1911 reports began to circulate that *Titanic* would not enter service until March 1912. At least as early as the beginning of August 1911, the White Star Line began to issue notices and revised sailing lists to travel agents, showing 20 March 1912 as the maiden voyage – a push-back of about seven weeks from the original estimates.

In June 1911, as fitting out of *Titanic* was just beginning, the White Star Line and Harland & Wolff were keenly monitoring *Olympic*'s performance following her entry into passenger service on 14 June. Despite the intentions of her designers to give passengers ample space throughout her accommodations and promenades, it was found that *Olympic*'s enclosed B Deck promenade was little used but the exclusive *à la carte* Restaurant on the same deck was extremely popular. The D Deck Reception Room was too crowded during concerts and the layout of the Turkish Bath facilities on F Deck wasn't quite right. Given that *Titanic* was still in the early stages of fitting out, this presented the perfect opportunity to refine her accommodations and incorporate lessons learned from *Olympic*. As a result, the Turkish Bath facilities were redesigned, removing one of the Electric

Companies supplying fittings to the world's largest ships took every opportunity to promote their association with these ships. The Waygood & Co. advertisement on the previous page shows *Olympic*'s elevator landing on D Deck, while the Hoskins & Sewell advertisement above shows an Empire-style bed as fitted aboard *Titanic* in B54 and C83. These staterooms were occupied by J. Bruce Ismay and Mr and Mrs Henry B. Harris of New York, respectively.

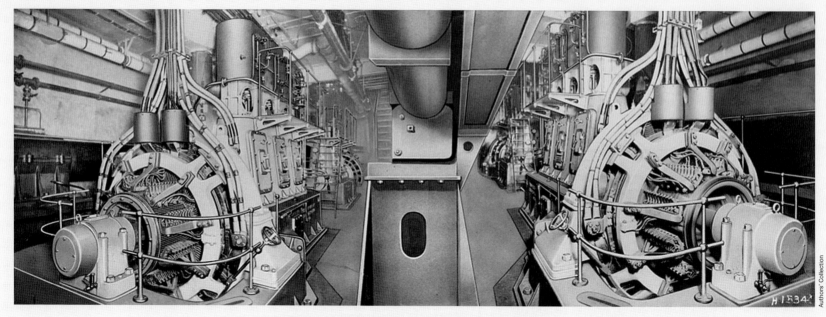

Authors' Collection

Olympic and *Titanic* were designed with an extensive array of electrically operated equipment. The electrical supply required to operate these 'floating cities' was supplied by way of four 400-kilowatt, 100-volt DC steam-operated generators (dynamos). As a reserve, there were two 30-kilowatt emergency generators which were situated on D Deck. Each liner had more than 200 miles of cable installed to run power to the large assortment of electrical machinery, equipment and appurtenances: winches and cranes, electric heaters, galley appliances, a fifty-line telephone switchboard, elevators, a wireless telegraph set, fans and ventilators, plus dozens of other electrically operated devices. Also fitted aboard the ships were more than 1,500 electric bell pushes, or 'service buttons', and forty-eight clocks which could all be adjusted simultaneously by two master clocks located in the Chart Room. *Titanic* was very much an 'electric ship' despite being powered by steam.

Baths as these did not prove popular on *Olympic* and the D Deck Reception Room was also enlarged.

The most significant structural change, however, was the almost complete redesign of B Deck. This included extending First-Class staterooms and suites to the side of the ship as well as enlarging the *à la carte* Restaurant and adding an adjoining Reception Room. Reluctant to completely eliminate the enclosed promenade, a length of deck space along the starboard side of the Restaurant was retained as a 'Restaurant Promenade' and was later converted to the Café Parisien. As a result, most of the already fitted plating and windows along each side of B Deck would need to be removed and new shell plating would need to be manufactured and fitted with narrower oblong windows, which also needed to be ordered and manufactured. Plans for this new configuration must have been approved at the end of June 1911 but work would not begin until later as a great deal of preparation was still required. This additional work took over six weeks to complete and posed the longest delay that affected *Titanic*'s completion, and ultimately resulted in her entry into service being delayed from the end of January to 20 March 1912.

Once the heavy machinery had been fitted by the end of July 1911, work continued with the construction of deckhouses and plating the large areas of deck that had been left open to allow the

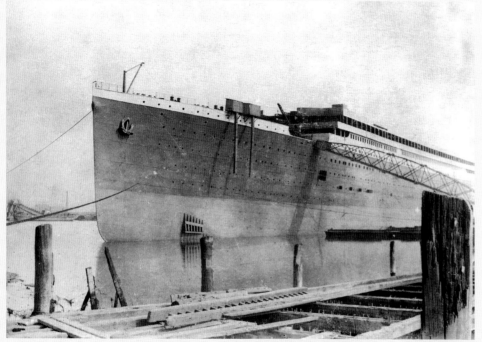

Henry Aldridge & Son

As *Olympic* was being readied for her maiden voyage, *Titanic* is seen here lying placidly on a warm summer's day – Sunday 4 June 1911. Although this photo was taken only four days after her launch, early signs of preparation for fitting out are already visible.

The Fitting-Out Wharf was located at some distance from the shops. To transport all the heavy machinery that would be required – such as boilers, funnels, engine bedplates, turbines, condensers and other peripheral equipment – Harland & Wolff operated a narrow-gauge steam railway within the yard. An extensive network of rail lines ran throughout the yard and terminated at the Fitting-Out Wharf. To transfer all the heavy equipment from the dockside into the ship, Harland & Wolff purchased a 200-ton floating crane from Deutsche Maschinenfabrik AG (Demag) of Germany. This new crane had a lifting capacity of 150 tons, a lifting height of 150ft and a loading radius of 100ft. The crane also had a smaller cable-operated hook capable of lifting 50 tons.

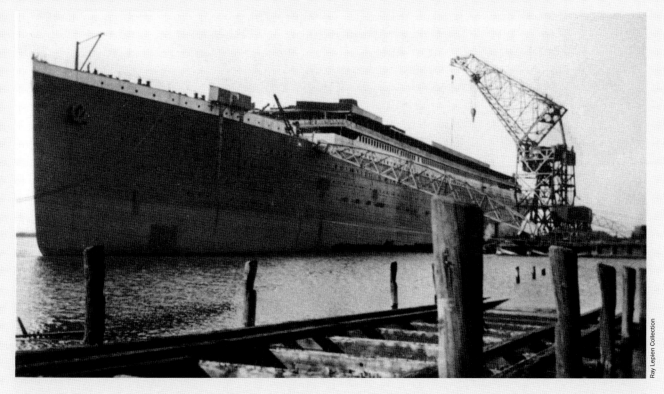

Titanic at the Fitting-Out Wharf in early June 1911, with the floating crane by her side. Over the next few months, the crane would be used to lower heavy machinery, including engine parts and boilers, into her cavernous hull.

lowering of boilers and engines into the hull. By 20 August 1911, the foremast was fitted and the mainmast was in place shortly thereafter. By September work began on reconfiguring B Deck, first removing most of the original shell plates and windows. A small section of the original B Deck promenade was retained on each side in the area which corresponded with the B Deck entrance foyer and the three First-Class suites immediately aft. These sections of deck would become part of the very first private promenade suites and would offer a level of luxury hitherto unavailable on any other ship. Part of the removed shell plating was refitted aft on B Deck along an area outboard of the Restaurant. On *Olympic*, this area was part of the promenade afforded to Second Class who often peered into the Restaurant windows, curious to see inside. On *Titanic*, prior to converting this area to the Café Parisien the problem was solved by segregating the section of Promenade Deck opposite the Restaurant for exclusive use of First-Class passengers.

Work continued apace and as manufacture of *Titanic*'s first funnel to be fitted was underway, *Olympic* suffered a serious accident with the Royal Navy cruiser HMS *Hawke* on 20 September 1911 in which the cruiser's reinforced bow rammed *Olympic* on her starboard quarter. This necessitated her return to Belfast in order to assess and repair the damage. Remedial repairs were carried out in Southampton and thereafter *Olympic* proceeded to Belfast, arriving on 6 October 1911 and anchoring in Carrick Roads. The next day, she proceeded up Belfast Lough and was secured at the Fitting-Out Wharf, *Titanic* having been temporarily moved from her place to make room for her damaged sister. Due to the damage and flooding in her aft compartments, *Olympic* was down at the stern and spent several days at the Wharf being 'considerably lightened'. *Olympic* was finally moved into dry dock on 11 October 1911. As the water was pumped out of the dock, the severity of the damage was immediately obvious and Harland & Wolff engineers met with White Star Line officials to discuss the delays this would cause to *Titanic*'s construction. That same day, the White Star Line officially announced that *Titanic* would sail on her maiden voyage from Southampton to New York, via Cherbourg and Queenstown

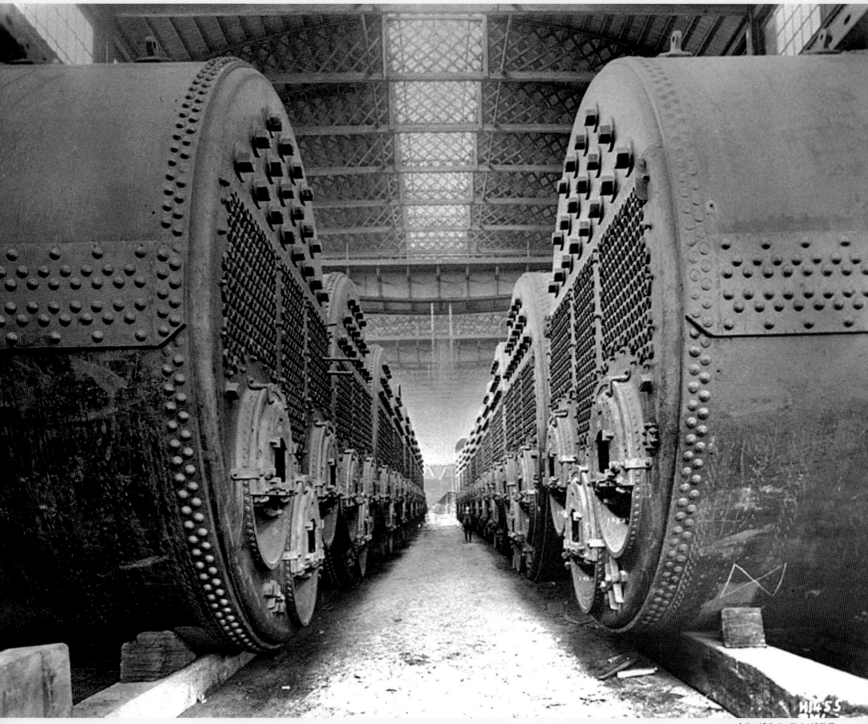

Olympic and *Titanic*'s boilers were manufactured almost simultaneously, with priority given to those boilers intended for the first ship to be completed. Here they are seen in the Boilers Shed, most likely intended for *Olympic*. (The enormous size of these boilers can be seen by noting the relative size of the man standing against one of them partway down the aisle.) The steam required to power the ships was provided by twenty-nine of these huge boilers, twenty-four double-ended and five single-ended. This meant that there were a total of 159 separate furnaces to be fired, with a heating surface of 144,142 square feet. To heat these massive boilers, the ship's bunkers had a combined capacity of 6,611 tons of coal and, at a speed of 21 to 22 knots, could consume 620 to 640 tons of coal per day, all stoked by hand.

on 10 April 1912 – a delay of three weeks from her previously published maiden voyage.

Since *Titanic*'s launch, this was the first time that *Olympic* was back in Belfast, thus offering a unique sight of the two sister ships together for the first time – *Olympic* in dry dock and *Titanic* at the nearby Fitting-Out Wharf. In order to return *Olympic* to service as soon as possible, approximately 1,000 men were diverted from *Titanic* to work on *Olympic*. Nonetheless, all efforts would be made to complete *Titanic* in time for the rescheduled maiden voyage. Approximately 2,000 men were at work on her directly while a similar number was at work throughout Harland & Wolff's various shops and departments preparing material, equipment and furnishings for equipping and fitting out the ship.

Despite setbacks necessitated by *Olympic*'s repairs, steady progress was being made in the construction of *Titanic* and by the time the two ships were together in early October 1911, the replating of B Deck was virtually complete. *The Scotsman* and *The Leitrim Observer* published similar reports on the progress at this time:

> The electric turbine and auxiliary machinery, refrigerating plant, steering gear, and all the boilers are on board; the funnel uptakes complete; and one of the funnels [the No.2 funnel] is erected in position, as also are the masts. As regards the state of things on some of the principal decks, it may be mentioned that the second and third class accommodation, aft, on the lower deck [G Deck], is well advanced; whilst on the middle deck [F Deck] the stateroom bulkheads are finished throughout, and work is proceeding in the engineers' accommodation. The stateroom bulkheads on the upper deck [E Deck] are also practically complete, and well under way on the saloon deck [D Deck], where the first and second class dining saloon and first-class reception room joinery grounds are all up and ready for proceeding with the framing, panelling, and ceiling. On the shelter deck [C Deck] the third-class smoking room and general room joinery grounds are finished, and the framing has been commenced. The framing of all first-class staterooms on this deck is well in hand. As further indicating the progress that has been made, it may be added that the main staircase is in position; also the electric elevators, the work in connection with which is advancing speedily.

When *Olympic* was fitted out at the beginning of 1911, all four of her funnels were emplaced within two months. *Titanic*'s funnels, it seems, were being fitted at a slower rate of one per month. By

10 November 1911, *Olympic*'s repairs were nearly complete as she was being readied to leave Belfast and the second of *Titanic*'s funnels to be fitted (the No.1 funnel) was in position. By 6 December 1911, the third of her four funnels (No.3) was also in place.

On the night of 6 December 1911, the Cunard liner *Mauretania* broke loose from her moorings during a gale while at anchor in the River Mersey. The ship grounded, sustaining damage to about eighty hull plates at the bottom amidships. (At the time the vessel had been undergoing boiler maintenance, and had no steam with which to manoeuvre.) With passenger traffic at a seasonal low, dry dock space was at a premium during the winter months as ships were laid up for their annual overhauls, maintenance and necessary repairs. The nearby Canada dry dock in Liverpool had a long list of waiting ships and a rumour spread that the new dry dock at Harland & Wolff in Belfast could be used in order to repair the *Mauretania*. Early press accounts exhaustively compared the newest ships, often reporting that a certain new ship was more luxurious, larger, or faster – and in some cases, all three – than a previous one. As *Titanic* was being built at the nearby Fitting-Out Wharf, the press eagerly anticipated the visual comparison that could be made between the once-largest ship and the new holder of that title nearing completion. *Mauretania*'s repairs were likely to take some time and as it was anticipated that the new dry dock would soon be required for *Titanic*, the event never took place. Instead, the *Mauretania* was accommodated in Liverpool's Canada dry dock after all.

In early January 1912, *Titanic*'s last funnel (No.4) was in position and for the first time she began looking as her designers had intended – her classic lines suggesting speed, power and grace. With her completion less than three months away, *Titanic* began attracting more and more attention from the press, including interest from across the Atlantic. The *New York Maritime Register* wrote:

> The signs of progress on the vessel are plainly visible. The masts and all four funnels are now erected, the machinery on board, and the iron work of the superstructure well advanced. The inside work is also proceeding apace. In addition to the joiners' and carpenters' work, such as framing, panelling, etc, and laying of decks, the fitters and plumbers are proceeding throughout the ship with the fitting of baths, plumbing, pipes, scuppers, etc, etc. The first and second class elevators are fitted. The floors are well advanced and an interesting feature is the cementing and tiling of the swimming pond, which is progressing rapidly, as

also the elaborate decorative work in the magnificent saloon, smokeroom, restaurant and other public apartments.

Throughout January 1912, work proceeded swiftly. *Titanic*'s lifeboat davits were fitted, followed by the return of her two bow anchors (which had been removed some time after launch). Her hull above the waterline was painted grey; this was an undercoat prior to painting it black. By the end of the month she was ready to go into dry dock. On Saturday morning, 3 February 1912, conditions were perfect and *Titanic* was dry docked successfully, the move taking little more than two hours. A correspondent from the *Irish Times* was present to report on the event:

Lord Pirrie was on the scene as early as 9 o'clock, at which hour the ropes were loosened and the three tugs, *Hercules*, *Jackal*, and *Musgrave* – the latter the property of the Belfast Harbour Commissioners – towed the huge liner from the fitting-out wharf round to the entrance of the dry dock. High water was at 10.58a.m. and there was a good tide and only a little breeze was blowing. Very few people were about, for it was not generally known that the work was to be done this morning. The dock having been opened, the *Titanic* was towed in, the principal towing rope being connected with the bow of the vessel and the top end of the dock, and when it is stated she was put into position without so much as scraping her sides of the walls of the dock it will be seen the feat could not have been done any better. At 11.15 o'clock the majority of the ropes steadying the vessel were tied to the 'pauls' and the work of placing the shores between the vessel and the dock sides was commenced, that being also carried out most expeditiously.

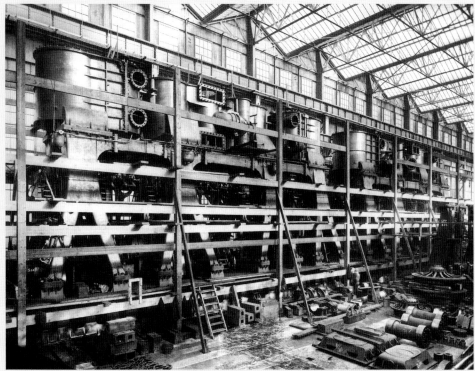

These images show *Titanic*'s engines in the Engine Works Erecting Shop at Harland & Wolff, around July 1911. By the end of the month, all of the heavy machinery, including the engines, would be in place within the hull. Each of these engines developed 15,000 IHP (indicated horsepower) at 75 RPM (revolutions per minute). The low-pressure turbine developed approximately 16,000 SHP (shaft horsepower) at 165 RPM. This impressive combination of traditional and revolutionary technology was capable of generating up to 59,000 HP (horsepower) total at maximum revolutions, giving the ships a service speed of 21 to 21½ knots. The maximum speed of each ship was believed to be 24 knots. The highest speed ever achieved by *Olympic* was 24.2 knots.

Even though it was not widely known that *Titanic* would go into dry dock on this day, the occasion must have been seen as significant enough for a cameraman to be present, who recorded the only moving footage of *Titanic* that is known to exist. Perhaps the cameraman was arranged by Lord Pirrie, who keenly oversaw the entire procedure, and the minutes of the Belfast Harbour Board meeting the following Tuesday (6 February 1912) glowingly recorded Pirrie's words that 'everything passed off without a hitch and the arrangements were everything that could be desired'. *Titanic* would remain in dry dock for two weeks and while the furnishing of her interiors continued, the primary reason for dry docking was to fit her three giant propellers and for her final preparation of the hull for sea; this involved cleaning

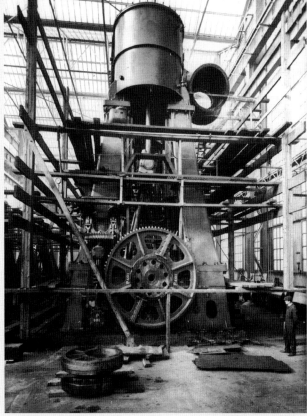

the hull below the waterline of marine growth and applying red antifouling paint.

Titanic's brief stay in dry dock was not eventful but nearly became so when she came close to being visited by one of the most prominent figures in history. As her last funnel was being lifted into position in early January 1912, political tensions were beginning to escalate in Belfast. The First Lord of the Admiralty, Winston Churchill, was planning a visit in order to address the Ulster Liberal Association on 8 February 1912 in the Ulster Hall in favour of Home Rule. Every effort was being made by the Orangemen to prevent this address and one of the representatives of the Orangemen declared that the 'meeting will not take place in any public building or space in any of the three Unionist parliamentary divisions of Belfast'. Plans were continuously foiled by the Orangemen, who made it impossible for the Liberals to secure a large enough public venue by booking out all the venues themselves. As the meeting loomed and no venue had been secured by late January 1912, the Ulster Liberal Association looked to public parks and even Harland & Wolff where the workers declared that they would 'burn down their dining-room before they will allow the place to be used by Mr. Churchill'. As it happened, Lord Pirrie was the chairman for Winston Chirchill's projected meeting in Belfast and in a last bid to secure a venue suggested that the meeting should take place aboard *Titanic*. Eventually, the Celtic Park football grounds were secured for the Home Rule address and Winston Churchill came to Belfast in the morning of 8 February 1912 amidst violent protests and attacks.

During his visit to Belfast, Churchill was to be taken on a tour of Harland & Wolff in order to inspect the dry dock where *Titanic* sat, as well as to inspect the Victoria Channel with an eye to further dredging and widening for Admiralty use. However, given the turmoil surrounding his visit to Belfast, Churchill's visit did not come to pass and one of his representatives had the privilege of the visit instead. The representative was taken around Harland & Wolff and later recalled:

> Stepping into the vacant shoes of the First Lord of the Admiralty, I was given permission at the Belfast Commissioner's office to see the docks. Mr. W. Redfern Kelly, the engineer-in-chief, who would have been Mr. Churchill's guide, was also my guide, and thus I saw what Mr. Churchill would have seen and what he would have heard.
>
> We first went to the largest dry dock in the world ... At present, the dock is occupied by the world's largest liner, the *Titanic* ...

Titanic's main feed filters. Before being returned to the boilers as feed-water, the feed filters removed the grease, lubricating oil and other hard contaminants that had been collected by the now-condensed steam during its passage through the machinery and piping.

> We walked round the dock, and gazed admiringly upwards and downwards on the monster bulk it contains, but the ship is so large that one cannot see its real size. Then we went down steep stone steps to the base of the dock, walking under the enormous flat bottom of the vessel form one side to the other.
>
> By the courtesy of Lord Pirrie I was also able to visit Messrs. Harland and Wolff's yard in company with Mr. Redfern Kelly. We saw the model of the first steel ship built by the firm in 1863. 'We could put two vessels of that size in one of the *Titanic*'s funnels,' said one of the firm's engineers. A ship even larger than the *Titanic* is now being built. It is to be called the *Gigantic*, and I walked under the keel, so that I could boast of having in one day walked under the largest completed ship in the world and under the bare keel of – one still larger.

On Saturday 10 February 1912, a thirty-five-year-old yard worker by the name of D. Campbell was on a section of staging while painting the lower part of *Titanic*'s hull with red antifouling paint. A serious accident occurred when he suddenly slipped and fell into the dry dock. He was immediately taken to the Royal Victoria Hospital where he was found to be suffering from a severe shock and concussions to the body.

It is interesting to note that the earliest reference to the screen of windows enclosing the forward section of *Titanic*'s Promenade (A) Deck is dated 14 February 1912 – less than two months before the scheduled maiden voyage, indicating it was a very late revision

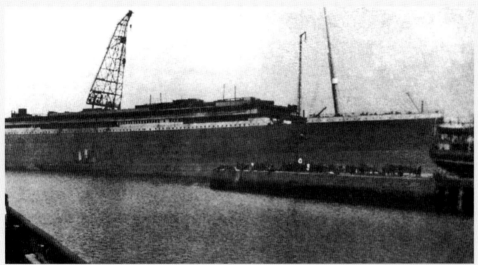

R. Terrell-Wright Collection

By September 1911, preparations required for the changes on B Deck were complete and work commenced on removing the standard Utley's vertical sliding windows (once intended to enclose the promenade) to a narrower version that better accommodated the interior design of the new staterooms. The photo above shows the removal of these windows almost completed, while the image on the right shows all the required windows removed. Some of these would later be refitted along the deck area where the Café Parisien would be added. Note Harland & Wolff's yard tug *Jackal* alongside *Titanic:* to provide the electricity needed aboard during construction, Harland & Wolff ran shore-side electrical cables and power could also be obtained from *Jackal* moored alongside, as she was specially outfitted to act as a floating auxiliary power station.

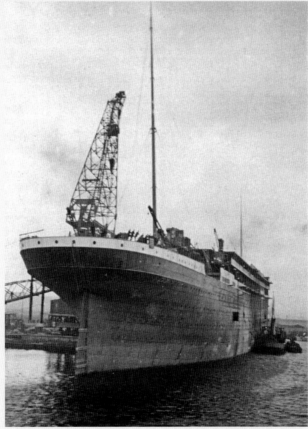

R. Terrell-Wright Collection

to *Titanic*'s design. Once fitted, this screen would become the most readily identifiable difference between *Olympic* and *Titanic*. During a crossing in January 1912, *Olympic* endured some heavy weather and very rough seas that the North Atlantic is so famous for, which likely prompted *Titanic*'s designers to realise that with the changes on B Deck, *Titanic* no longer had a substantial promenade that was enclosed and protected from the elements. It was around this time that Harland & Wolff also took the opportunity to implement a number of other modifications. It was noticed aboard *Olympic* that the large space afforded to the A Deck foyer of the after grand staircase was little used, so two large staterooms (A36 and A37) with adjoining bathroom and WCs were installed. On B Deck (with the introduction of an enclosed promenade elsewhere), the 'Restaurant Promenade' adjoining the aft B Deck Reception Room and Restaurant would be converted to the Café Parisien.

Some time during her second week in dry dock, *Titanic*'s sixteen lifeboats were also emplaced beneath their davits, and with her hull below the waterline painted and her propellers fitted she was ready to leave dry dock. On Saturday 17 February 1912, two weeks to the day of entering the dry dock for the first time, *Titanic* was taken out and moored back at the Fitting-Out Wharf. With the Belfast tugs *Hercules* and *Musgrave* in attendance, the move took less than an hour and was accomplished without a hitch. *Titanic* began moving out of the dock about 8.55a.m. and within twenty minutes was fully out of the dock. A few minutes later, she was secured at the nearby Fitting-Out Wharf. With only six weeks remaining before her trials, all efforts would be made to complete the ship. *The Scotsman* reported that 'the finishing touches will be given to the equipment of the vessel [and] work will now be pushed on night and day'.

Only a week later, on 24 February 1912, *Olympic* suffered another incident when she threw a propeller blade. Once again, she was required to return to Belfast but it was intended that the stay would be brief with repairs carried out swiftly. *Olympic* reached Belfast in the evening of 1 March 1912 and was dry docked immediately the next day on the morning's tide. The replacement of her propeller blade was done in record time and by the morning of 4 March, *Olympic* was backed out of the dock. But in order to leave and proceed down the Victoria Channel to the sea, it was necessary to swing her around. A strong wind was blowing and it soon became obvious that it would be dangerous to swing the huge vessel in the restricted waters of the turning basin. With the high winds acting against the hull and superstructure, the tugs assisting the vessel had difficulty in controlling her. As *Titanic* occupied the nearby Fitting-Out Wharf, the only safe option under the

circumstances was to place *Olympic* back in dry dock, which was left full of water after the move in case an opportunity presented itself to move the ship the following day. By the next morning the weather had not moderated and *Olympic* was forced to remain in place. With pressure mounting to return her to service, Harland & Wolff achieved something that had never been attempted before: taking *Olympic* out of dry dock and moving *Titanic* in on the same tide, thereby freeing up space at the Fitting-Out Wharf for *Olympic,* which could be moored there until the weather moderated. Once again, an *Irish Times* correspondent was on the scene to report the events which took place on Thursday 6 March 1912:

Today an interesting piece of work, which has no precedent in the record of shipbuilding, was performed in the harbour, when the *Olympic* was taken out of the graving dock, and the *Titanic* removed into the dock from the fitting-out wharf on the one tide. Anyone looking at the two huge vessels in the harbour ... could not believe such a feat possible until they saw it actually performed. Owing to the presence of the *Titanic* at the fitting-out wharf, it was not possible to swing the *Olympic* around at the new deep-water turning basin, and Messrs. Harland and Wolff conceived the idea of removing the *Titanic* and undocking the *Olympic* at the one operation. About ten o'clock, two hours before high tide, the operation of taking the *Olympic* out of the dock commenced. Half a dozen Liverpool tugs were employed, and, in face of a strong wind, the work was carried out successfully. The *Titanic* was then brought into the dock, the whole work being accomplished shortly before one o'clock. It was carried out under the supervision of Mr. Charles Payne and Mr. Andrews, of Harland and Wolff, Ltd., and Captain Bartlett [*Titanic*'s first captain], the marine superintendent of the White Star Line, while every assistance was given by Mr. Redfern Kelly, engineer of the Harbour Commissioners.

Despite the annoying delays, *Olympic*'s visit to Belfast presented a unique opportunity of visually comparing her with the almost-completed *Titanic*. This was only the second time that the two ships were seen together since *Titanic*'s launch, and as it turned out, it would also be the last. *Olympic* eventually cast off her mooring lines and was turned in the turning basin on 7 March 1912, and with her bow pointing toward the sea was finally able to leave Belfast. On 8 March, *Titanic* was promptly taken out of dry dock, turned in the basin and moved back to the Fitting-Out Wharf. Less than four weeks remained until her sea trials and official handover

to the White Star Line but much work was yet to be done, including the fitting of weather screens along the forward part of the A Deck promenade.

By the last week of March 1912, pressure was mounting and *Titanic*'s interiors were in a varying state of completion. Miscellaneous fittings were still arriving throughout March, and by the last week, wicker furniture for the two private promenades and the Café Parisien had been delivered but not yet placed. On 14 March all but one of the Steinway pianos were delivered (including the grand piano for the D Deck Reception Room) and the last piano was delivered on 18 March. On 12 March H.P. Mutters & Zoon delivered special doonas (down quilts) for the twelve suites *de luxe* that they furnished on B and C Deck, and by Monday 25 March they delivered cushions and antimacassars for sofas for these same suites.

At some point during *Titanic*'s last week in Belfast, Harland & Wolff photographer Robert Welch decided to take a number of photos – these being the first images taken of *Titanic*'s nearly complete interiors. Welch started on the Boat Deck and took a photo of *Titanic*'s Gymnasium. Having photographed *Olympic*'s interiors so extensively and as the two ships were so similar, Welch then decided to focus primarily on areas that were unique to *Titanic* and took his camera down to B Deck where most of the changes had been implemented. Starting on the port side, he took a photo of the private promenade where only a handful of chairs were placed for effect. Welch then took photos of B58 and the two adjoining staterooms before going to the starboard side to take photos of B57, B59, B63 and finally finishing off in the Café Parisien.

By 25 March 1912, *Titanic* had already taken 3,000 tons of coal on board and a date of 1 April was set for her sea trials. With the maiden voyage just over two weeks away, Thomas Andrews was concerned that the ship might not be finished in time. Throughout the ship tiles and carpets were still being laid, panelling and bulkheads were being painted and light fixtures were still being installed. Work would continue up until the very last moment even as *Titanic* lay in Southampton taking on supplies for the voyage. However, these final installations were, in the overall view, relatively minor and for all intents and purposes *Titanic* was a completed ship and ready for sea.

As the first day of April 1912 dawned across the British Isles, it brought an unusual mix of weather – bright sunshine, snow, biting winds, hail, sleet and rain. In London, at one point in the afternoon some snow fell, while in the north of Ireland, as the *Daily Express*

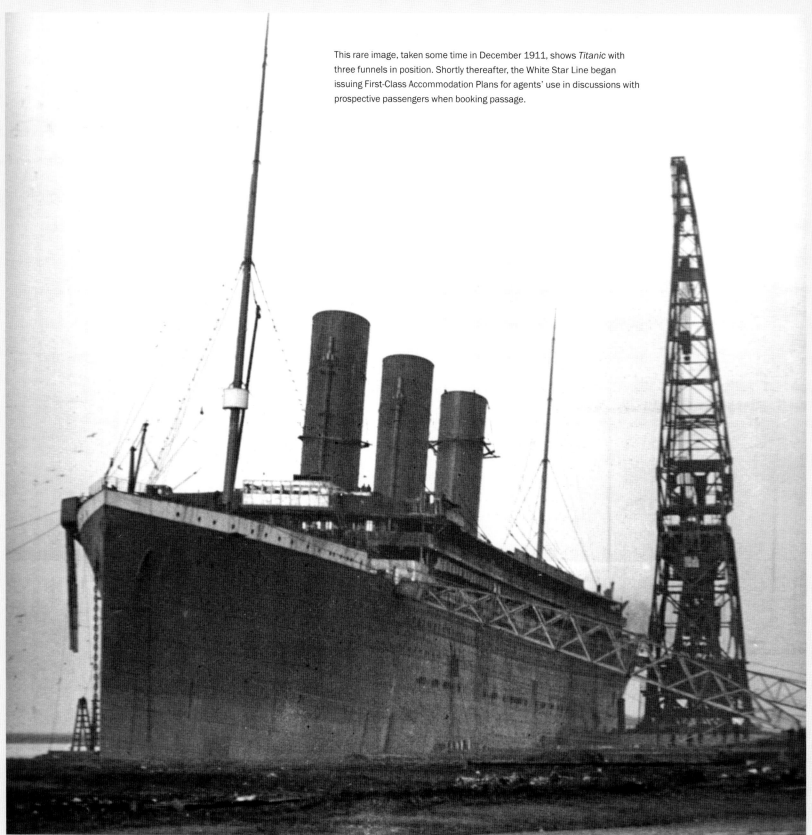

This rare image, taken some time in December 1911, shows *Titanic* with three funnels in position. Shortly thereafter, the White Star Line began issuing First-Class Accommodation Plans for agents' use in discussions with prospective passengers when booking passage.

Authors' Collection/Harland & Wolff

reported, 'so violent a gale raged in Belfast Lough that the trial trip of the new White Star liner *Titanic* had to be postponed'.

Titanic's sea trials had been planned for 10.00a.m. that day and the required Alexandra company tugs had been dispatched from Liverpool to Belfast on 31 March. By the following day weather conditions had moderated considerably and the skies began to clear. By 9.30a.m. the tugs *Herculaneum*, *Hornby*, *Hercules*, *Herald*, and *Huskisson* were escorting *Titanic* up the channel. *Titanic*'s sea trials, though by no means perfunctory, were considerably shorter than those of her sister as the ships were identical in hull design and propulsion machinery and had identical handling characteristics. *Titanic*'s trials were designed more to ensure that she handled as intended rather than to determine what those handling characteristics were, and to ensure that all of her systems worked as they were intended to.

During her sea trials *Titanic*'s two wireless operators, John (Jack) Phillips and Harold Bride, tuned and tested the ship's new Marconi system. The equipment was in constant use as messages about the details of the sea trials were transmitted to J. Bruce Ismay in London. Other Marconi-equipped vessels were also being contacted to test the vessel's equipment. At one point Phillips and Bride experienced freak atmospheric conditions and briefly established communications with Port Said near Cairo, Egypt, some 3,000 miles away.

Titanic returned to Belfast at 6.30 that evening. The Board of Trade's certificate of seaworthiness, valid for one year, was signed by BOT representative Francis Carruthers. This attested that he had been satisfied with the ship's performance throughout the trials. With this document in hand, the directors of the White Star Line would have seen the obligations of the contract finalised, thereby permitting the official transfer of the vessel from builder to owner. *Titanic* would now be registered as a British steamship at the port of Liverpool with her official number 131,428. She was listed with a gross registered tonnage of 46,383 and a net registered tonnage of 21,831. Although Southampton had been the main eastern terminus for White Star Line ships for several years now, *Titanic* would still be lettered with Liverpool as her home port, as White Star's offices had been located there since the company's inception.

With the formalities dispensed with and officials having disembarked, *Titanic* weighed anchor about 8.00p.m. After leaving Belfast Lough, *Titanic* briefly tracked eastward across the Irish Sea and then altered course for the English Channel. During the 570-mile trip from Belfast to Southampton, the opportunity was taken to perform additional engine and manoeuvring tests. Making an

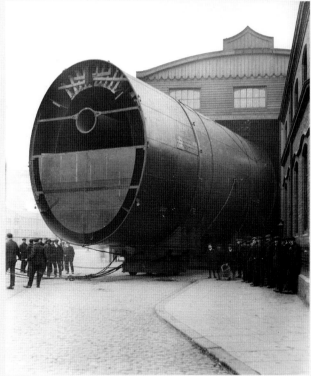

Authors' Collection/Harland & Wolff

average of 18 knots, it was expected that *Titanic* would conveniently arrive at Southampton at high tide. Although the ship encountered fog six hours into the voyage, conditions cleared just after 6.00a.m. the following morning.

At approximately 10.00p.m. that evening, *Titanic* steamed past the Isle of White and slowed at the Nab Lightship to embark the Southampton pilot. With the pilot now on her Bridge, *Titanic* proceeded cautiously at 'Half Ahead' past Cowes, rounded the treacherous Bramble Bank and steamed into Southampton Water. A short period later, five Red Star tugs – *Ajax*, *Hector*, *Hercules*, *Neptune* and *Vulcan* – assisted the ship into the calm waters of the River Test. The time was just after 11.30p.m. With the bow facing downstream, it was then necessary to bring the ship through a turn to port to align the vessel up parallel with the dock. Using a push-pull action, the tugs manoeuvred the huge ship slowly astern. Finally, just after midnight, the White Star Line's newest and most famous ship was finally moored alongside Berth 44. ★

Olympic's fourth funnel leaving the workshop – all four funnels aboard *Olympic* and *Titanic* would have been delivered in a similar fashion and lifted aboard by the floating crane. Once fitted, the huge funnels rose 72ft above the Boat Deck. They were painted black at the top to mask the accumulation residue caused by the smoke. The fourth funnel was a dummy, but did provide ventilation of the Turbine Engine Room, galleys, First-Class Smoke Room fireplace flue and other areas. (The galley flue is the large tube near the centre of the funnel.) The ventilation of these areas could have been accomplished by other means but it was thought at the time that it would be more aesthetically pleasing to have four funnels for such a large ship. This gave the illusion of power and stability, and also followed the four-funnel arrangement seen on some of the German liners as well as the Cunard Line's *Lusitania* and *Mauretania*.

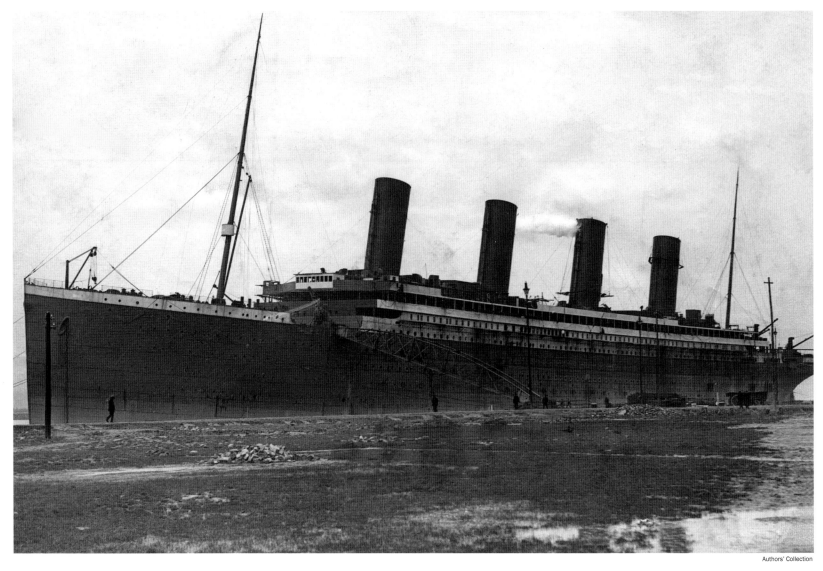

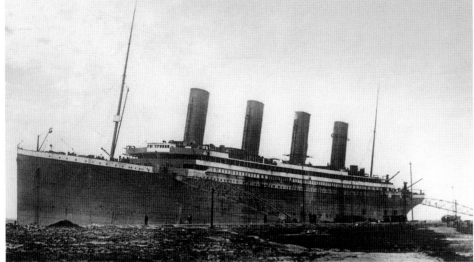

Titanic seen here in early January 1912 at the Fitting-Out Wharf, her last funnel newly fitted. Now appearing more like a completed ship, press photographers begin to make regular visits to Harland & Wolff. Note that the two images (above and left) were taken mere moments apart, but from different vantage points.

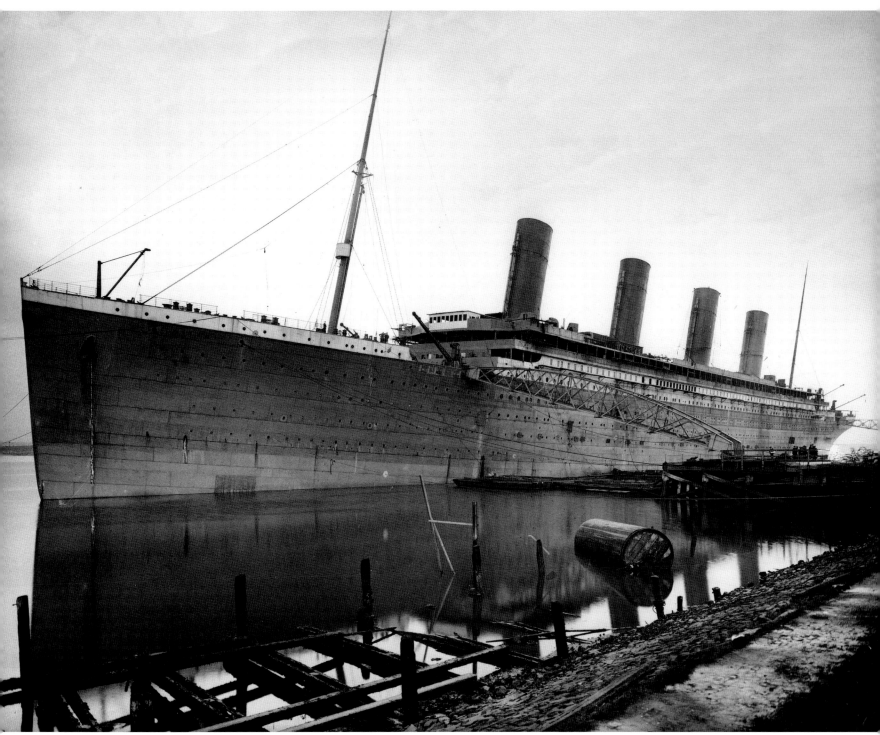

Some days later, Robert Welch takes a photograph for Harland & Wolff's archives, showing *Titanic* with all four funnels in place.

This rare and unusual image shows sixteen sets of *Titanic*'s davits being transported from the works of the Welin Davit & Engineering Co. Ltd in Trollhättan, Sweden.

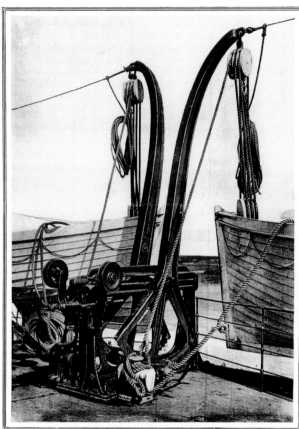

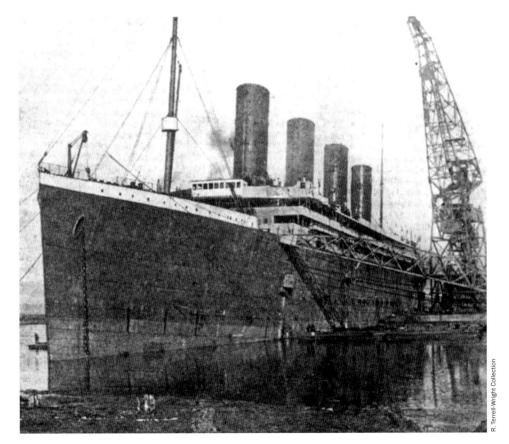

Titanic is seen here in late January 1912, with her lifeboat davits fitted. The port and starboard anchors are yet to be refitted and shortly after this photo was taken *Titanic* would enter dry dock.

Titanic was fitted with twenty lifeboats: fourteen 30ft wooden lifeboats permanently suspended beneath Welin double-acting davits; two 'emergency cutters' 25ft 2in in length that were kept permanently swung out when at sea in case of someone falling overboard; and four Engelhardt collapsible lifeboats 27ft 5in in length. Two of these collapsibles were secured to the deck beneath the emergency cutters and two were secured to the roof of the Officers' Quarters.

Titanic and *Olympic* were originally designed to carry sixty-four lifeboats, as the double-acting Welin davits were specifically designed to launch up to four lifeboats from one location. However, only sixteen boats were needed to meet the minimum number required by the Board of Trade regulations and by fitting the extra four Engelhardt collapsibles, the White Star Line actually exceeded the regulations by 17 per cent despite having a total capacity of only 1,178 people.

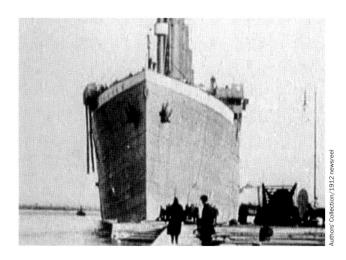

Authors' Collection/1912 newsreel

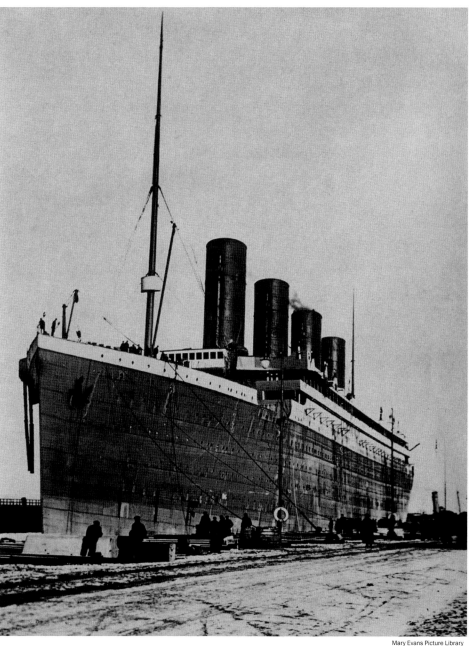

This series of images show *Titanic* in the morning of Saturday 3 February 1912 as she entered dry dock for the first time. The image above is a frame from the only known moving footage of *Titanic* and shows her moments before her bow begins to enter the dock. (Note the propeller blades sitting on the dockside.) The image on the right shows the newly dry docked *Titanic*; note the shoring timbers and scores of workmen waiting to put them in position. A short time later, as seen below, smoke rises from the pump-house chimney, indicating that water is being pumped out of the dock.

The dry dock – also known as the Thompson Graving Dock – was owned and operated by the Belfast Harbour Commission. It was impressive in its dimensions: 100ft wide and 850ft long, with its length capable of being extended to over 886ft if a special caisson was placed against the outward-facing quoins. The dock's floor depth at the centre was 37ft 3in at mean high water during ordinary spring tides, and the distance from the top level of the dry dock coping to the base floor was 43ft 6in. Its concrete walls were 18½ft thick and had a line of 332 massive keel blocks along its centreline to support the ships within.

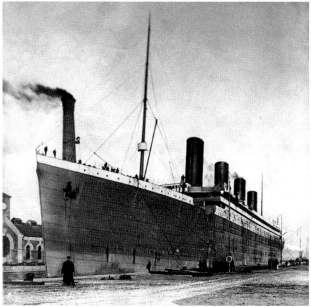

Josha Inglis Collection

Mary Evans Picture Library

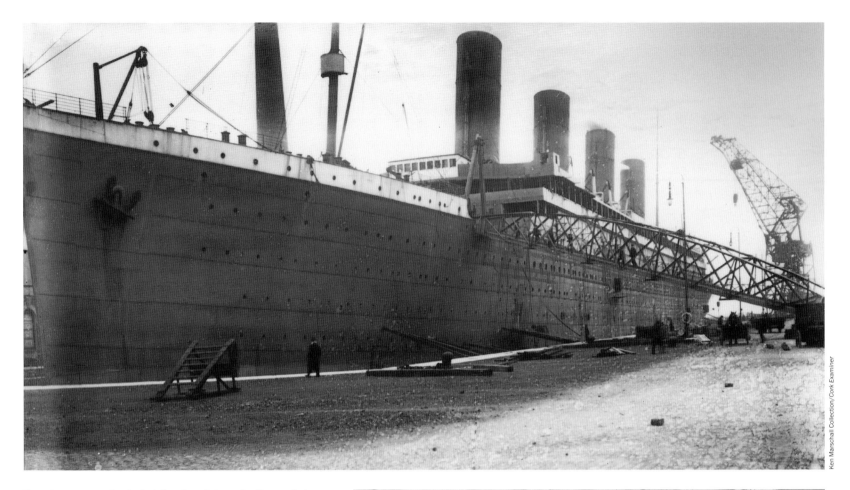

These images were taken by *Cork Examiner* photographer Thomas Barker on 8 February 1912. After taking a general photograph of *Titanic* in dry dock, above, Barker walked around to the starboard side and took a closer shot showing graffiti on *Titanic*'s bow, one of the many anti-Home Rule slogans to be found all across Belfast at the time in protest to Winston Churchill's visit and demonstration in favour of Home Rule. Note the tall staging erected on the dry dock floor alongside *Titanic* in preparation for painting the hull below the waterline.

Ken Marschall Collection/*Cork Examiner*

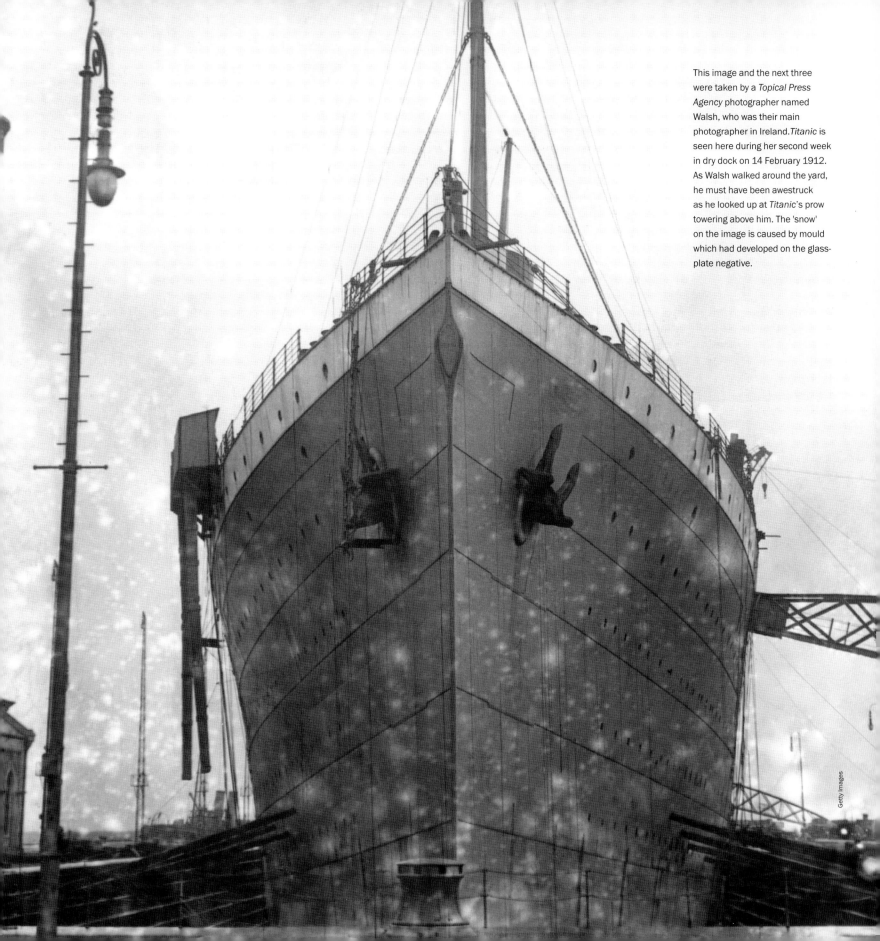

This image and the next three were taken by a *Topical Press Agency* photographer named Walsh, who was their main photographer in Ireland. *Titanic* is seen here during her second week in dry dock on 14 February 1912. As Walsh walked around the yard, he must have been awestruck as he looked up at *Titanic*'s prow towering above him. The 'snow' on the image is caused by mould which had developed on the glass-plate negative.

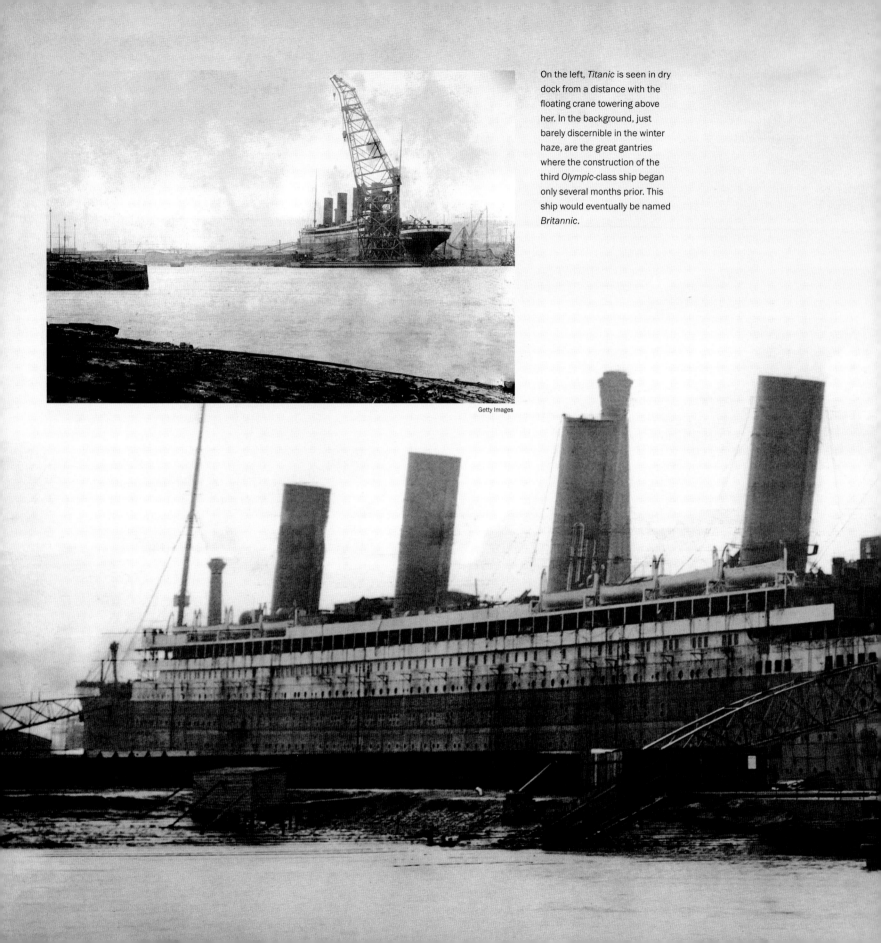

On the left, *Titanic* is seen in dry dock from a distance with the floating crane towering above her. In the background, just barely discernible in the winter haze, are the great gantries where the construction of the third *Olympic*-class ship began only several months prior. This ship would eventually be named *Britannic*.

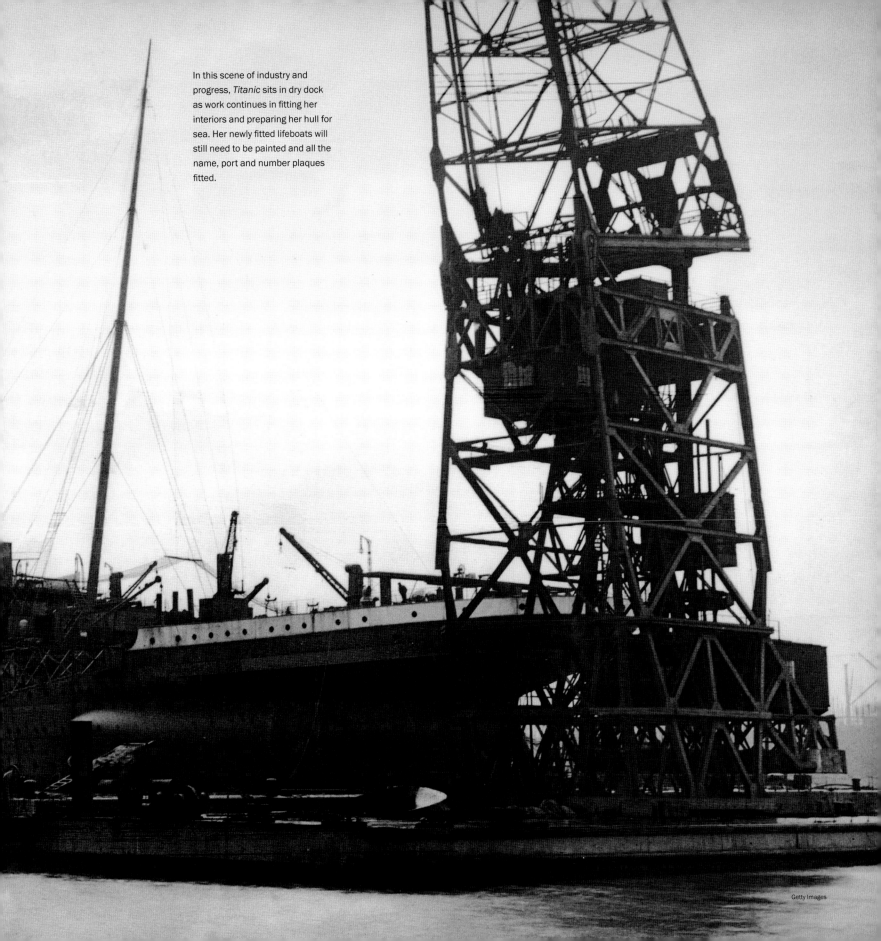

In this scene of industry and progress, *Titanic* sits in dry dock as work continues in fitting her interiors and preparing her hull for sea. Her newly fitted lifeboats will still need to be painted and all the name, port and number plaques fitted.

Stepping to the right, the *Topical Press Agency* photographer takes a photo of *Titanic*'s port side towering above the dry dock floor, with staging by her side as the painting of her hull below the waterline nears completion. Looking at this image it is easy to imagine what the Admiralty representative would have seen when he expressed that 'the ship is so large that one cannot see its real size'. The distance from the planks on the staging to the dock floor was over 20ft, which is how far a worker had fallen only days before this image was taken.

Getty Images

When *Olympic* suffered yet another mishap, this time throwing a propeller blade, she had to return to Belfast for repairs as no other dry dock was large enough. This series of images show *Olympic* entering dry dock on the morning of 2 March 1912, with *Titanic* at the Fitting-Out Wharf. By now *Titanic*'s funnels have been painted their black and buff colours.

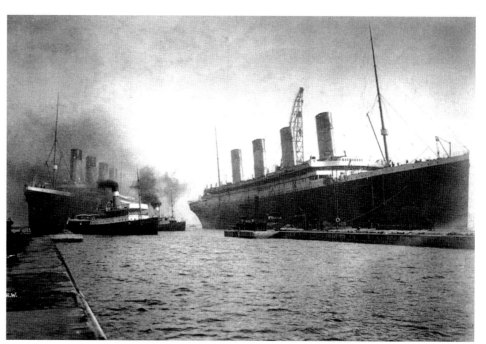

R. Terrell-Wright Collection

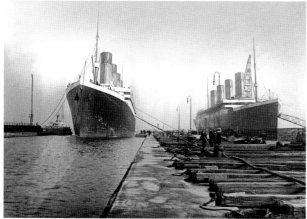

Authors' Collection/Harland & Wolff

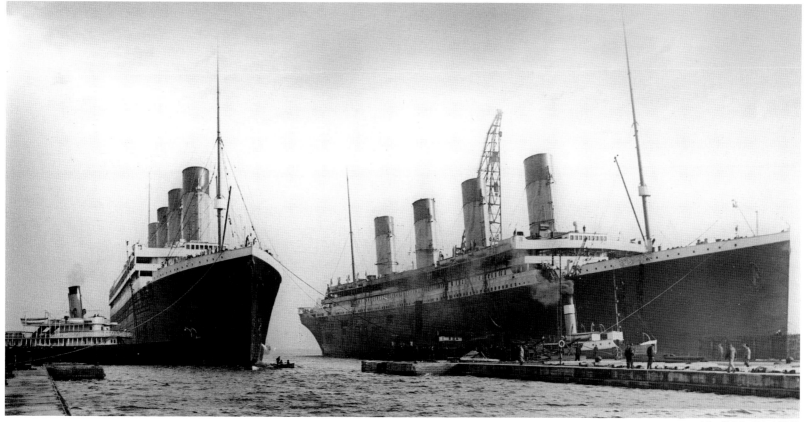

Authors' Collection/Harland & Wolff

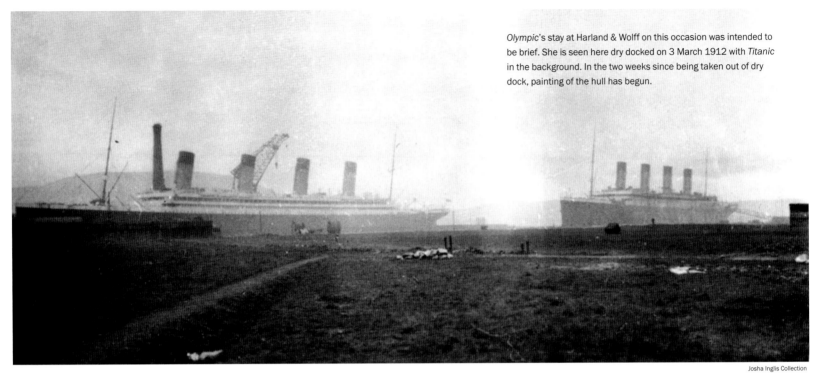

Olympic's stay at Harland & Wolff on this occasion was intended to be brief. She is seen here dry docked on 3 March 1912 with *Titanic* in the background. In the two weeks since being taken out of dry dock, painting of the hull has begun.

Josha Inglis Collection

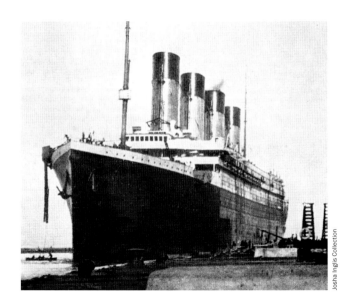

Josha Inglis Collection

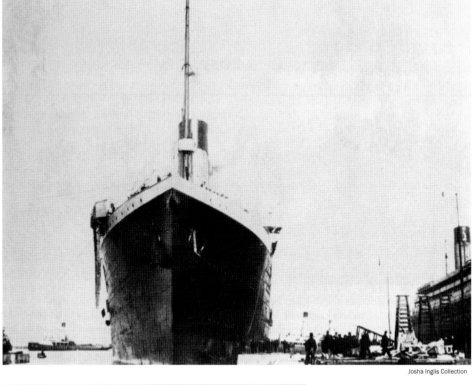

Josha Inglis Collection

As *Olympic* was unable to leave Belfast due to bad weather, Harland & Wolff made a bold move to remove her from the dry dock and put *Titanic* there instead – all on the one tide. By doing so, *Olympic* could then be moored at the Fitting-Out Wharf and could depart as soon as the weather permitted turning her in the new deep-water turning basin. This series of images show *Titanic* being assisted into dry dock around midday on 6 March 1912.

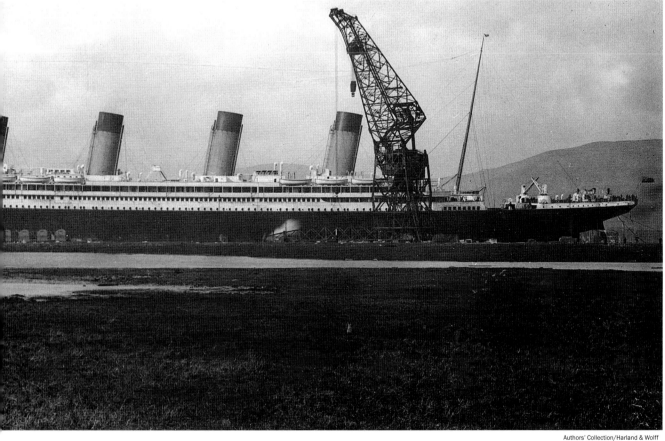

Authors' Collection/Harland & Wolff

With the manoeuvring of the two ships complete, *Titanic* is seen here on 6 March 1912 in the dry dock while *Olympic* is moored at the Fitting-Out Wharf. The next day, *Olympic* would be turned in the turning basin and would sail for Southampton.

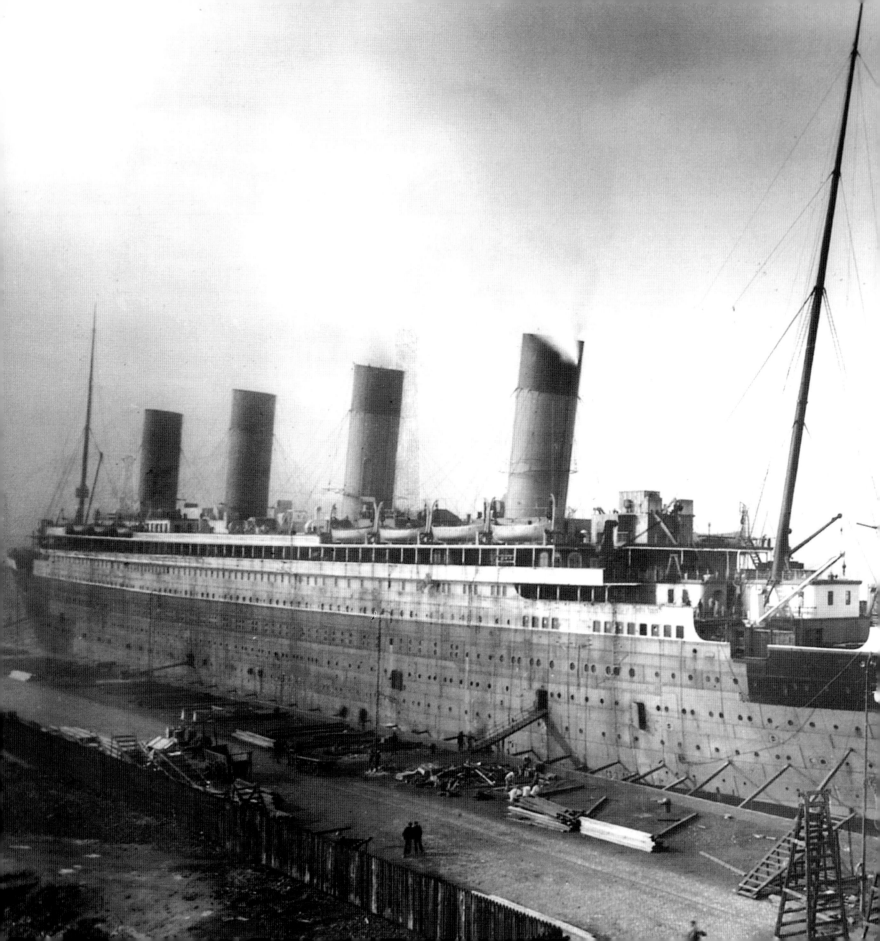

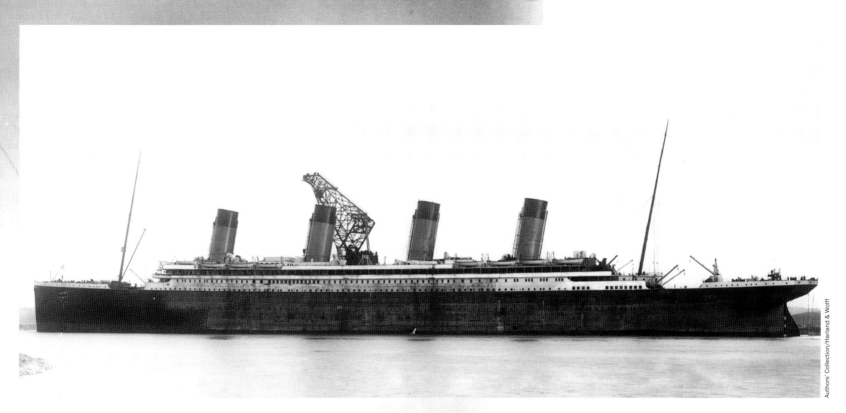

Authors' Collection/Harland & Wolff

Once *Olympic* had departed, *Titanic* was promptly taken out of dry dock on 8 March 1912 and took her place back at the Fitting-Out Wharf (above), which she had been forced to temporarily vacate for her sister. Owing to difficulties with manoeuvring *Olympic* in the strong winds, as a precaution *Titanic* was turned at this time so her bow faced the channel. This would make a later turning unnecessary and she could depart as soon as she was ready several weeks hence. In the two days that had passed since the previous photo was taken, painting of *Titanic*'s hull had progressed marginally, as seen in this photo taken on 8 March 1912.

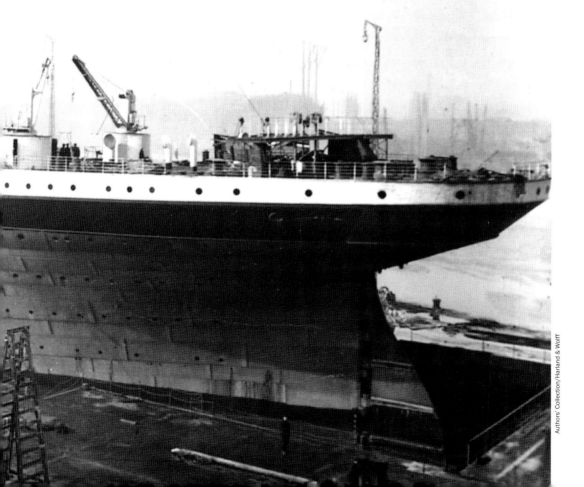

Authors' Collection/Harland & Wolff

With *Titanic* in dry dock and *Olympic* immediately behind in the Fitting-Out Wharf, this presented Robert Welch with a unique opportunity of taking this striking image of *Titanic* from the decks of *Olympic* (left).

Titanic was the first ship to offer private promenades. While today this concept is usually seen only in the form of a cramped balcony, the space aboard *Titanic* offered a real promenade in every sense – fully 48ft long, heated, and arranged with a substantial quantity of furniture, the two private promenades were the ultimate in sea-going luxury. Although not yet complete, the promenade shown here belonged to the port First-Class suite of rooms – B52, B54 and B56 – which would be occupied by J. Bruce Ismay on *Titanic*'s maiden voyage.

Although most of *Titanic*'s Gymnasium equipment had already been fitted, the punching bag and weights machine were still missing. These would be installed in Southampton.

Ken Marschall Collection/Harland & Wolff

Authors' Collection/Harland & Wolff

H1730
R.W.

Fitting out of this First-Class stateroom (B58, in Louis XVI style) was almost complete in January 1912, with some minor additional work carried out in February. While the doona (quilt), cushions and other miscellaneous articles were delivered in March, the room had lain virtually idle for over a month, as evidenced by the layer of dust that had collected on the table top, where Robert Welch had only moments before left his finger marks and moved the lamp while composing the scene for his camera. Note the rack with lifebelts seen behind the open door to the wardrobe room – these would be worn by Canadian First-Class passengers Hélène Baxter and her daughter, Mary Hélène Douglas, who occupied this stateroom.

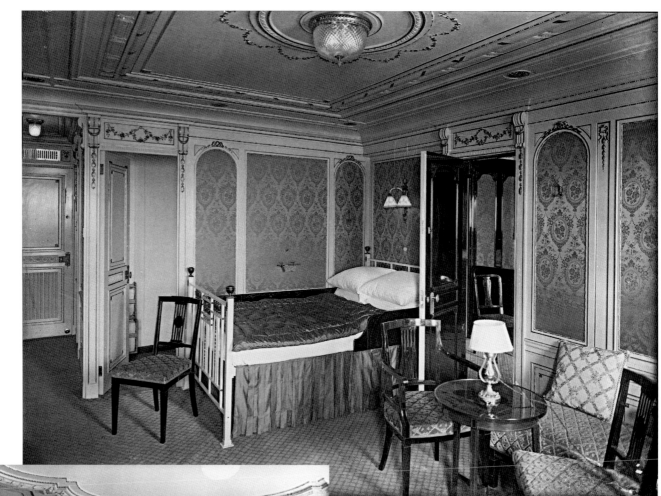

Authors' Collection/Harland & Wolff

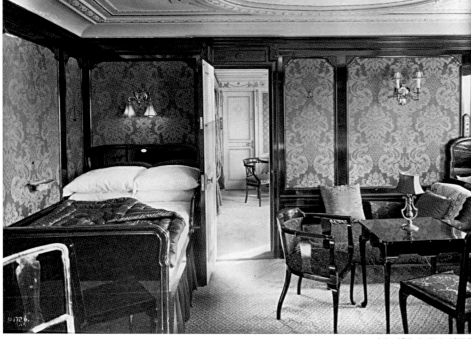

Authors' Collection/Harland & Wolff

The adjoining stateroom, B60 in Queen Anne style, would be occupied by Hélène Baxter's son, Quigg Baxter. He would not survive.

79

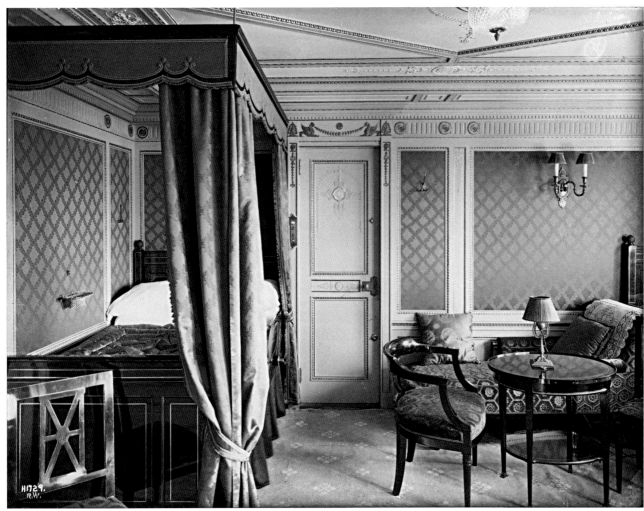

First-Class stateroom B64 in Empire style was only one of four staterooms aboard *Titanic* with a canopy bed. This stateroom is not known to have been occupied during the voyage.

Authors' Collection/Harland & Wolff

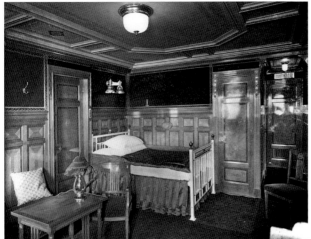

Authors' Collection/Harland & Wolff

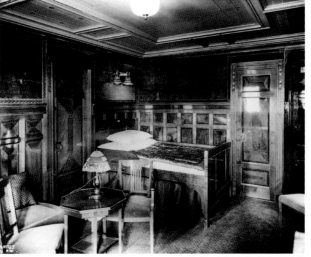

First-Class staterooms B57 (far left) and B63 (left), were both decorated in the Modern Dutch style, but offering a slightly different interpretation – one fitted with oak panels and brass beds, the other with sycamore panels and matching beds and furniture. These staterooms are not known to have been occupied during the voyage.

Ken Marschall Collection/Harland & Wolff

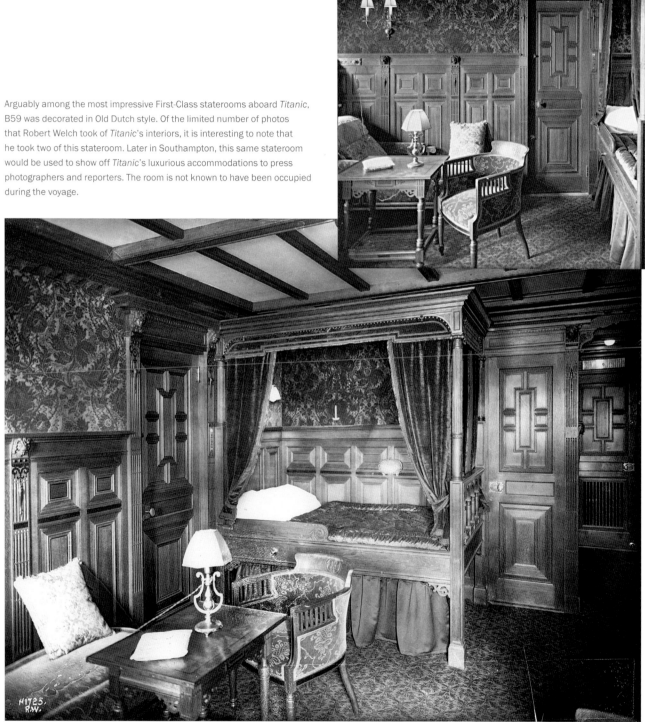

Arguably among the most impressive First-Class staterooms aboard *Titanic*, B59 was decorated in Old Dutch style. Of the limited number of photos that Robert Welch took of *Titanic*'s interiors, it is interesting to note that he took two of this stateroom. Later in Southampton, this same stateroom would be used to show off *Titanic*'s luxurious accommodations to press photographers and reporters. The room is not known to have been occupied during the voyage.

Authors' Collection/Harland & Wolff

Authors' Collection/Harland & Wolff

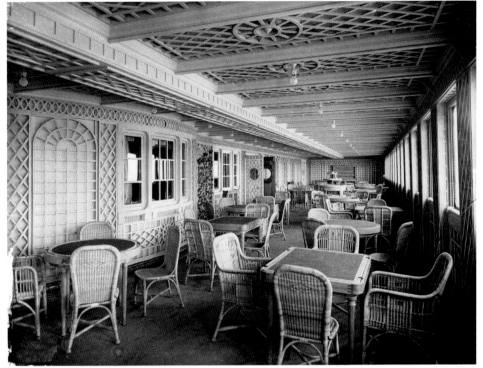

This space aboard *Titanic* was originally designated and finished as a promenade for the First-Class *à la carte* Restaurant. Panelling is seen here newly fitted over the already white-painted bulkheads and exterior doors. The furniture is haphazardly arranged, but in Southampton it would be neatly set, a runner would be placed along the length of the room and climbing ivy would adorn the trelliswork – thus transforming this space into an authentic recreation of a French café much like those found in Paris.

Authors' Collection/Harland & Wolff

Titanic is now complete with her A Deck screen of windows fitted, the hull painted and her boilers fired. She now awaits departure for her trials on 1 April 1912, but due to high winds that day, her departure for sea trials had to be postponed. (The strength of the wind can be seen by the smoke from her funnels blowing nearly horizontal.)

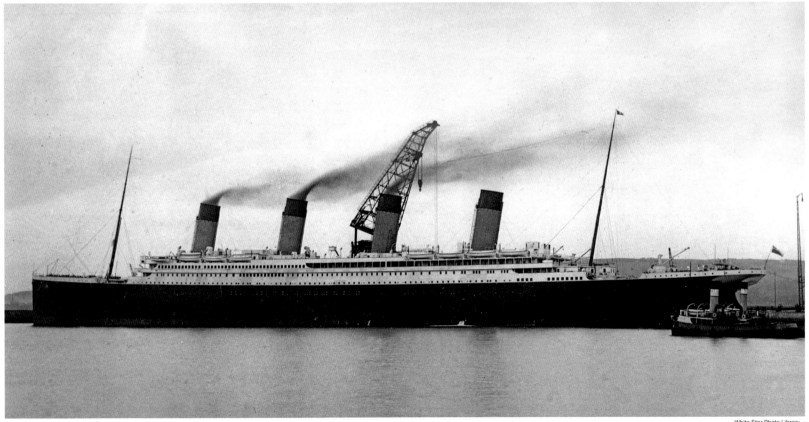

White Star Photo Library

With weather conditions now favourable, the *Topical Press Agency* photographer captures *Titanic* proceeding down Victoria Channel around 9.30a.m. on 2 April 1912. In the bottom image, note the two figures on the shore at the far left, adjusting their camera tripods as they each captured this moment for posterity. Unfortunately, the images they took have not come to light at the time of the writing of this book.

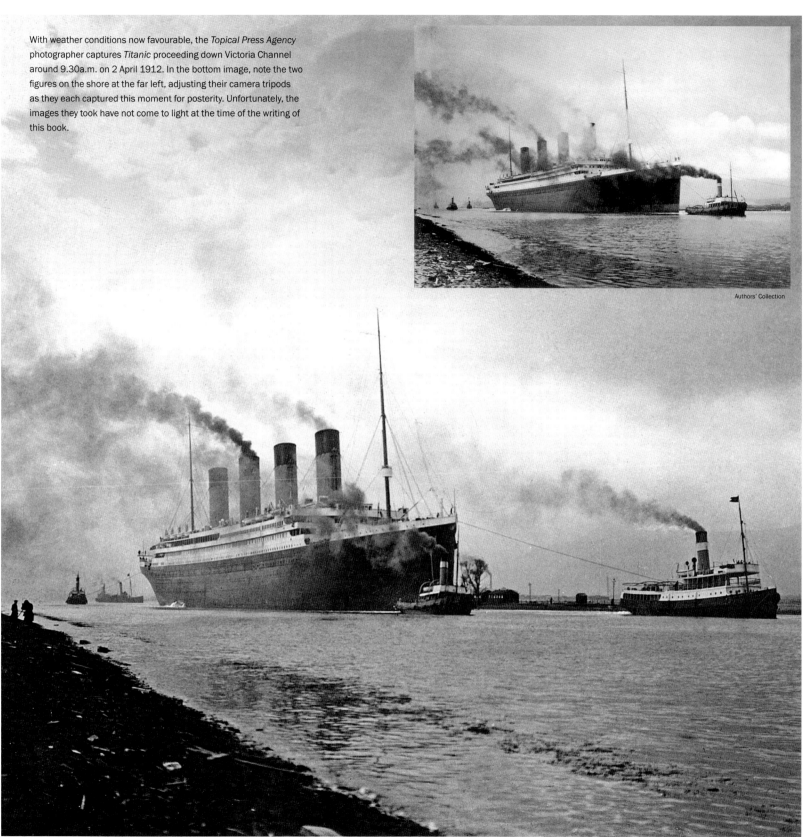

Authors' Collection

White Star Photo Library

In order to record *Titanic*'s departure for her trials, Harland & Wolff photographer Robert Welch takes to the water (below and opposite) while his assistant, James Glass, sets up his tripod on the banks of Belfast Lough (overleaf).

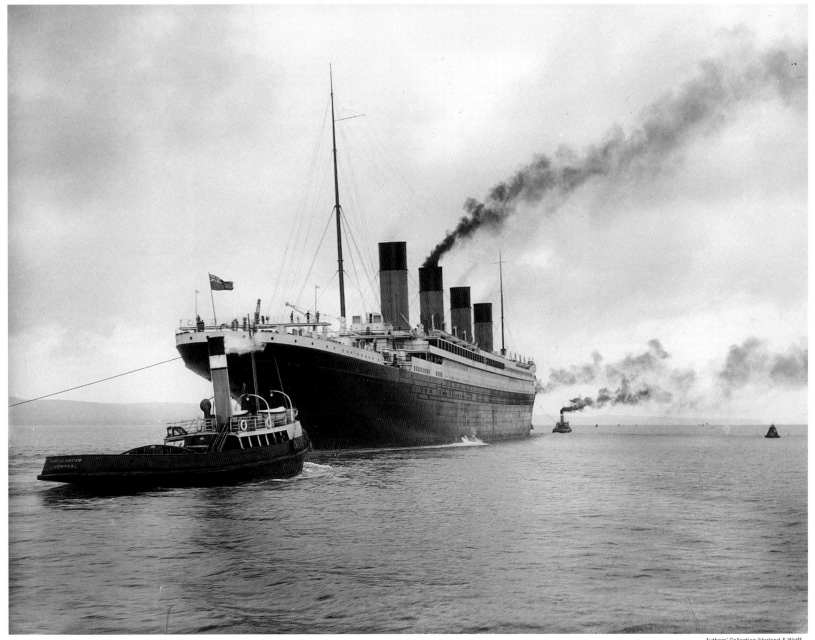

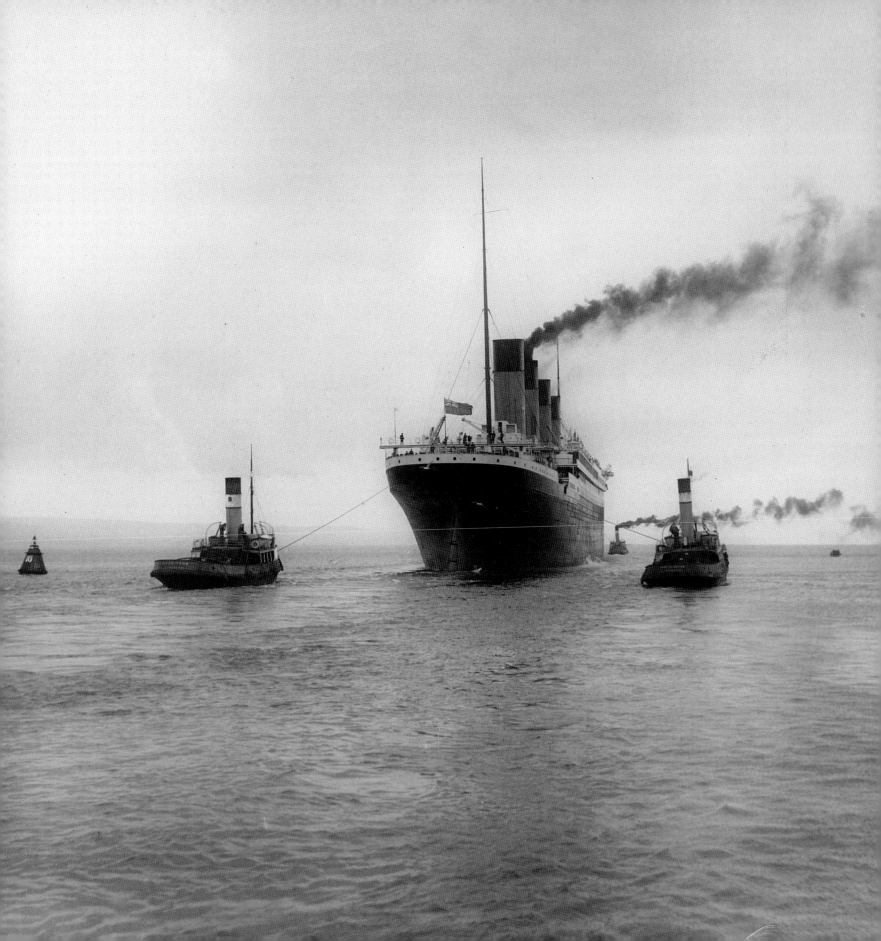

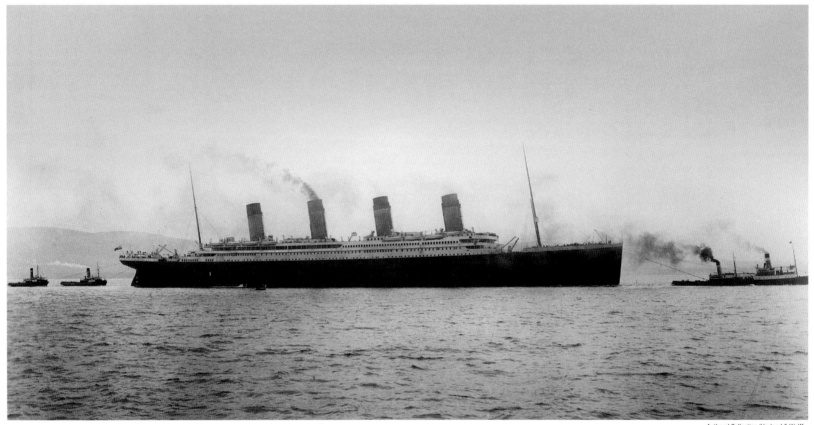

Authors' Collection/Harland & Wolff

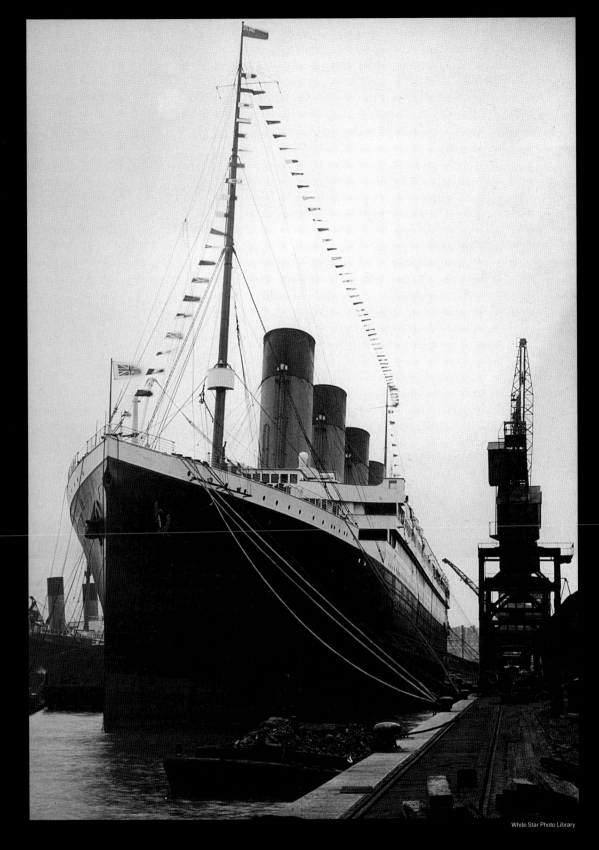

This is likely the first photograph ever taken of *Titanic* at Southampton. The image was captured by local photographer H. Symes in the early hours of 4 April 1912.

4 ★ PREPARATIONS & VOYAGE

On the morning of Thursday 4 April 1912, Southampton awoke to find *Titanic* moored at the Ocean Dock, having arrived shortly after midnight. She was dressed in flags, a custom in the maritime community to celebrate a ship's maiden arrival in a new port. Southampton had special reason to take pride in *Titanic*'s arrival, for while Liverpool was her home port, Southampton would be the initial point of departure for her transatlantic voyages to America. A quick glance may have given some reason to think she looked just like her sister ship *Olympic*; *Titanic* was nevertheless a brand new ship and generated an air of excitement. Less than a week remained before her maiden voyage and a significant amount of work had yet to be done.

Eager to take some photographs of the world's newest luxury liner on her first day in port, a *Hampshire Advertiser* photographer visited the docks. With *Titanic*'s interiors still being made ready, he was not able to fully explore the ship but was permitted to take a number of photographs of her upper decks. Another local photographer, Mr H. Symes, was at the docks early in the morning to take a photograph which he quickly produced into postcards available for purchase later that day.

In addition to preparing *Titanic*'s interiors and provisioning her with stores, the hiring of the remainder of her crew had also commenced in preparation for sailing on Wednesday 10 April.

Although her Deck Department was at full compliment and she already had many other crewmen aboard in the other departments, her 'black gang' still had to be filled out with firemen and trimmers, and she required hundreds of stewards, galley workers and others to be selected from the multitude of potential crew who called Southampton home. Over the week leading up to sailing day, finishing touches would also be undertaken to some of her interiors, including painting, securing fixtures such as racks and electric fittings, and arranging furniture. Because of this whirlwind of last-minute activity, *Titanic* was never opened up for public inspection as *Olympic* had been, the public being informed that 'sightseers need not apply'. For the same reason, *Titanic* had been unable to make a courtesy call to her home port of Liverpool prior to arriving at Southampton.

To add to the turmoil associated with *Titanic*'s last-minute preparations, a coal strike was in full effect. Coal miners throughout Great Britain had been on strike since 12 January 1912 and nearly all of the country's coal mines were closed. This created 'log jams' of ships in port with no coal to fire their boilers, some of the ships even moored alongside each other for lack of berthing space. The coal loaded aboard *Titanic* in Southampton was taken from other White Star Line ships that lay idle, and extra coal was also brought in advance by *Olympic* from New York. The strike had caused many cancelled voyages which ultimately resulted in a large number of unemployed crewmen ashore. Consequently, on 6 April 1912 – recruitment day for *Titanic*'s crew – the unions had no problem supplying workers to man White Star Line's new wonder ship. Some of the crew were brought over from other International Mercantile Marine ships with a select few hand-picked by White Star Line management from *Olympic* for the maiden voyage of her younger sister.

On Good Friday, 5 April 1912, *Titanic* lay at her berth seemingly abandoned (only ten men were employed to keep watch). On Saturday work resumed but on Easter Sunday things were quiet once again. With the day dawning on Monday, work on *Titanic* resumed at a hectic pace. Fewer than three days remained before the maiden voyage and the quay swarmed with workers as cargo was brought on board and provisioning was completed at a hurried pace. Well over 70 tons of perishable foodstuffs had to be loaded, including such diverse items as 40,000 eggs, 37,000 lemons, 32½ tons of beef and 1,750 quarts of ice cream. In addition there were nearly 37,000 bottles of beer, wine, stout and mineral water to be brought aboard. No less important were all the linens for the ship's Restaurant, dining saloons, passenger accommodations and

Titanic seen from across the water on Thursday 4 April 1912.

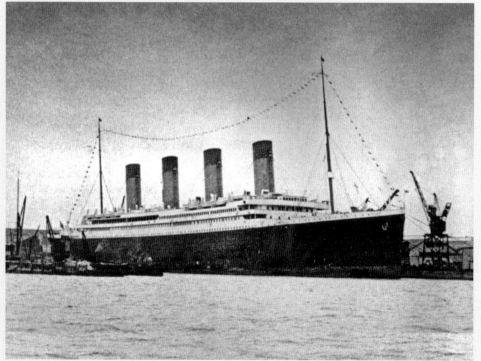

R. Terrell-Wright Collection

other areas, every piece of which had to be loaded at the start of each voyage.

As preparations continued and *Titanic*'s interiors were nearing completion, in the early afternoon of Tuesday 9 April 1912 two press photographers from London came to see the ship and photograph some of her interiors. They were from the *Illustrations Bureau* located at 12 Whitefriar's Street and *Central News*, situated at 5 New Bridge Street. Both were located only a few blocks apart near London's busy Fleet Street district, home of the British press at the time. While access to *Titanic*'s interior spaces was limited, both men had the opportunity to visit her Gymnasium, Swimming Bath and the richly decorated Cooling Room in the Turkish Bath complex. Some time after 1.30p.m. they found themselves on the Forecastle Deck, where each took a photograph looking aft towards *Titanic*'s Bridge. Later that same afternoon, employees from the nursery of F.G. Bealing & Son distributed hundreds of flowers, potted palms and plants throughout *Titanic*.

Sailing on *Titanic*'s maiden voyage would be Thomas Andrews, acting as Harland & Wolff's official representative on board. Accompanying him was a hand-picked 'Guarantee Group' from the shipyard. This group of eight men, whose appointment was no doubt a source of considerable pride and prestige, were William Parr, Assistant Manager of the Electrical Department; Roderick Chisholm, Chief Ships' Draughtsman; Anthony Frost, Outside Foreman Manager; Robert Knight, Leading Hand Fitter Engineer; William Campbell, Joiner Apprentice; Alfred Cunningham, Fitter Apprentice; Francis Parkes, Plumber Apprentice; and Ennis Watson, Electrical Apprentice. Andrews, Chisholm and Parr travelled in First Class while the others were berthed in Second Class. These men would be available for consultation and assistance with any matters that might arise with the operation of the ship's equipment, as did happen aboard *Titanic*: among the letters Andrews wrote to his wife, he mentioned the serious trouble experienced with the ship's Restaurant Galley hot press. Andrews, who would see to any problems that arose, also tended to details of the smallest order, such as devising a plan for reducing the number of screws in stateroom hat hooks, discussing with Ismay the colour of the pebble dashing in the private promenades on B Deck and the staining green of the wicker furniture on one side. In the evening before sailing day, Andrews reflected on all the work that had taken place in order to get the ship ready and he was satisfied that *Titanic* was now ready and would make the White Star Line proud when she sailed.

Sailing day finally arrived and the dock was filled with anticipation and activity. Those members of the crew who were

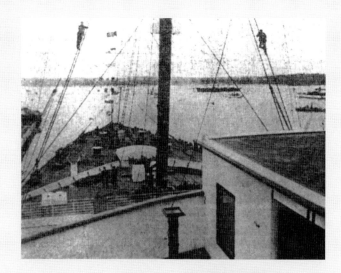

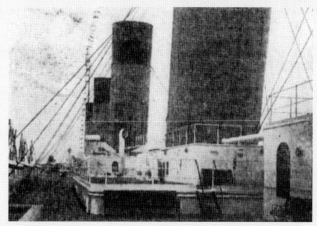

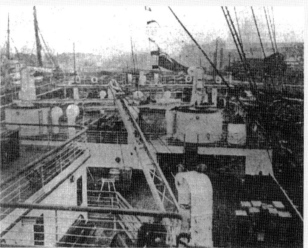

All Authors' Collection/*Hampshire Advertiser*

These three images of *Titanic*'s upper decks were taken by the *Hampshire Advertiser* photographer. Work to prepare the ship for sailing day had begun and crates can be seen in the aft Well Deck (bottom image) awaiting distribution.

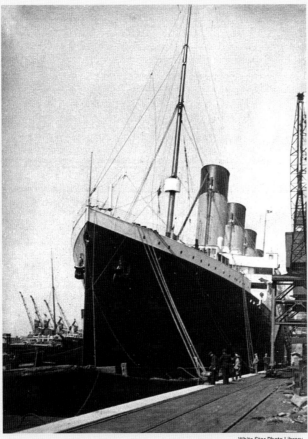

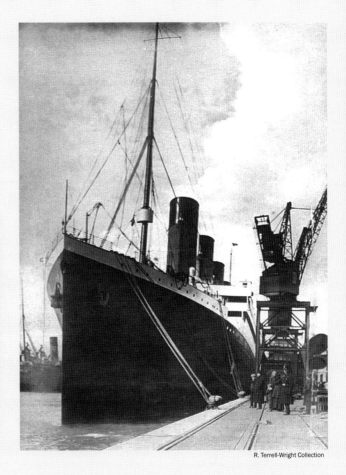

Titanic seen here at various times throughout her six-day stay at Southampton prior to departure on her maiden voyage.

White Star Photo Library

R. Terrell-Wright Collection

not already aboard were lining up the gangway to sign on for their 8.00a.m. muster. Many of the boiler room crewmen who were not required for duty until later that morning went back ashore for a traditional last drink, and several did not make it back to the ship in time for the noon sailing. This was not an unusual occurrence and extra hands had been signed on as standby crewmen in case they were needed. When *Titanic* sailed she would carry a Master, seven Master's Mates, twenty-five engineers, five electricians, two boilermakers, 175 firemen, seventy-three trimmers, thirty-three greasers, two pursers, 255 stewards and waiters, thirty-five cooks, twelve bakers, eight butchers, two barbers, a squash instructor – plus many more. Also aboard, but not technically part of the crew, were sixty-eight employees of the *à la carte* Restaurant, eight musicians, two Marconi operators and five sea post clerks.

Also present this morning, although he would not remain aboard for the voyage, was Captain Maurice Clarke, the Board of Trade's Immigration Officer. Clarke would formally inspect and clear *Titanic* to sail as an emigrant ship. In addition to the duties involved with the official paperwork required by his office, Clarke also witnessed the manning and lowering of two lifeboats

under supervision of Fifth Officer Lowe and Sixth Officer Moody. Captain Clarke saw to the completion of the muster lists for the crew, while the ship's surgeons, William O'Loughlin and J. Edward Simpson, met with the Board of Trade's medical representatives in regard to the health of the crew. From early morning passengers began boarding the ship, some having stayed overnight in local hotels or boarding houses. Others would arrive aboard two special 'Boat Trains' – Third and Second Class at 9.30a.m.; and First Class at 11.30a.m.

With *Titanic*'s interiors having finally been completed, the White Star Line management took pleasure in extending an invitation to members of the press (including photographers) to tour the ship. Shortly after 9.00a.m. two press photographers from London boarded *Titanic* – they were from *Newspaper Illustrations Ltd* and *Illustrations Bureau*; the latter had already photographed *Titanic* the day before. As they embarked via B Deck, the first areas they visited were the two large promenade suites. Perhaps someone proudly informed them that, at the height of the summer season, these luxurious suites could be booked at £870 per voyage, an amount that even the average First-Class passenger would consider

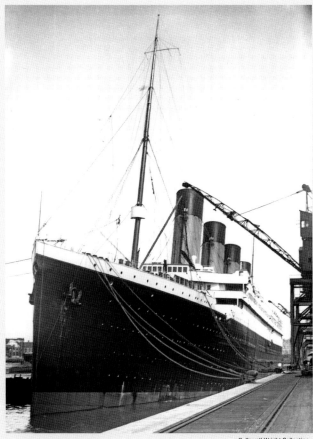

R. Terrell-Wright Collection

their own. They ascended the grand staircase and marvelled at the beautifully carved panelling and the wrought iron and glass skylight dome above. A short time later, they made their way to A Deck and out onto the port-side promenade area. They were directed to wait near the after grand staircase entrance from where the guided tour would commence. Standing at the rail and looking out onto the dock, they watched passengers arriving. Curious to explore, the *Newspaper Illustrations Ltd* photographer walked aft around the corner where he found the Verandah Café. With its trellis panelling and gilt-framed mirrors, it reminded him of the Savoy Hotel in London close to where he worked at 161a, Strand. Leaning over the starboard side rail he saw the *Saint Louis*, *Philadelphia* and *Majestic* tied together, their voyages cancelled by the coal strike. Looking back toward *Titanic*'s Poop Deck, he noticed very few passengers about. Right at that moment, around 9.30a.m., the first Boat Train arrived from London's Waterloo station, bringing with it mostly Third and Second-Class passengers, along with several journalists from across the country. It was around this time that the *Central News* photographer joined the group as well.

Within minutes, the journalists were aboard and joined their counterparts aft on the A Deck promenade. The aft grand staircase was the perfect starting point for the tour. Turning left and proceeding down a short passage the group were likely taken to the palatial First-Class Lounge; then retracing their steps and going aft, the group would have been taken into the richly panelled First-Class Smoke Room. A nearby flight of stairs led them down to the Restaurant Reception Room on B Deck, a new feature not found on *Olympic*. Another short passageway led the group to the Restaurant itself where they noted that having 'proved a most successful institution, [it] has been considerably increased in size'. However, the room that delighted them most of all was the Café Parisien, another innovation unique to *Titanic*. With wicker furniture, trellis panelling throughout and climbing ivy (which apparently was 'not growing'), the builders had successfully recreated the authentic feel of a sidewalk café in Paris. During *Titanic*'s construction, the greatest number of changes was implemented on this deck and it is no wonder that a significant part of the tour took in the public rooms and accommodations here. One stateroom toured was B59, which occupied part of the space taken up by a second promenade area on *Olympic*. In this room on *Titanic*, the press admired the 'old-fashioned English four-poster wooden bedstead, with old rose canopies and valences'.

The press tour continued up the grand staircase and out onto the Boat Deck. Here on the port side, just outside the Officers' Quarters,

a substantial sum. Very few passengers would ever see these suites, but for now they were open for inspection by the press. Had anyone made inquiry as to who would occupy these spacious and palatial accommodations, they would have been told that the suite on the starboard side (B51, B53 and B55) was reserved by American millionairess Charlotte Cardeza for herself and her son Drake, Mrs Cardeza having paid just over £512 for the privilege (peak-season prices having not yet taken effect). The port-side suite remained unoccupied after a series of cancellations, so Bruce Ismay – who initially had the port-side C Deck parlour suite (C62 and C64) set aside for him – had taken up the reservation for this suite of rooms (B52, B54 and B56). Ismay had not yet boarded and the Cardezas would embark later in the day at Cherbourg, and consequently both suites were available for inspection while the press were aboard. Both of the London photographers took the opportunity to capture images of these elegant apartments.

The tour that had been arranged for the invited press representatives was scheduled for shortly after 9.30a.m. so, with time to spare, the *Newspaper Illustrations Ltd* and *Illustrations Bureau* photographers took the liberty to explore part of the ship on

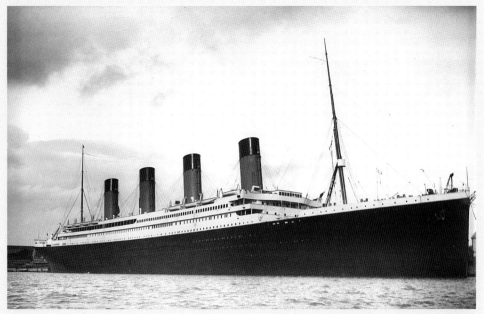

Authors' Collection

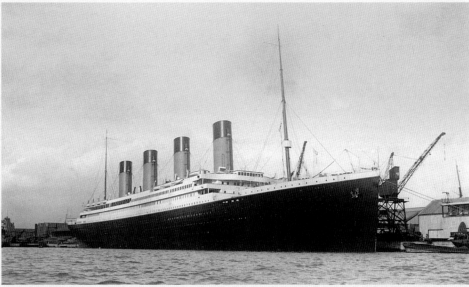

Günter Bäbler Collection

Two views of *Titanic* from across the harbour during her stay at Southampton.

First-Class use during the voyage, prior to sailing Second-Class passengers were allowed to explore the First-Class public areas and Beesley took full advantage of the opportunity:

> Between the time of going on board and sailing, I inspected, in the company of two friends who had come from Exeter to see me off, the various decks... We wandered casually into the gymnasium on the boat-deck, and were engaged in bicycle exercise when the instructor came in with two photographers and insisted on our remaining there while his friends – as we thought at the time – made a record for him of his apparatus in use. It was only later that we discovered that they were the photographers of one of the illustrated London papers. More passengers came in, and the instructor ran here and there, looking the very picture of robust, rosy-cheeked health and 'fitness' in his while flannels, placing one passenger on the electric 'horse' another on the 'camel', while the laughing group of onlookers watched the inexperienced riders vigorously shaken up and down as he controlled the little motor which made the machines imitate so realistically horse and camel exercise.

While Beesley and a friend posed for photographers having a bicycle race, in the opposite corner of the Gymnasium nineteen-year-old Second-Class passenger Lillian Bentham was perched on the electric horse. Observing the scene (but misidentifying the apparatus she was riding) an *Irish Times* reporter later recalled:

> On one side a lady was having a camel ride and recalling the delights of the Pyramids; in another corner there was a bicycle race; many passengers took their own weights on the automatic chairs, and some had a spin on the mechanical rowing machines.

the press gathered to meet Captain Edward John ('E.J.') Smith. By this time, it was around 10.30a.m., the tour thus far having taken a little less than an hour. As the photographers occupied themselves with capturing shots of Captain Smith, the journalists took the opportunity to ask him a few questions. At this time, they were joined by *Titanic*'s Gymnasium attendant, Thomas McCawley, clad in his white flannels. McCawley, who had heard that the press were aboard, had gone in search of photographers to record images of people using all the latest exercise equipment. In the Gymnasium was Second-Class passenger Lawrence Beesley, a science teacher from London. Although the Gymnasium was exclusively for

While the *Illustrations Bureau* and *Central News* photographers, as well as a number of journalists, followed McCawley to the Gymnasium, others remained near the Officers' Quarters and had the opportunity to view the Bridge and also to visit the Marconi Operating Room. One, describing their visit to the latter, recalled that, 'you entered by a cool, white passage, closed the white door behind you, and there you sat in a quiet, white enamelled Marconi cell, seemingly as much cut off from the rush of the world as if you were in a Trappist monastery'. Perhaps the tour finished here; surviving accounts do not say. The press likely continued to explore the ship, and we know they found the spectators' gallery for

the Squash Court, where they watched 'two Americans… fighting the battle of their lives – it might have been at the Bath Club, so thoroughly at home did they look'.

At 11.30a.m. the second Boat Train arrived from London, bringing the majority of *Titanic*'s First-Class passengers, including Francis (Frank) Browne, a candidate for the Jesuit priesthood. The voyage aboard *Titanic* was a gift from his uncle and was the opportunity of a lifetime for the young man. Browne would not be travelling all the way to New York, but just overnight from Southampton via Cherbourg to Queenstown where he would disembark. As he disembarked from the Boat Train at Southampton he was met by a friend, Tom Brownrigg, and together they proceeded to the ship. While crossing the elevated gangway to board the ship, Browne suddenly stopped, struck with the realisation of just how huge the ship was:

> Left and right stretched a wall of steel that towered high above the roof of the station that we had just left. We were about forty feet above the quay level, and yet scarce more than half way up the side of the ship. Below us the people looked tiny, while some hundred and twenty yards aft we could see the Second-Class passengers crossing the gangway into their portion of the ship.

After boarding, Frank Browne paid a visit to the Purser's Office on C Deck where he was given his stateroom allocation. He was then 'sent looking for Cabin A37'. Browne also had a large and detailed 'Plan of First Class Accommodation'. Printed in December 1911, it showed a deck arrangement for *Titanic* that varied very slightly from the actual layout of staterooms due to some last-minute changes, among which were two staterooms added in the last two months of construction and which, for that reason, did not appear on the plan given to Browne. This would have been undetectable to nearly every passenger; unfortunately for Browne, he occupied one of them (A36) and consequently had some difficulty locating it. A steward could only tell him 'that's somewhere aft, sir'. Browne eventually found his stateroom located off the after grand staircase foyer, where it and its port-side counterpart had been added to take advantage of the excessive space initially given over to this area. All the time lost gave less opportunity for Browne and his companion to explore the ship, and soon the bugler sounded the call for 'all visitors ashore'. As *Titanic*'s passengers relaxed and settled into their new rooms or lined the upper decks, friends and family who came to see them off soon disembarked. Scattered among the crowds

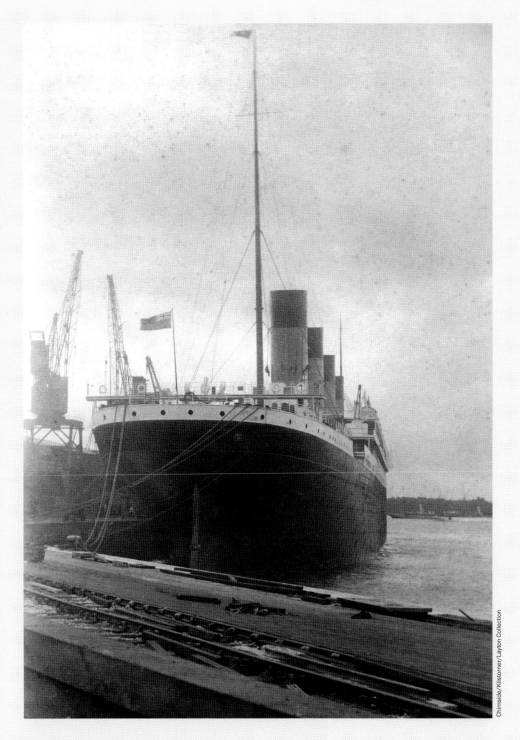

leaving the ship were journalists from across the country, along with the three London photographers carrying their priceless glass plates on which were rare glimpses of *Titanic*'s interiors.

At 12.15p.m., the heavy mooring lines were cast off. A *Daily Express* reporter from London described *Titanic*'s graceful departure thus:

Titanic is seen here on 8 April 1912, only days before departure. Her funnels are receiving one last coat of paint.

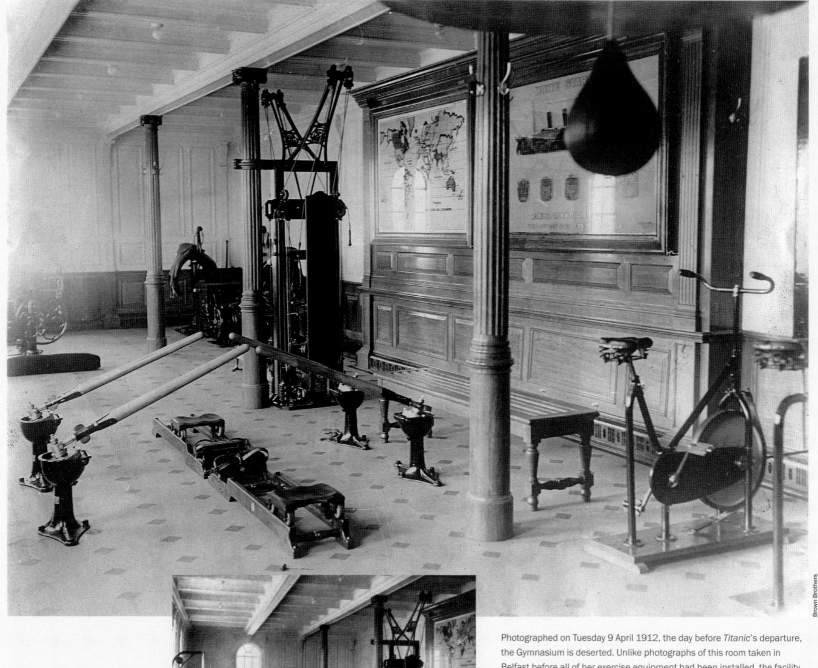

Brown Brothers

Photographed on Tuesday 9 April 1912, the day before *Titanic*'s departure, the Gymnasium is deserted. Unlike photographs of this room taken in Belfast before all of her exercise equipment had been installed, the facility is now fully fitted with the weight-lifting machine and punching bag installed. The Gymnasium was equipped with the latest exercise devices and boasted such equipment as an electrically driven mechanical horse and camel, two fixed cycling machines where passengers could race in tandem, a weight-lifting press and even a rowing machine. *Illustrations Bureau* (above); *Central News* (left).

Authors' Collection/*Illustrated London News*

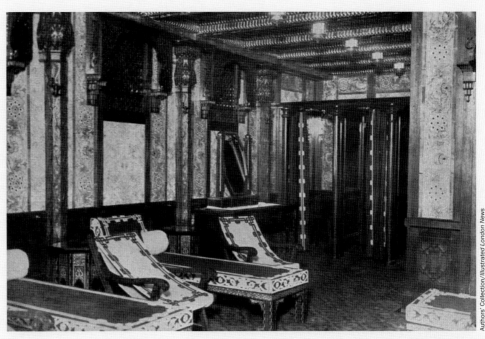

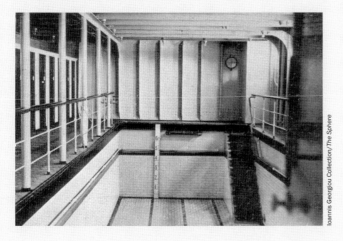

Titanic's Swimming Bath as captured by the *Central News* photographer (above) and *Illustrations Bureau* photographer (below) on 9 April 1912. Over the circular aperture on the forward bulkhead would be mounted a clock, which was not yet fitted when this photo was taken – another sign of work still being done at the last minute, but not yet complete. Exploring the ship on sailing day, First-Class passenger John B. Thayer Jr noticed that the pool was empty. Due to the dirty waters in port, the saltwater pool would not be filled until *Titanic* reached the clean open waters of the Atlantic en route to Queenstown.

The vast steel wall in front of us began to move. For the first yard a caterpillar might have raced the *Titanic*. It was difficult to imagine such a tremendous object moving so slowly. I walked to the end of the deep water dock and saw her come by at a slow pace, within a stone throw of the quay. Her propellers churned the green sea up to liquid grey mud.

As *Titanic* left her berth and entered the River Test, the tugs cast off their lines and *Titanic* proceeded under her own power, slowly picking up speed. Upon negotiating the turn at the end of the pier she began to pass the two liners, *Oceanic* and *New York*, moored in tandem at berths 38 and 39. Under normal conditions only one ship would have been berthed here, but the coal strike had created a limited amount of space to berth all the ships that were idle for lack of fuel. The *Daily Express* reporter continued:

She had to go round a bend to the left – not at all a sharp bend – about half a mile further on, in order to clear the end of the long quay, which juts out slantwise into Southampton Water. It was while trying to round this bit of a bend that the *Titanic* pulled the 10,508-ton *New York* from her berth.

When the *Titanic* started I walked the half-mile or more seaward to see the last of her. Hundreds of townsfolk had already gathered at the quay end. For some minutes the line of cold storage and other buildings blocked the view. When I came out on the quay end an astonishing spectacle held the gaze of the crowd, for between the *Titanic* and the quay – a distance of two or three hundred yards – the *New York* was drifting stern first towards the outgoing new liner.

The *Oceanic* lay moored along the quayside. A few minutes before, the *New York* was moored close beside her. Now the *New York* was adrift and sweeping towards the *Titanic*. What was said to have happened seemed a fantastic absurdity until I saw the frayed end of the steel wire hawser, about as thick as a man's wrist, lying on the quay. 'It snapped like the crack of a gun' a man told me who saw it break. Broken hemp cables hung down the *New York*'s side.

The crowd was breathless with excitement. People climbed into railway trucks to see what was going to happen. As soon as

Much of *Titanic*'s panelling was being completed prior to launch, often at the same time as *Olympic*'s. The original design of the Cooling Room of the Turkish Bath incorporated the portholes in the ship's side, which, as *The Shipbuilder* reported, were 'concealed by an elaborately carved Cairo curtain, through which the light fitfully reveals something of the grandeur of the mysterious East'. However the layout of *Titanic*'s Cooling Room was changed around July 1911 and eliminated its proximity to the ship's side – but as the panelling was likely already prepared, the 'Cairo curtain' casings for portholes were retained and incorporated into a new design with *faux* portholes. It is possible that concealed lights were also installed to give the impression of real light coming in from outside. This view was captured by an *Illustrations Bureau* photographer on 9 April 1912 and it is likely that the *Central News* photographer also took a picture of the same room.

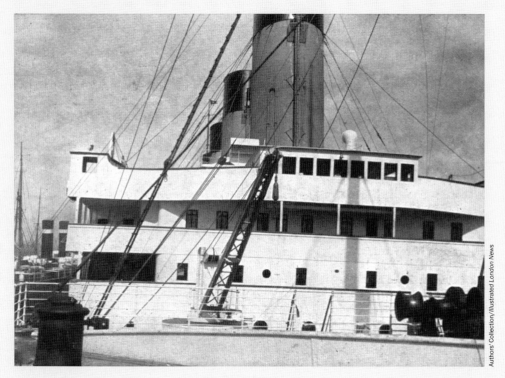

Authors' Collection/Illustrated London News

A view of *Titanic*'s Navigating Bridge from the Forecastle Deck as captured by the *Central News* photographer some time after 1.30p.m. on 9 April 1912. His colleague from the *Illustrations Bureau* captured a similar view. The telegraphs on the Bridge are covered and the decks appear deserted, but inside the ship was a hive of activity with last-minute work being completed.

Shortly after *Titanic* resumed her journey following the delay at Southampton, the bugler's call announced that lunch was ready and most passengers went below decks for their very first meal at sea aboard the great liner. After lunch, many of them made for the ship's lounges and writing rooms, putting pen to paper to regale their friends and families ashore with tales of the excitement at Southampton and the marvellous new ship they were aboard. Having left the difficult channel in the Solent safely behind, *Titanic* slowed to drop the pilot before heading into the open waters of the English Channel. Ahead was the 77-mile cross-Channel trip to Cherbourg, France, to pick up additional mail and passengers. Cherbourg was a large, modern port facility but did not have berthing facilities for ships the size of *Titanic*. To ferry passengers out to the new ships, the White Star Line utilised the new tenders *Nomadic* and *Traffic*, which were specially built and permanently kept at Cherbourg for this purpose. The *Nomadic* was used primarily for First and Second-Class passengers while the *Traffic* handled Third-Class passengers and mail.

Owing to her delay in departing Southampton as a result of the *New York* incident, *Titanic* arrived at Cherbourg over an hour late, entering the harbour at approximately 6.30p.m. – moments before sunset. White Star Line records show that 142 First-Class, thirty Second-Class and 102 Third-Class passengers boarded here while twenty-four cross-Channel passengers disembarked. As darkness fell, *Nomadic* and *Traffic* reached *Titanic*'s side and began embarking their passengers while the service began in the Dining Saloons. Shortly after 8p.m., *Titanic* weighed anchor and steamed out of port heading toward her final stop in Ireland. Frank Browne later recalled:

the *New York* broke loose the *Titanic* reversed her engines and in a brief space of time stopped dead and began to back. Then the tugs *Neptune* and *Vulcan* raced at the *New York*, caught her with ropes by the bows and the stern, and tried to lug her back to her place.

It was difficult to tell distances, looking broadside on, but it seemed as if you could have thrown a hat from the *Oceanic* to the *New York*, and from the *New York* to the *Titanic*. There was not much room to spare between the *New York*'s stern, the *Titanic*'s side, or between her bows and the side of the *Oceanic*.

But no one in uniform was flurried. A master of port navigation, with a megaphone, stood stolidly on the quay, issuing orders across the water as calmly as if he were having his tea. He had the *New York* pulled back across the *Oceanic*'s bows and round the bend to the quay, and there moored securely, and then he let the *Titanic* come on again towards the open water. She had backed right away towards the deep water dock while the *New York* was being tugged about like a naughty child.

It was a relief to everyone when the *Titanic* at last passed ... and glided slowly away to sea, with the Royal Mail liner *Tagus* following her like a maid of honour holding the train of a queen. It was a thrilling start for the maiden voyage of the largest steamer in the world.

While we were saying good-bye to those to whom the excitement of the morning had served as an introduction, and who were getting off at Cherbourg, the bugle sounded the Dinner Call. That I was not the only person 'at sea' on the *Titanic* was proved by the requests made me by some who could not find their way to the Dining Room!

As we sat down to dinner – we were eight at our table – we could see the newly arrived passengers passing in the lobby outside and occasionally hear the busy hum of work as the luggage and mails were brought on board. But soon it all quietened down and after a time someone remarked, 'I wonder have we started yet.' We all stopped for a moment and listened, but noticing no vibration or noise the answer came, 'No, we can't have started yet.' But the waiting steward leant over and

Able to boast of the newest and largest steamers in the world, the White Star Line took every advantage to promote their luxury and exclusivity. To this end, promotional booklets and postcards were printed to illustrate the luxurious appointments in magnificent colour.

Because colour photography was in its infancy in *Titanic*'s time, artist's renditions were widely used to illustrate the ship's accommodations. The White Star Line took pains to ensure that these works were accurate and high quality. Although the illustrations that follow are of *Titanic*'s sister ship *Olympic*, these renditions readily convey what *Titanic*'s accomodations and public rooms must have looked like.

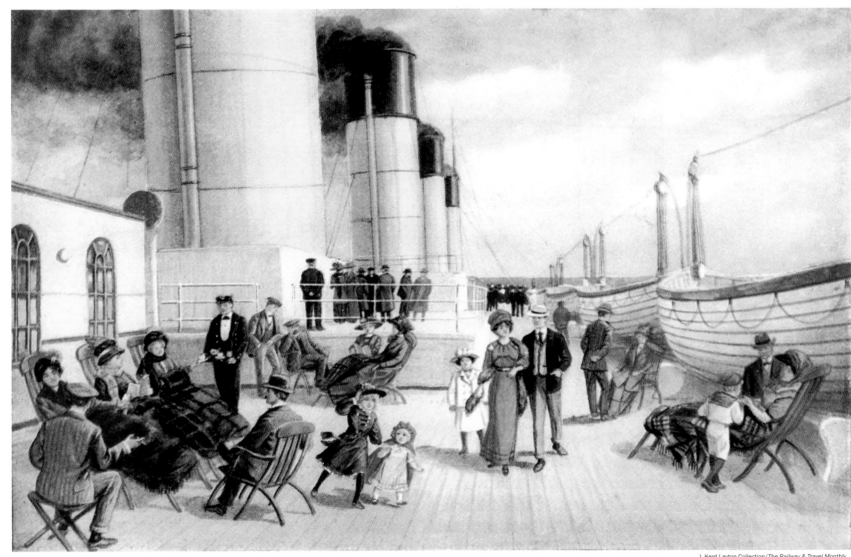

This scene captures the idyllic life of days at sea, showing passengers relaxing and enjoying the Second-Class promenade area of *Olympic* and *Titanic*'s Boat Deck. *Cork Examiner* photographer Thomas Barker took a similar photo aboard *Titanic*.

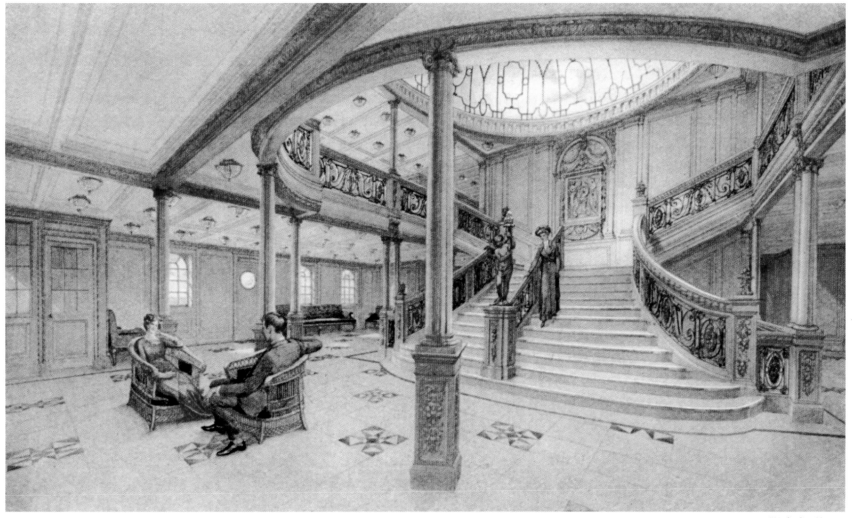

The centrepiece of First-Class accommodation, the forward 'grand staircase' was panelled in pale English oak, spanned seven decks and was capped by a magnificent wrought-iron and glass skylight dome.

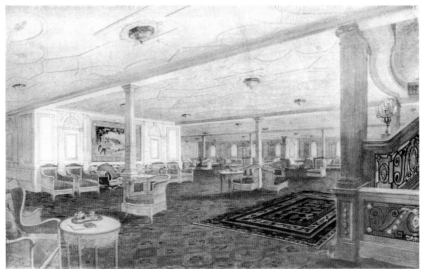

Adjoining the First-Class Dining Saloon, the Reception Room on D Deck was immensely popular. Passengers gathered here before and after meals and the room was often filled to capacity with some passengers having to sit on the stairs when the band played after dinner.

The First-Class Reading and Writing Room was designed to be a retreat for the ladies. Decorated in Georgian style and panelled in white, it was offset by a rich carpet of 'old rose' hue. On *Olympic* the great bay window boasted views of the sea, but on *Titanic* the view was obscured by a weather screen shielding the promenade deck outside from the ocean spray.

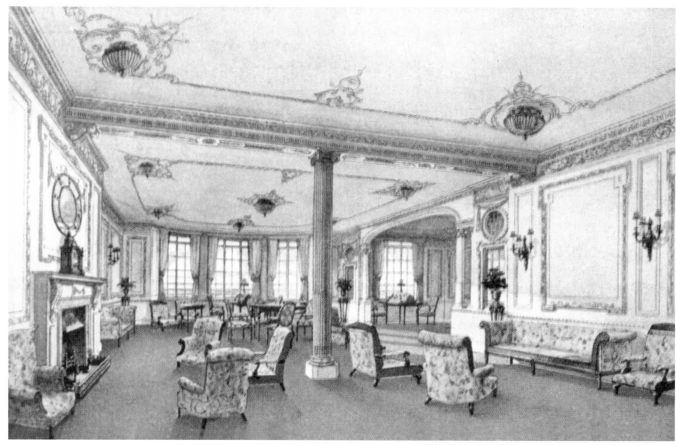

The First-Class Smoking Room was for exclusive use of the First-Class male passengers. Designed as a gentleman's club, it was panelled in rich mahogany with inlaid mother-of-pearl. Colourful stained-glass windows depicting allegorical figures as well as nautical and country scenes accented the room. Unlike the colours used on *Olympic* (as seen here), *Titanic*'s Smoke Room had its own distinct feel – with red and blue floor tiles, burgundy leather chairs and a painting depicting Plymouth Harbour. As the *Titanic* sank, several groups of men were seen playing cards in this room and Thomas Andrews was last seen standing alone by the fireplace.

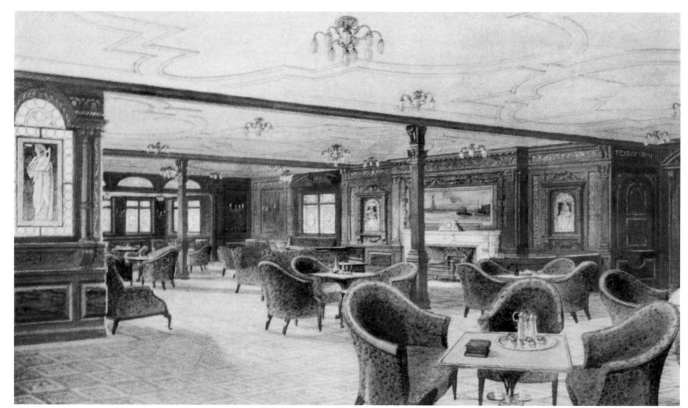

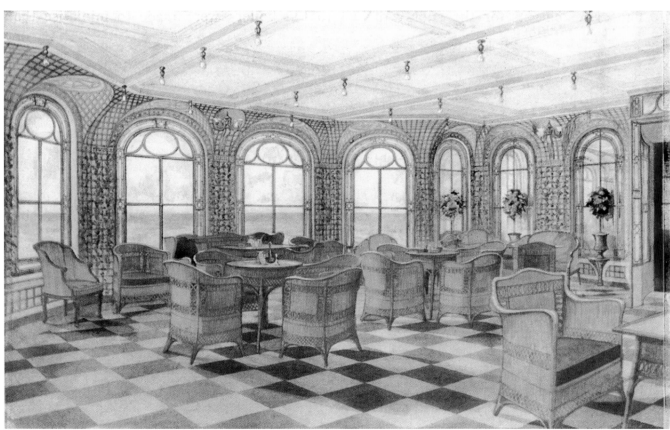

The First-Class Verandah Cafés were light and airy and perfectly positioned at the after end of the promenade deck where patrons could watch the ocean and fellow passengers passing by.

J. Kent Layton/*The Railway & Travel Monthly*

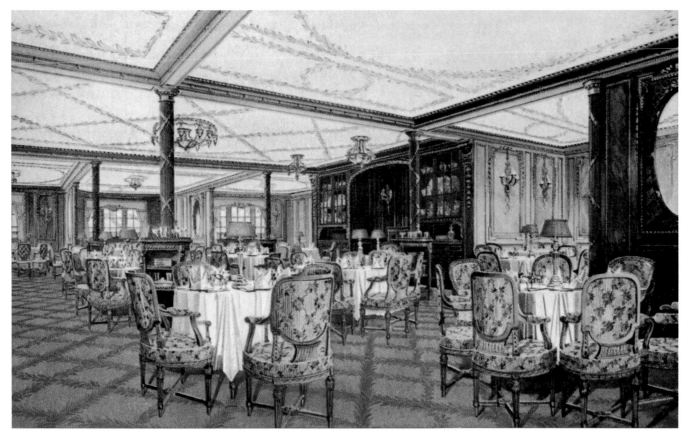

A somewhat novel feature for its time, the First-Class *à la carte* Restaurant provided passengers with fine dining fit to rival that of the Ritz on shore. On the night of the sinking, passengers Mr and Mrs George Widener hosted an exclusive dinner party for Captain Smith. Among the passengers attending were the Carters, the Thayers and Major Archibald Butt.

Other First-Class passengers dining elsewhere in the Restaurant included Mr and Mrs Henry B. Harris, Mr and Mrs Jaques Futrelle and Sir Cosmo and Lady Duff Gordon. Bruce Ismay dined with the ship's surgeon, Dr O'Loughlin, and American millionaire Benjamin Guggenheim dined at a private table for two with his mistress, Mlle Pauline Aubart.

Ken Marschall Collection

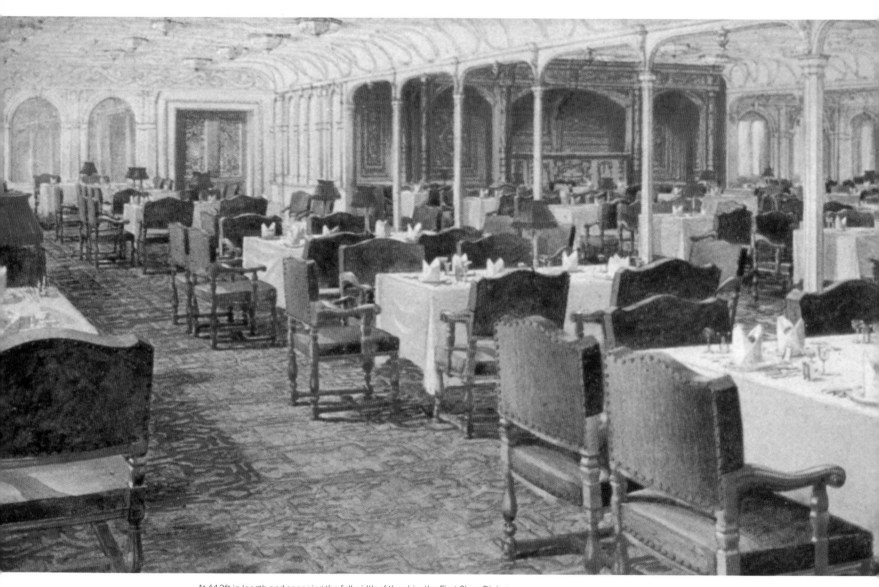

At 113ft in length and spanning the full width of the ship, the First-Class Dining Saloon was by far the largest room afloat at the time, capable of seating 554 passengers in a single sitting. With only 324 First-Class passengers aboard, some of whom dined in the *à la carte* Restaurant, the sparse occupancy of the room was noticed. Despite this illustration showing tables set with lamps, no photographs of *Olympic* or *Titanic* indicate that this was implemented in practice.

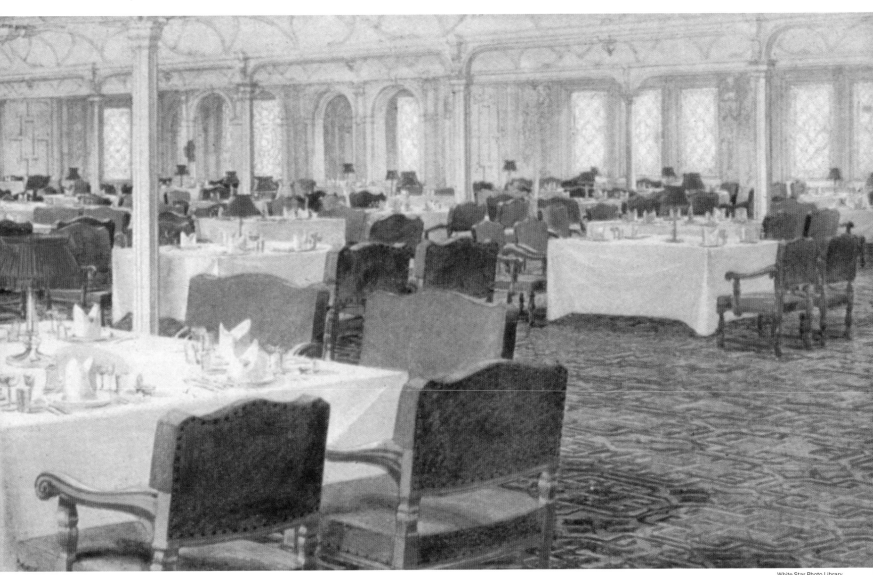

The sitting room of a First-Class parlour suite, decorated in Adams style. Although with a somewhat different layout, a room very much like this was part of the Promenade suite occupied by Mrs Charlotte Cardeza and her son.

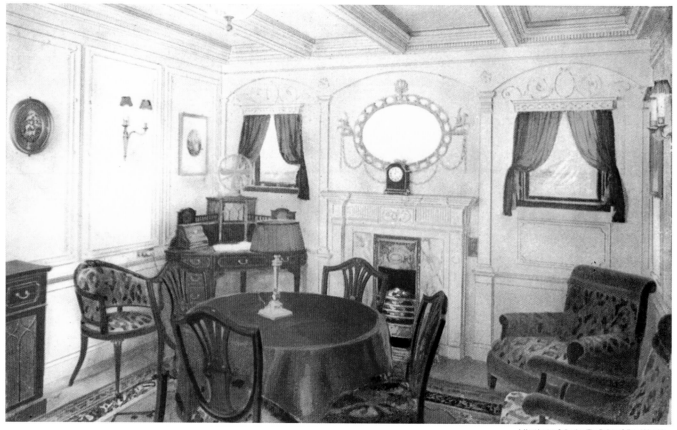

A First-Class stateroom decorated in the Georgian style. A stateroom in this same style was occupied by the Countess of Rothes and her cousin Gladys Cherry. During the sinking, the two ladies initially had trouble finding their life jackets, eventually locating them under their beds where they were stored so as not to detract from the luxury of the room.

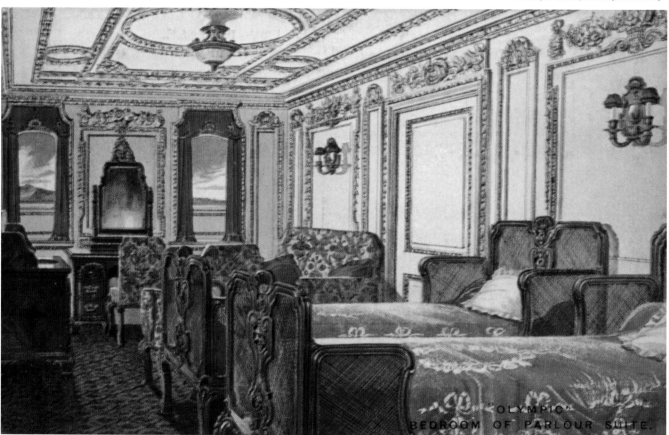

'OLYMPIC'
BEDROOM OF PARLOUR SUITE.

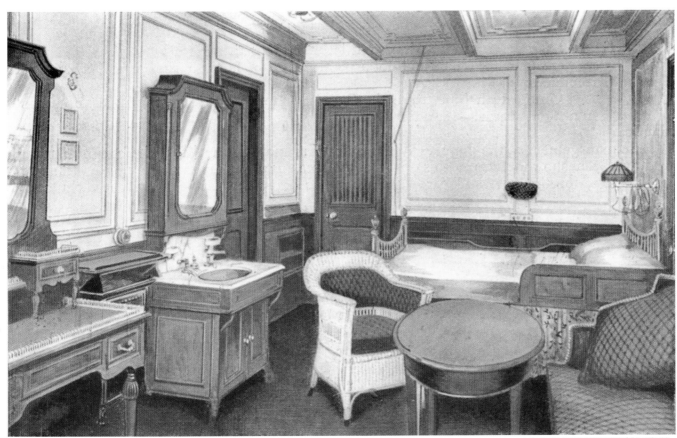

A First-Class 'special stateroom' in Harland & Wolff's 'Modern' style. The room illustrated here is very similar to *Titanic*'s stateroom C87, occupied by London journalist William T. Stead.

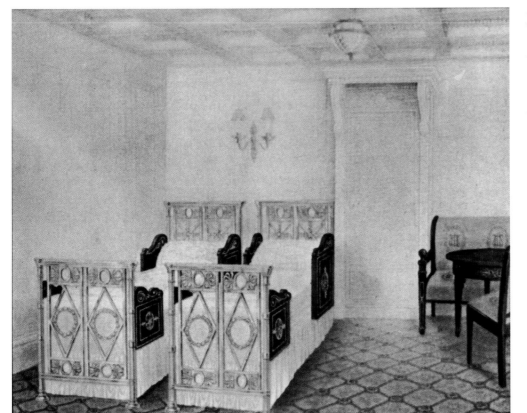

An early illustration showing two brass beds in a First-Class Empire-style stateroom. A room in this style was occupied by the Broadway producer Henry B. Harris and his wife. Fragments of a bed from their stateroom (C83) have been recovered from the debris field.

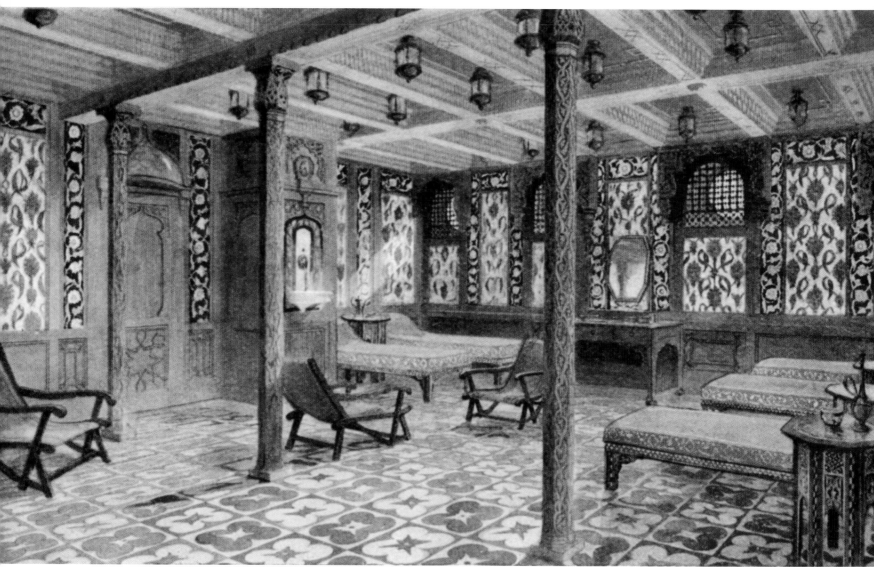

The Cooling Room of the First-Class Turkish Baths, although only one of the rooms that comprised this facility, is where passengers spent most of their time (up to half an hour) wrapped in towels while cooling off at the end of their experience.

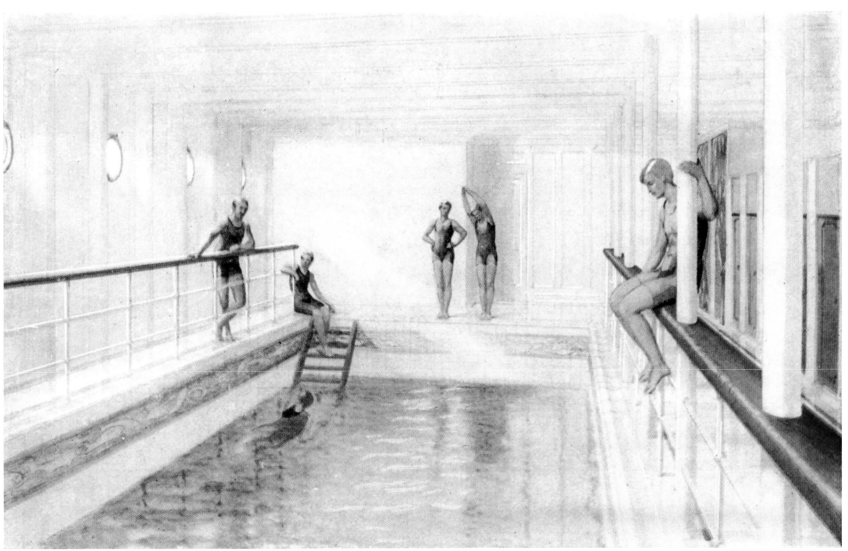

The First-Class Swimming Bath was a rather spartan facility but still a luxury at the time and a relative novelty. It proved extremely popular among passengers; American passenger Norman Chambers made it his daily routine to take a plunge every morning.

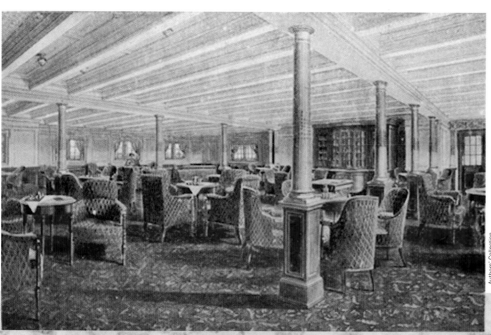

Although this illustration shows the Second-Class Library and Lounge Room empty, it was a hive of social activity aboard *Titanic*.

The Second-Class Dining Saloon was panelled in oak and decorated in a distinctly English style befitting the ship's origin. Unlike the Dining Saloon in First Class, which offered more intimate dining at individual tables, seating here was at long tables typically accommodating eight or ten diners. On the night of 14 April 1912, a small concert was held here and another was also scheduled for the following day.

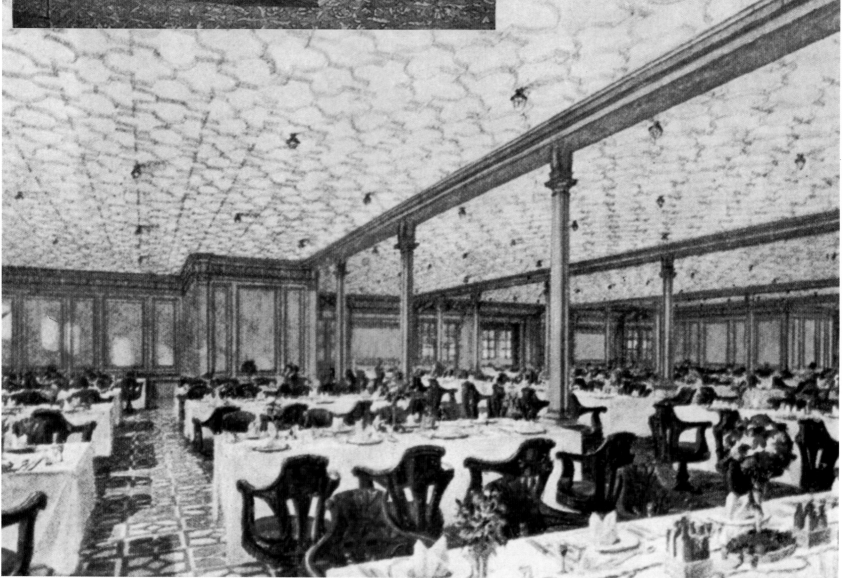

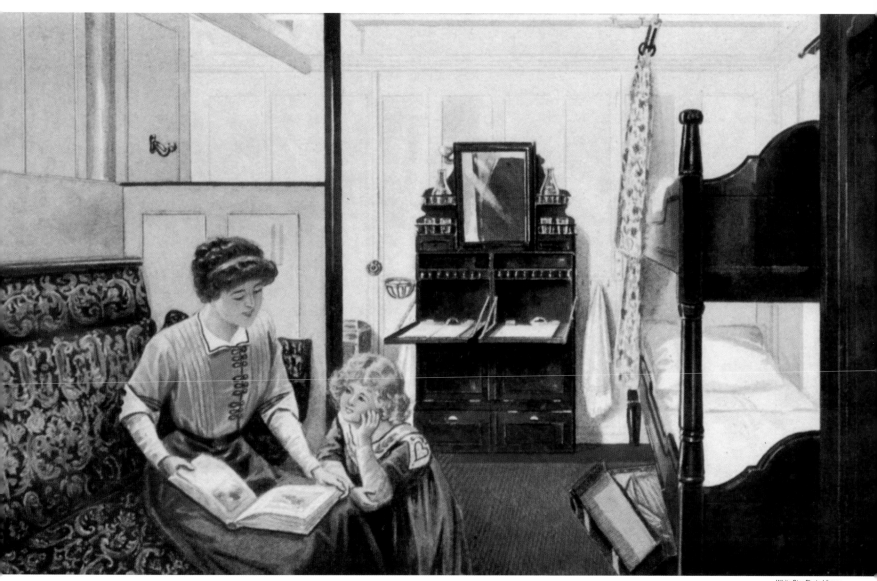

This illustration of an E Deck stateroom shows the comfort afforded to Second-Class passengers. When demand required it, some of these rooms were also used as First-Class accommodations and for that reason were designated 'Second Class/Alternate First Class'. During *Titanic*'s maiden voyage, American First-Class passenger Mrs Compton occupied stateroom E45, which looked just like this.

Although Third-Class accommodations aboard *Olympic* and *Titanic* were basic, they were worlds apart from the conditions emigrants endured in years gone by. Just as in First and Second Class, there was a Smoke Room with a bar for the use of Third-Class male passengers (right), while the women and families (and non-smoking men) could relax in the adjoining General Room (below).

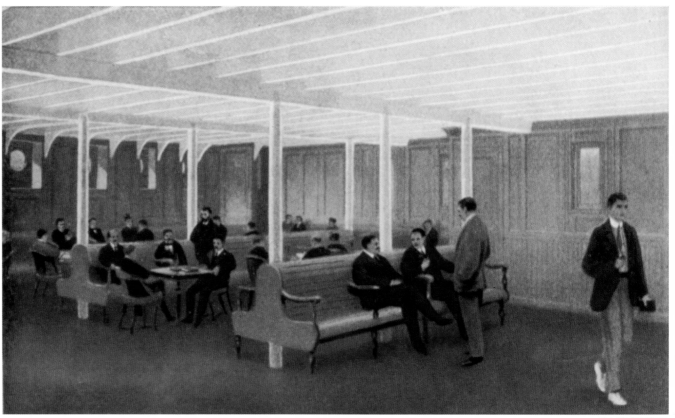

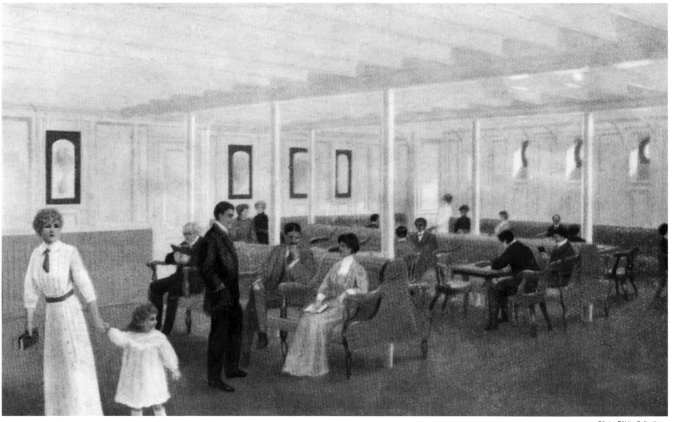

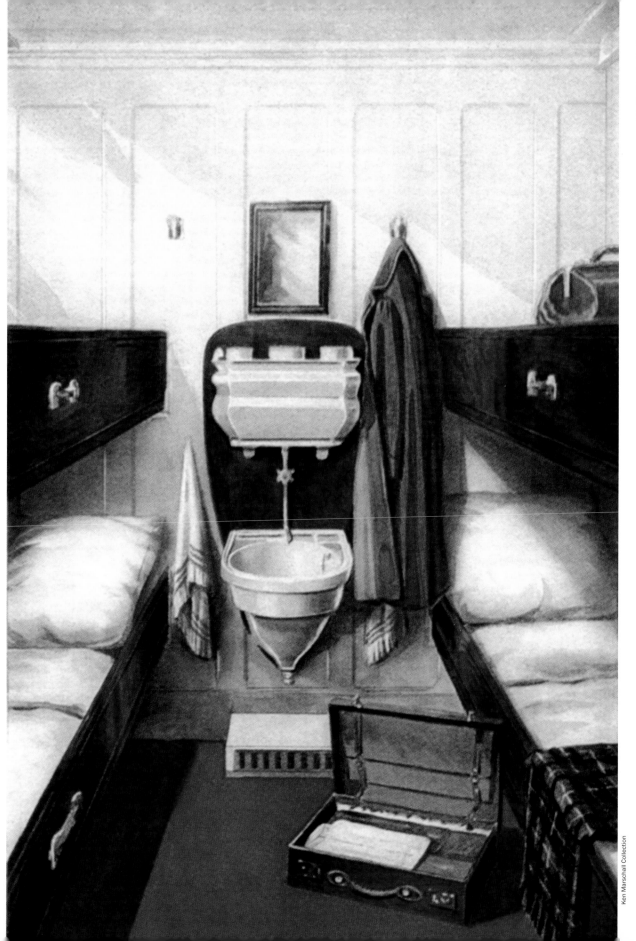

Although utilitarian, Third-Class cabins were clean and comfortable. The room seen here was typical of those in the aft part of the ship, designated for single female passengers and families.

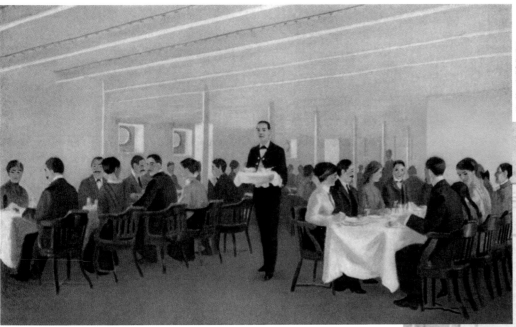

The Third-Class Dining Saloon was located amidships on F Deck and had seating accommodation for approximately 473 passengers at any one time. As such, more than one seating was usually required to feed all the passengers. Divided into forward and after sections by a watertight bulkhead, the Dining Saloon was essentially two separate rooms. The forward room was reserved for women and families, and the after room for single men. Although the decoration was simple, with white enamelled walls and ceilings, as well as exposed litosilo red floors, the Third-Class Dining Saloon was a clean, well-lit facility that was a far cry from what emigrants endured at sea not many years earlier.

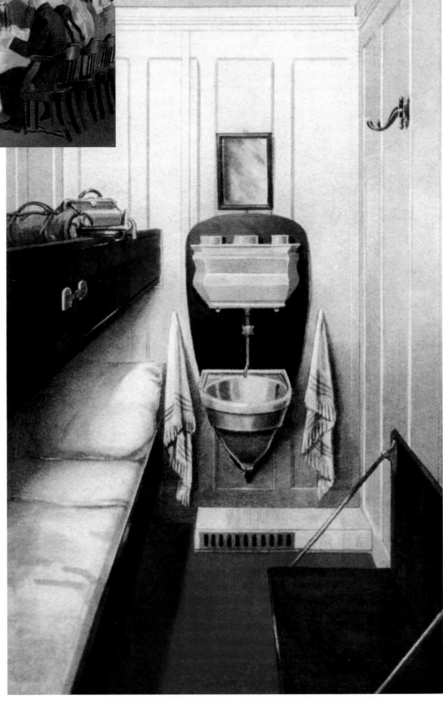

This two-berth Third-Class cabin is also typical of the rooms found in the after part of the ship, as evidenced by the provision of a wash-basin and linens on the bed. Single men were berthed in the forward part of the ship and were among the first to realise the seriousness of the situation after the collision with the iceberg, as water began to fill their rooms.

said, 'We have been outside the breakwater for more than ten minutes, Sir.' So gentle was the motion of the ship that none could notice its movement.

After dinner, we sat in the beautiful lounge listening to the White Star orchestra playing 'The Tales of Hoffman' and 'Cavalleria Rusticana' selections, and more than once we heard the remark 'You would never imagine you were on board a ship'.

Late the following morning, Thursday 11 April 1912, *Titanic* approached the Irish coast. After passing the Daunt Rock Lightship, she altered course and slowed to pick up Pilot John Whelan, whose four-man crew had rowed him out to meet her. With the water in the harbour approach too shallow for *Titanic*, she would anchor about a mile off Roche's Point. From the quay at Queenstown 4 miles away, the tenders *America* and *Ireland* carried three First-Class, seven Second-Class and 113 Third-Class passengers as well as 1,385 bags of mail.

Arriving in Queenstown early that day in great anticipation was a man from the *Cork Examiner*. This was photographer Thomas Barker who had watched *Titanic* almost from conception – he witnessed her launched and was there as *Titanic* was nearing completion when Belfast erupted in riots. Now, equipped with a brand new set of twelve glass plates, he made his way to Queenstown and would subsequently use all his plates to capture *Titanic*'s maiden call at the Irish port, her last before the long transatlantic crossing to New York. Watching *Titanic* steam into the harbour as the two tenders approached, Barker later recalled:

> As one saw her steaming slowly, a majestic monster floating it seemed irresistibly, into the harbour, a strange sense of might and power pervaded the scene. She embodies the latest triumphs in mercantile engineering and although a sister ship of the *Olympic*, is an improvement in many respects on the latter.

At 11.55a.m. *Titanic* slowed to a stop off Roche's Point and dropped anchor around 12.15p.m. Shortly therafter, the tender *Ireland* came alongside *Titanic*'s starboard-side E Deck gangway door, bringing ten First- and Second-Class passengers, onlookers and a quantity of mail. As the tenders approached, a black figure appeared atop the ship's fourth funnel. Unaware that the last funnel was not connected to the boilers, many passengers were disconcerted by the appearance of this spectral figure who was merely a stoker who had climbed the ladder from the engine spaces below to see the view. Many considered his appearance

a bad omen. Meanwhile, the tender *America* rounded *Titanic*'s stern and came alongside the port-side E Deck gangway door bringing Third-Class passengers, onlookers and the remainder of mail bags. Several bags carrying the last letters and postcards sent by passengers on board would also be offloaded here, and seven overnight passengers would disembark. Among them was Frank Browne, who had spent the time during the trip between Southampton and Queenstown touring the ship and taking photos. Little did he know at the time that he was recording rare moments in history with his camera.

With 324 First, 284 Second, 709 Third-Class passengers and 891 crew aboard her, at 1.55p.m. *Titanic* finally weighed anchor. The two tenders pulled away from the ship and *Titanic* slowly turned through a half circle and steamed out to sea. Lawrence Beesley would later remember:

> In our wake soared and screamed hundreds of gulls, which had quarrelled and fought over the remnants of lunch pouring out of the waste pipes as we lay-to in the harbor entrance; and now they followed us in the expectation of further spoil.

Bound for the New World and the promise of a new future for many of her immigrants, all afternoon *Titanic* steamed along the south-west coast of Ireland. As dusk fell, the coast disappeared astern, and the last *Titanic* saw of Europe was Ireland's green hills. Despite passing numerous ships on her voyage, the last known photographs taken of the great ship are of *Titanic* leaving Queenstown. Many passengers aboard also had their own cameras and would have recorded images of the voyage, but none of these photographs are known to have survived.

Across the Atlantic, plans for the White Star liner's arrival some six days hence were well known and countless photographers, both professional and amateur, would have been anticipating the event. Some of the best-known photographers and photo studios in New York at the time were Edwin Levick, father and son duo Joseph and Percy Byron, Underwood & Underwood, and numerous press agencies – all of whom had previously taken photographs of *Olympic*. Amateur photographers would have anticipated shooting the liner's arrival as well, whether from the shore or the windows of Manhattan's many skyscrapers. However, fate would intervene and their cameras would capture not the triumphant arrival of the world's newest and most famous ship, but tragic scenes of *Titanic*'s lifeboats and her survivors arriving aboard the *Carpathia* on a rainy, windswept night. ★

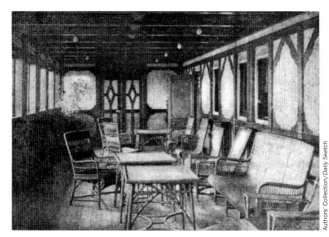

Boarding the ship shortly after 9.00a.m. on 10 April 1912, the *Newspaper Illustrations Ltd* photographer took the above photograph first. This private promenade, part of the port-side promenade suite B52, 54 and 56, would be occupied by Joseph Bruce Ismay who would board shortly at 9.30a.m.

The starboard private promenade suite (B51, 53 and 55) was occupied by American millionairess Charlotte Cardeza, together with her son, Drake Martinez Cardeza. As they would board at Cherbourg, the suite was open for inspection by the press and the *Illustrations Bureau* photographer took advantage of the opportunity (above left).

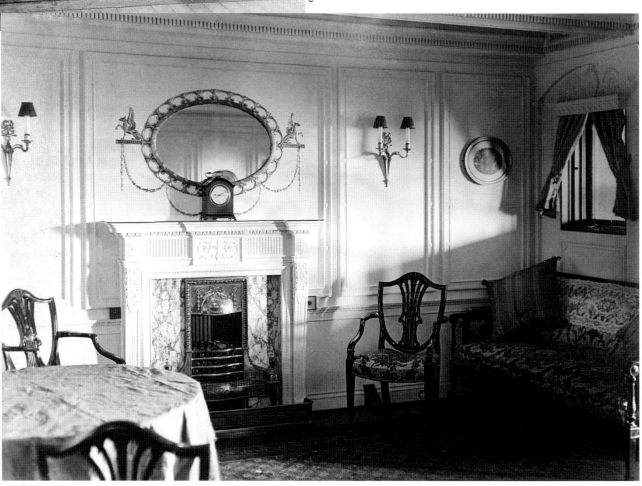

As his counterpart photographed the private promenade, the *Newspaper Illustrations Ltd* photographer stepped into the Sitting Room (B51), which was decorated in Adams style (right). The clock on the mantel above the fireplace shows the time this picture was taken, 9.10a.m.

White Star Photo Library

98

With a special tour for the press organised for 9.30a.m., the men are directed to wait on the A Deck promenade near the aft grand staircase. As they wait, the *Illustration Bureau* photographer takes this photo around 9.25a.m.

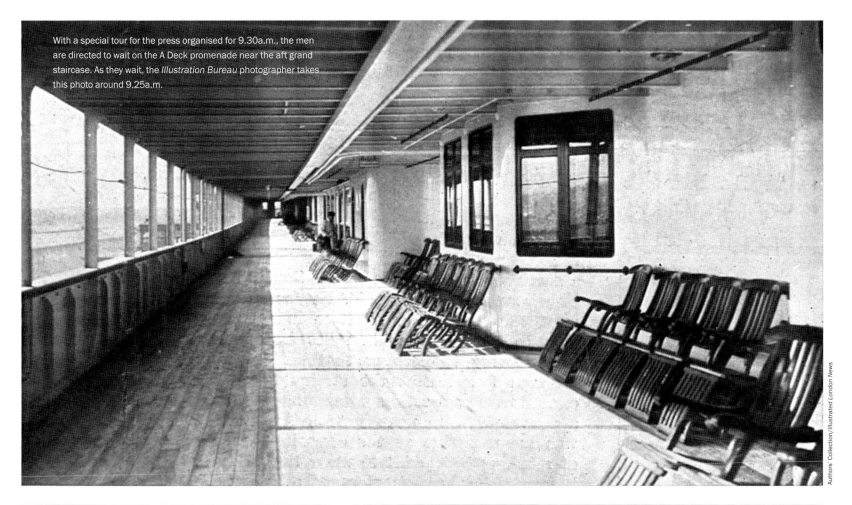

Authors' Collection/*Illustrated London News*

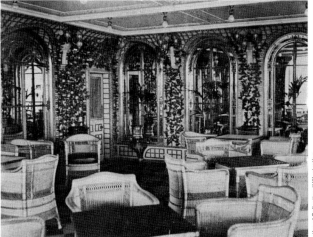

Authors' Collection/*L'Illustration*

The *Newspaper Illustrations Ltd* photographer took this photo of the starboard Verandah Café around 9.30a.m. This was the non-smoking side of the two cafés and passengers later recalled that some of the First-Class children, such as six-year-old Robert Douglas Spedden and two-year-old Lorraine Allison, played here.

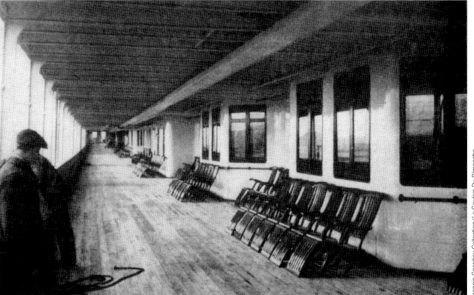

Ioannis Georgiou Collection/*Le Gaulois Du Dimanche*

Coming back to rejoin the group, the *Newspaper Illustrations Ltd* photographer found several of the journalists congregated by the rail, having recently arrived by the first Boat Train.

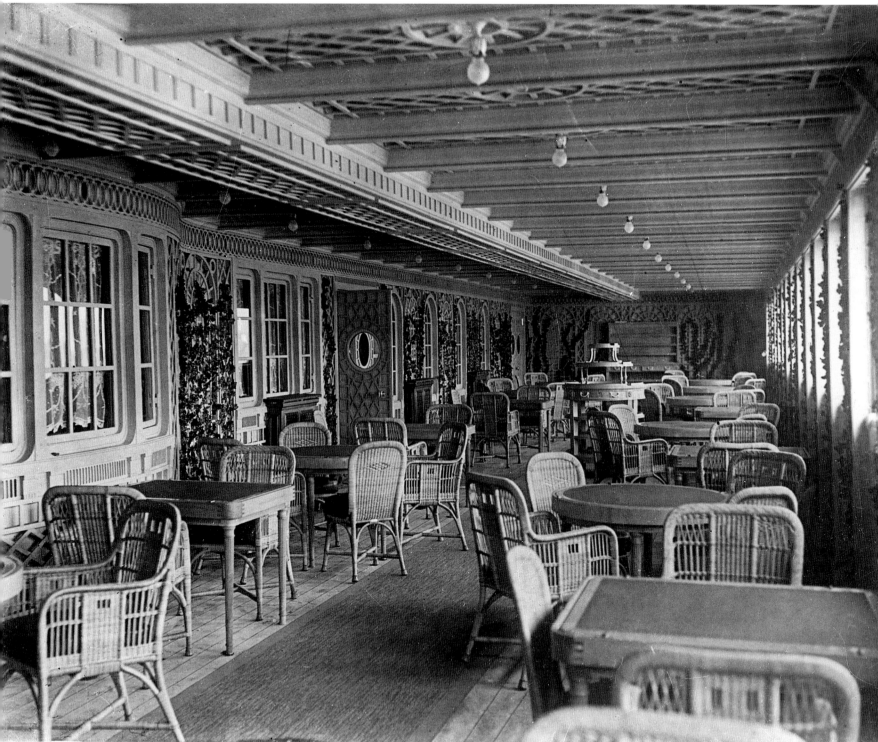

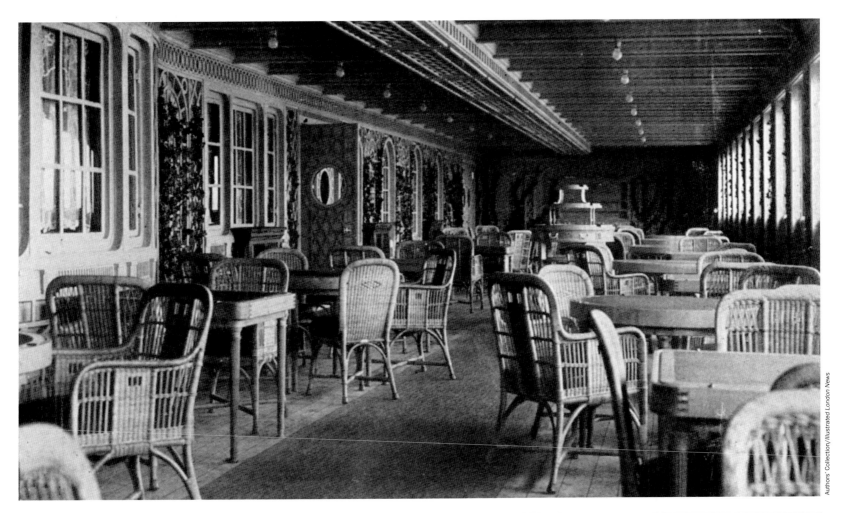

Authors' Collection/Illustrated London News

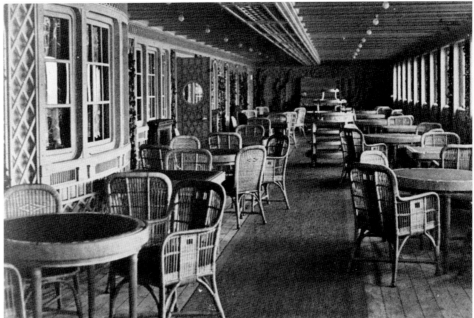

Authors' Collection/L'Illustration

The group of journalists and press photographers were soon met by a White Star Line representative and taken on a tour of *Titanic*. Images of the Café Parisien were captured by all three photographers: *Illustrations Bureau* (opposite), *Central News* (above) and *Newspaper Illustrations Ltd* (right).

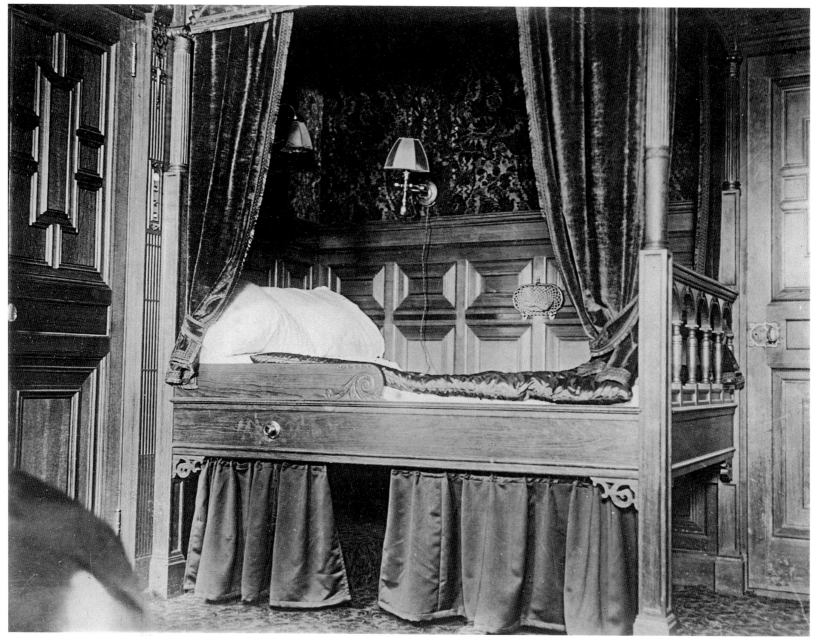

Brown Brothers

Authors' Collection/*Illustrated London News*

The appeal of First-Class stateroom B59, with its Old Dutch design, is evidenced by the fact that this was by far the most photographed stateroom aboard *Titanic*. Although the doona and pillows look as if an occupant recently lay there, most likely the reporters tried out the bed as this stateroom is not known to have been occupied. Photographs are from the *Illustrations Bureau* (above), *Central News* (left), and *Newspaper Illustrations Ltd* (opposite, above left).

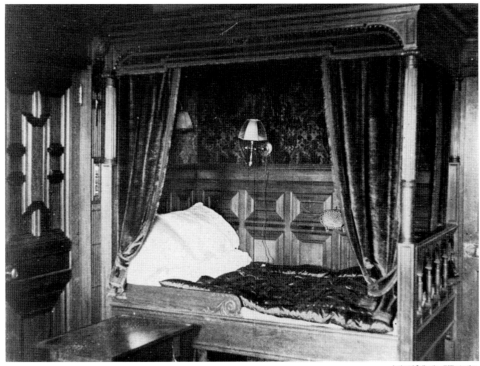

While the other photographers devoted their attention to photographing B59, the *Newspaper Illustrations Ltd* photographer also captured an image of the adjoining stateroom B57 (above), decorated in Modern Dutch.

By 10.30a.m. the press were conducted to the Boat Deck where they were given the opportunity to meet Captain Edward J. Smith. He is seen here standing on the port side, outside the First and Second Officers' cabin windows. Leaves and plant trimmings can be seen on the deck at his feet: these were almost certainly from the palms and other greenery set here by the florists the previous night prior to distributing them throughout the public rooms on the ship. *Newspaper Illustrations Ltd* (below, left), *Illustrations Bureau* (below, middle) and *Central News* (below, right).

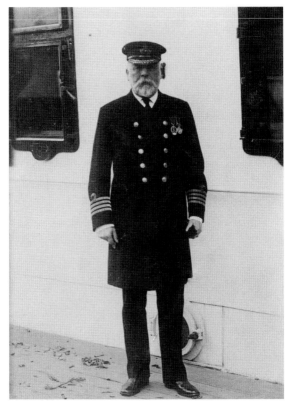

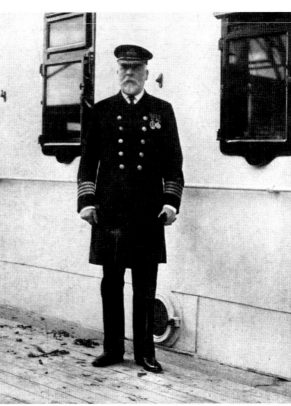

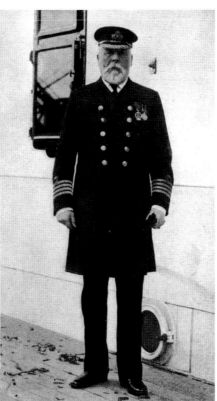

While some of the journalists moved on to the Gymnasium, including the *Illustrations Bureau* and *Central News* photographers, the *Newspaper Illustration Ltd* photographer took this photo of Captain Smith outside *Titanic*'s Navigating Bridge (below and top right). This partial view of the Bridge is the only known image ever taken of this space aboard *Titanic*.

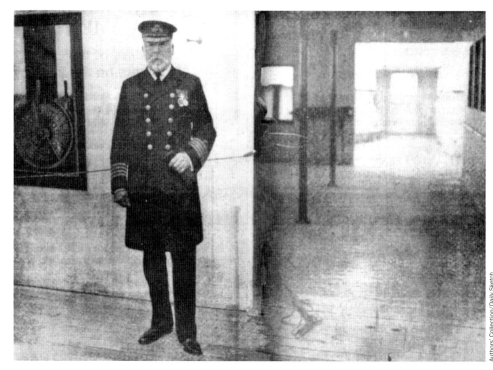

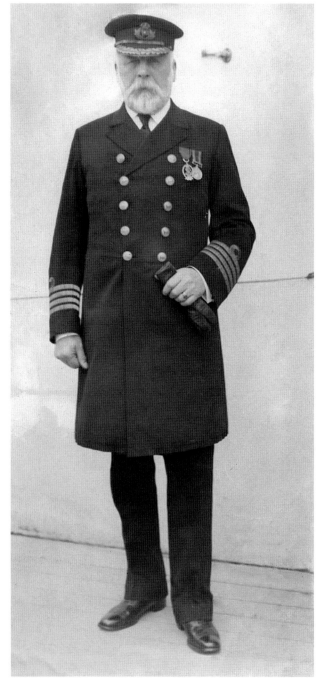

Below is a photograph of the Navigating Bridge on *Titanic*'s sister ship *Olympic*. As both ships were nearly identical, this image illustrates how *Titanic*'s Bridge would have appeared in its entirety.

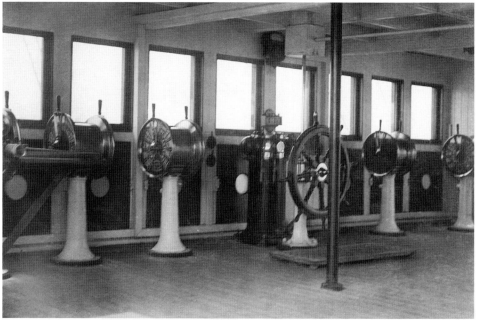

White Star Photo Library

Science & Society Picture Library/Father Browne SJ Collection

Authors' Collection/*Daily Sketch*

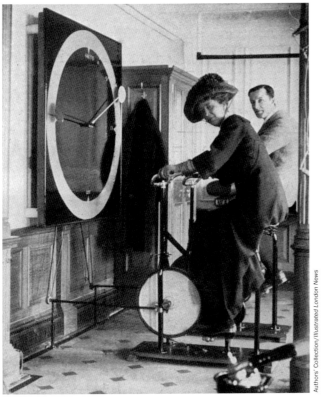

Ken Marschall Collection/*Illustrated Chronicle*

Authors' Collection/*Illustrated London News*

Brown Brothers

Second-Class passengers were allowed to explore First-Class areas prior to sailing and passenger Lawrence Beesley took the opportunity to try out some of the exercise equipment in the Gymnasium. He is seen here (above) with a friend, who came to see him off, trying out the stationary bicycle.

Nineteen-year-old Second-Class passenger Lillian Bentham enjoys a leisurely electrically simulated horse ride. (This machine is frequently misidentified as the electric camel.)

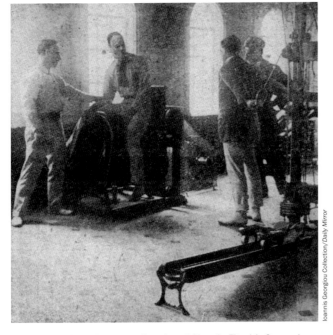

Ioannis Georgiou Collection/*Daily Mirror*

White Star Photo Library

Although the photo above was taken aboard *Olympic*, *Titanic*'s Gymnasium would have presented a similar scene before sailing.

A rare photo of racquet court attendant Fred Wright, seen here in *Olympic*'s Squash Court. During the sinking, First-Class passenger Colonel Archibald Butt, aide to US President Taft, joked with Wright that perhaps they should cancel their appointment for the following day. By that point the Squash Court was underwater.

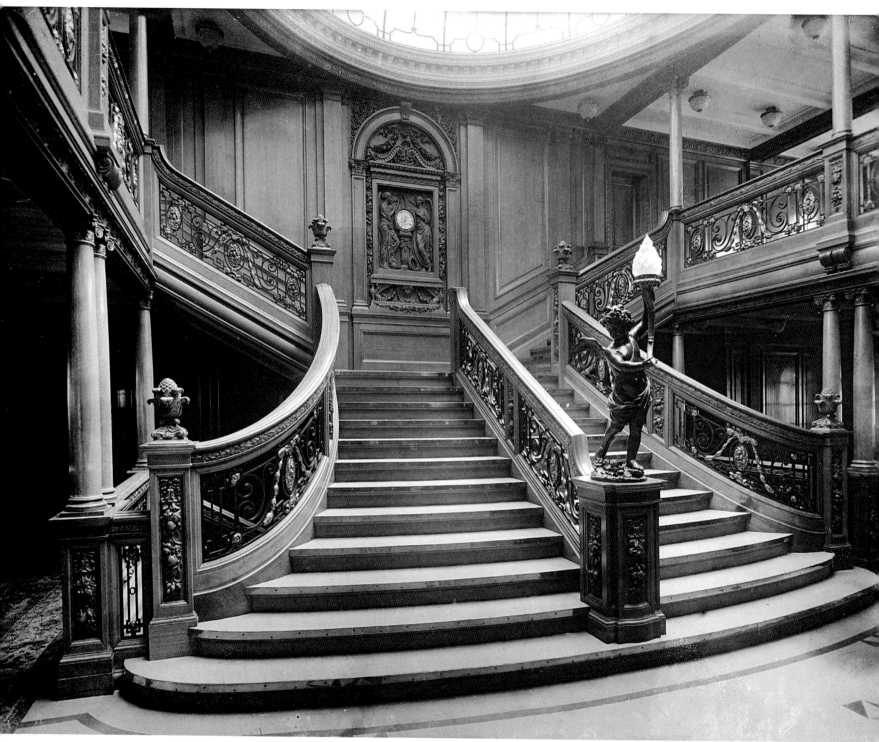

No photos of *Titanic*'s grand staircase are known to exist. This photo, taken aboard *Olympic* around 1912, conveys the feel of how *Titanic*'s staircase would have looked.

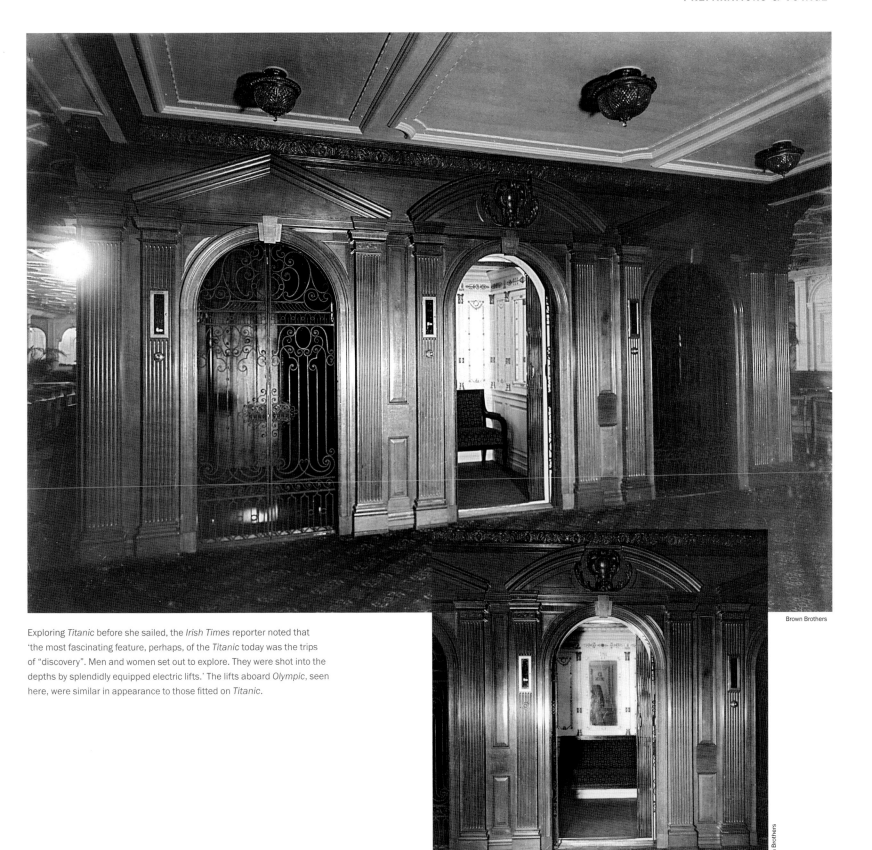

Brown Brothers

Exploring *Titanic* before she sailed, the *Irish Times* reporter noted that 'the most fascinating feature, perhaps, of the *Titanic* today was the trips of "discovery". Men and women set out to explore. They were shot into the depths by splendidly equipped electric lifts.' The lifts aboard *Olympic*, seen here, were similar in appearance to those fitted on *Titanic*.

Brown Brothers

Boarding just after 11.30a.m., Frank Browne was struck by the sheer size of *Titanic* and stopped to take this photo, looking aft along the port side. In the distance Second-Class passengers can be seen boarding through a similar gangway at C Deck.

Science & Society Picture Library/Father Browne SJ Collection

Ken Marschall/Father Browne SJ Collection

When Frank Browne finally found his stateroom (A37), it 'proved to be a large and very prettily furnished bedroom, with a small private entrance hall and large bathroom attached.' Impressed, Browne decided to photograph it in its pristine condition before he had the opportunity to unpack and make it 'home' for the next two days. The ghostly figure in the mirror, captured during the time exposure, is of his friend Tom Brownrigg waiting in the hallway.

Science & Society Picture Library/Father Browne SJ Collection

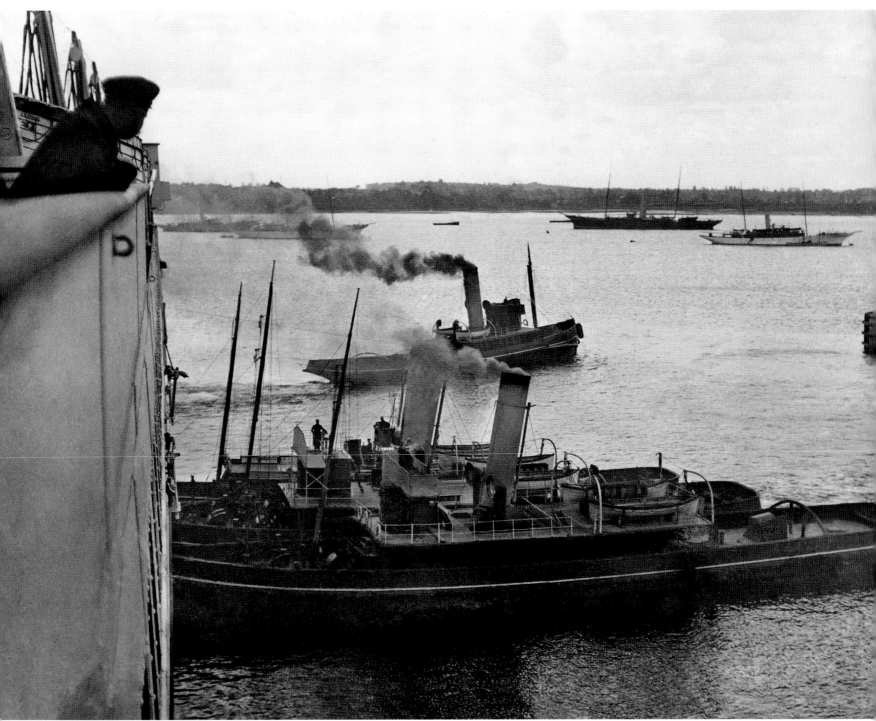

Tugs begin to strain as they pull *Titanic* away from the quay.

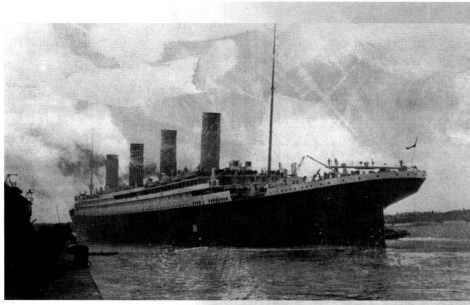

Six tugs slowly move *Titanic* away from her berth and out into the River Test.

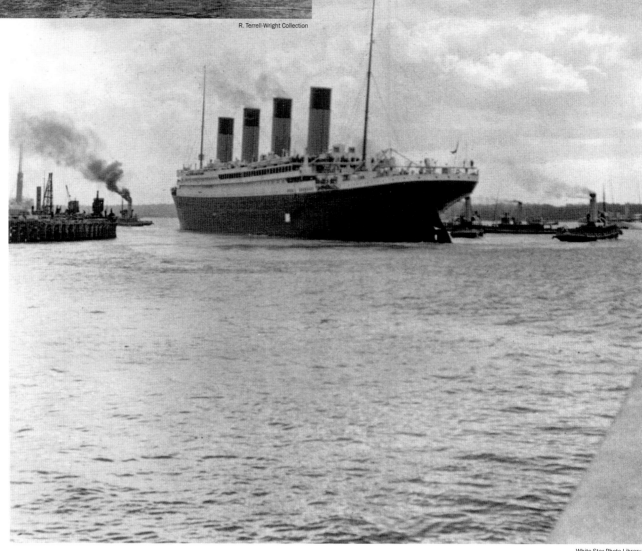

This photo, taken from across the basin at Pier 47, shows *Titanic* having just rounded the corner of Pier 43. The funnels and superstructure of the *New York* can be seen to the extreme left of the photograph. The white square on *Titanic*'s hull is the inside of the open gangway door on E Deck.

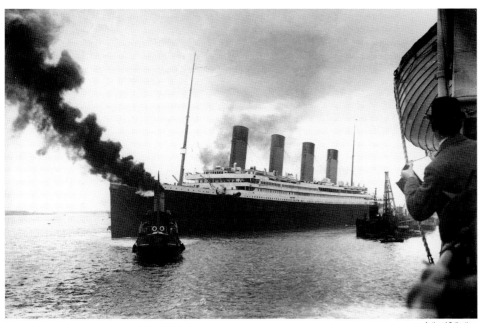

Two images taken from aboard the Houlder Line steamer *Beacon Grange*. A local Southampton photographer by the name of Courtney captured the image on the left as *Titanic* approaches. The man seen holding the camera in the right of this image is the *Illustrations Bureau* photographer from London, who moments later took the photo below.

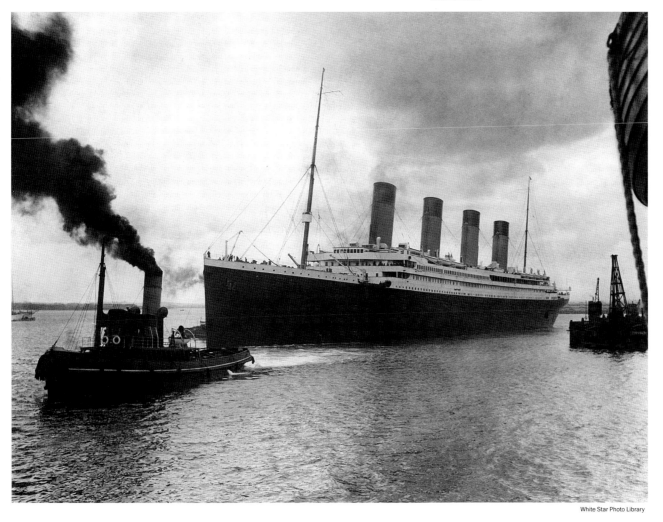

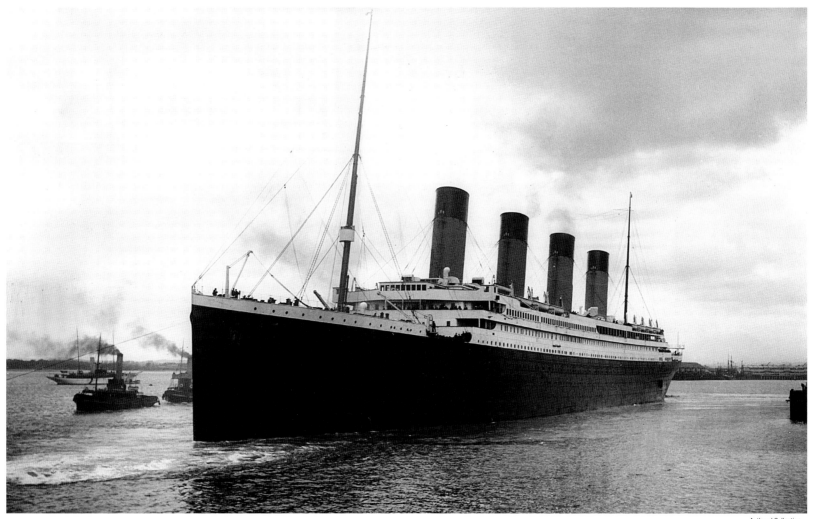

This series of images was also taken from the decks of the *Beacon Grange* as observers, eager to secure the best vantage point to watch *Titanic*, lined the rails. Among these was a *Central News* photographer whose image to the right would be used to produce a popular postcard. Soon, the tugs would cast off their lines and *Titanic* would proceed under her own power.

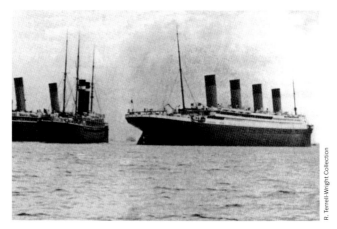

R. Terrell-Wright Collection

A view from across the river as the stern of the *New York* is drawn in towards *Titanic*.

Science & Society Picture Library/Father Browne SJ Collection

The above photograph was taken by Frank Browne from *Titanic*'s Boat Deck as the near-collision occurred.

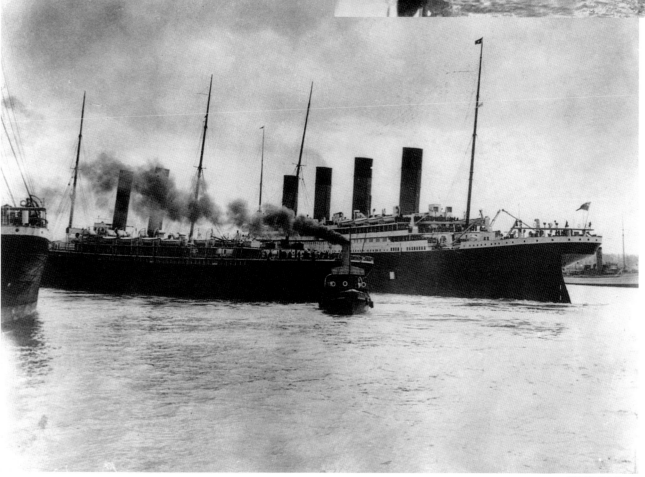

White Star Photo Library

As the crowds watch in disbelief, the *New York* drifts ever closer to *Titanic* until it appears a collision is imminent. The *Central News* photographer captured this image (left) as the tug *Vulcan* managed to get a line aboard and pull her away from *Titanic*. Heavy smoke pours from the tug's funnel as her engineers force every last ounce of steam her boilers can produce.

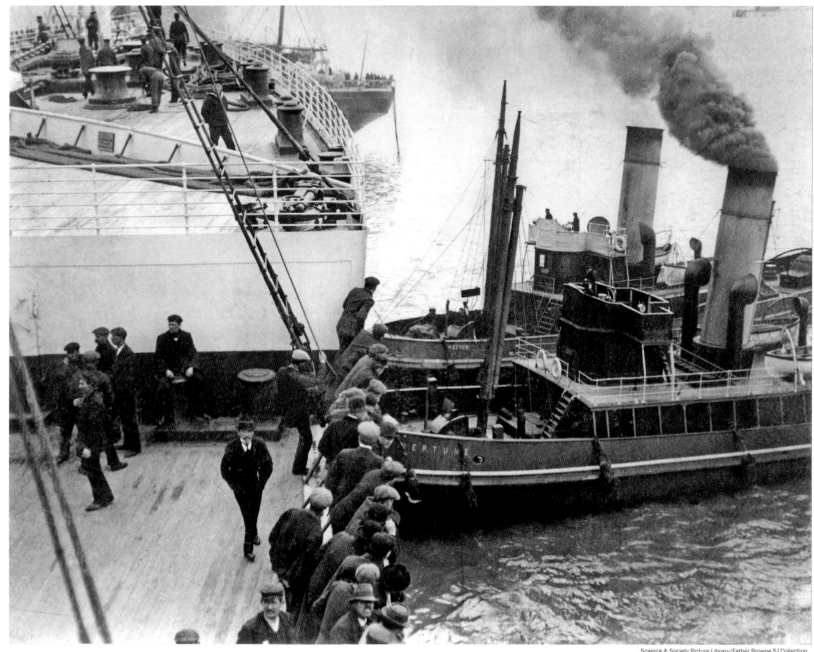

After narrowly averting a collision, *Titanic* was reversed as far back as the entrance to the pier she had just left in order to allow enough room for the tugs to manoeuvre the *New York* to a more secure location. Browne snapped this image of *Titanic*'s fo'c'sle as Third-Class passengers watch the tugs that helped avert the collision. In the background, the *New York*'s stern can be seen swinging across *Titanic*'s bow as she is moved to a new mooring at pier 37.

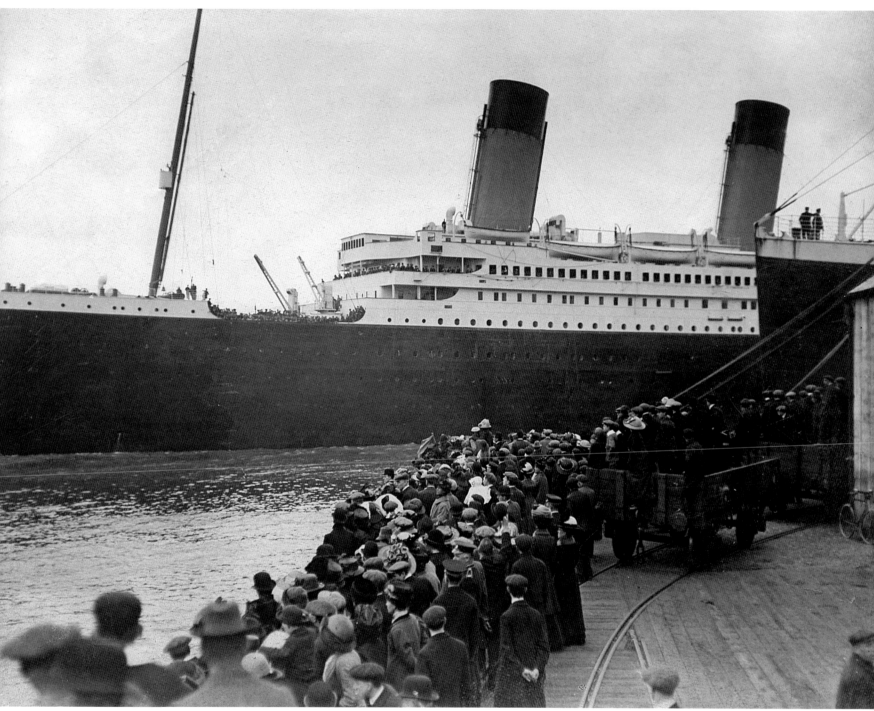

With the collision avoided, *Titanic* resumes her journey and steams past the *Oceanic*, whose bow can be seen here on the right in this image taken by the *Newspaper Illustrations Ltd* photographer. Out of view to the left, the *New York* is temporarily moored in her new berth.

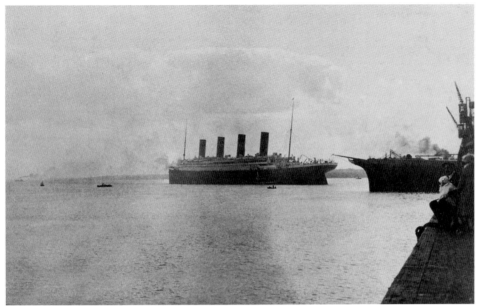

R. Terrell-Wright Collection

Ioannis Georgiou Collection

Titanic leaves the Southampton docks with the bow of the *New York* visible to the right (above). Note the small boat in the water at *Titanic*'s stern: the man standing up is likely the photographer who took the photo of *Titanic* departing with a tug alongside (above, right).

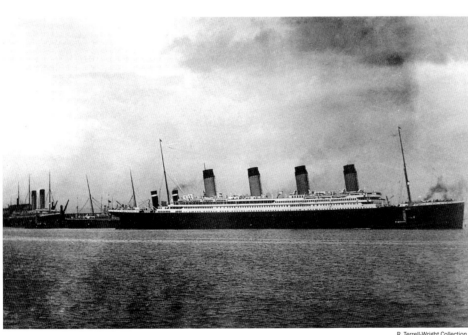

R. Terrell-Wright Collection

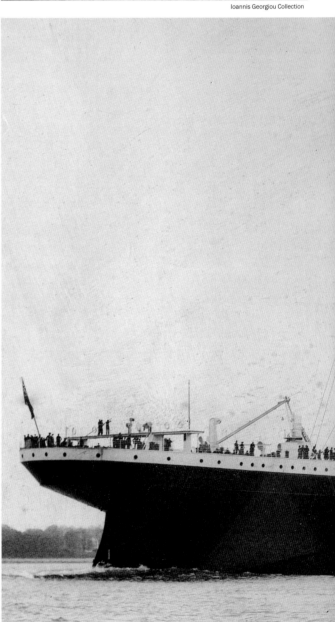

With the *New York* safely out of the way, *Titanic* begins going ahead once more. The tugs no longer required and their lines cast off, they lose way and fall astern (above and opposite, top).

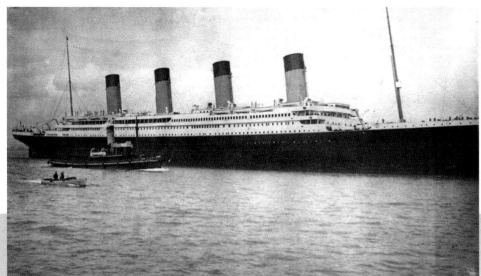

R. Terrell-Wright Collection

As *Titanic* proceeds down Southampton Water she passes a number of smaller craft, offering a perfect comparison to her enormous size. In the photo below note the position of the starboard anchor; during the near-collision with the *New York* Captain Smith had ordered it lowered to the waterline in case it had to be deployed to help stop the ship's forward motion.

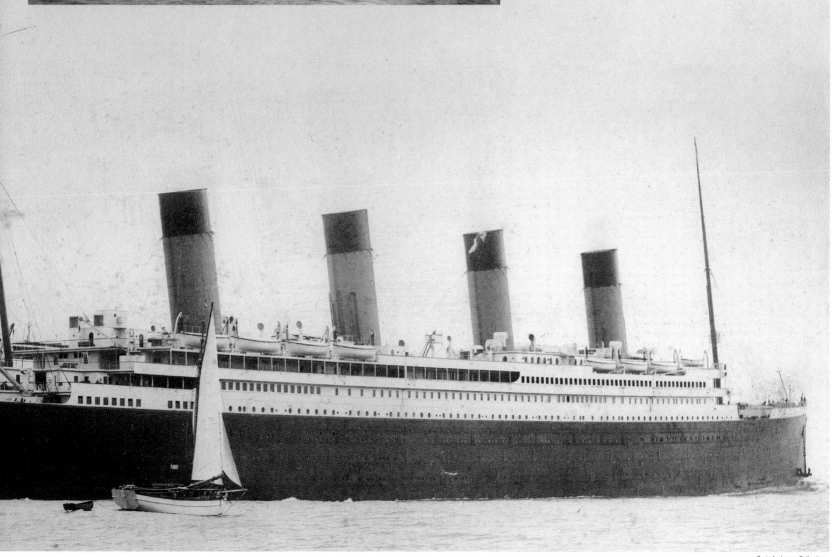

Craig Andersen Collection

This series of photographs was taken as *Titanic* was heading down the Solent, her First-Class decks temporarily deserted as lunch was being served. (The image on the opposite page was mounted in a circular mat to give the appearance of being viewed from the porthole of another ship.)

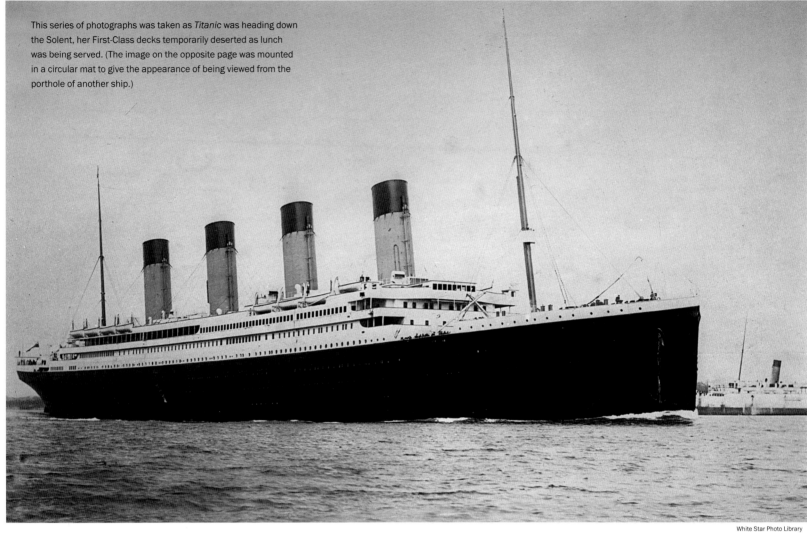

White Star Photo Library

Nearly all photos of *Titanic* proceeding down the Solent were taken from her starboard side. This rare view was taken from her port side.

George Behe Collection

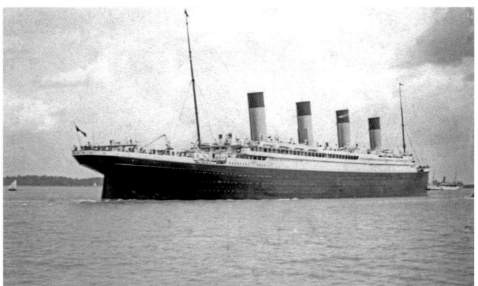

R. Terrell-Wright Collection

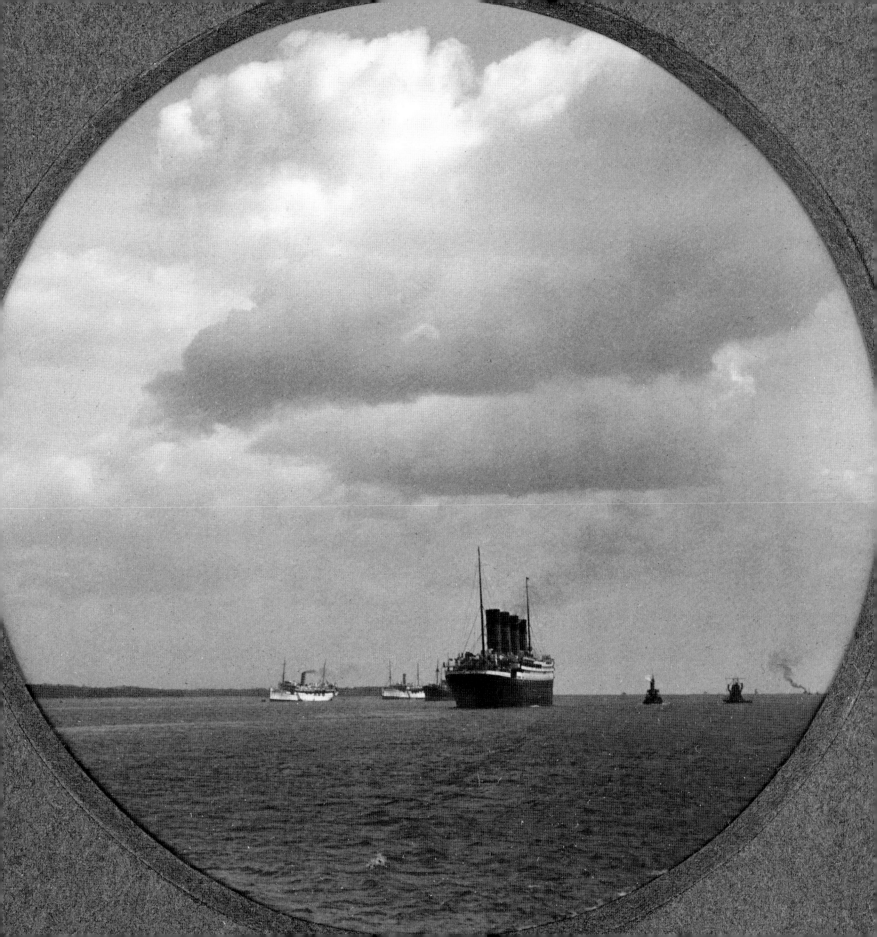

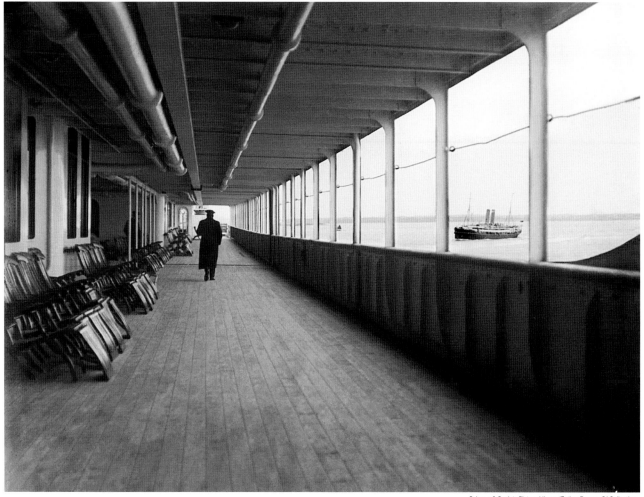

This image was taken looking aft along the port side of the Promenade Deck. The passenger strolling aft along the deck is frequently identified as Captain Smith. However, with *Titanic* negotiating a turn at the time and still under pilot, it would have been unthinkable for Smith to leave the Bridge. In the background is the RMS *Tagus*, a passenger and cargo liner built in 1899 for the Royal Mail Steam Packet Company for service between Southampton and the West Indies.

As *Titanic* was passing the Isle of Wight, Frank Browne had an unusual exchange with a fellow First-Class passenger, who had mistaken the land mass for the French coast. Browne corrected the man who, a little embarrassed, drifted away. This man was the American author Jacques Futrelle, whom Browne later photographed here outside the Gymnasium.

Science & Society Picture Library/Father Browne SJ Collection

On the left, Frank Browne photographed the forward end of the A Deck promenade, where fellow cross-Channel passenger Jack Odell stood at the rail and Major Archibald Butt talked with a group of people in the background. The seaman standing watch over this part of the deck is believed to be Quartermaster Alfred Olliver, who would be the standby quartermaster on the Bridge when *Titanic* collided with the iceberg.

Science & Society Picture Library/Father Browne SJ Collection

Science & Society Picture Library/Father Browne SJ Collection

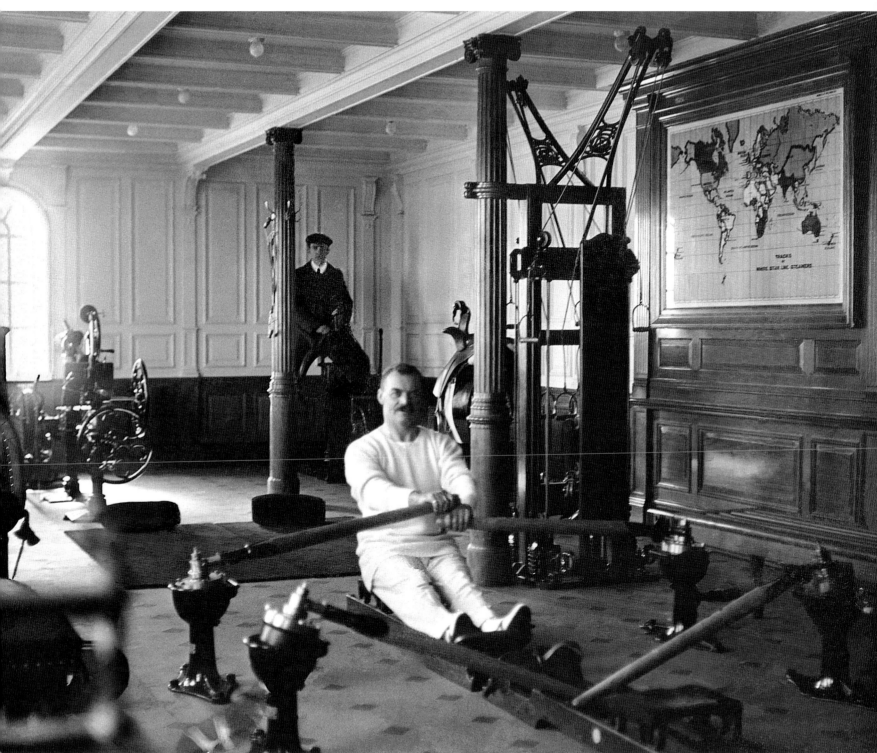

Inside the Gymnasium, attendant Thomas McCawley (whose business card identified him as a 'Physical Educator') was demonstrating the various exercise devices in his domain. In this image, William Parr of the Harland & Wolff Guaranty Group (representing the Electrical Department) is sitting on the 'electrical horse'.

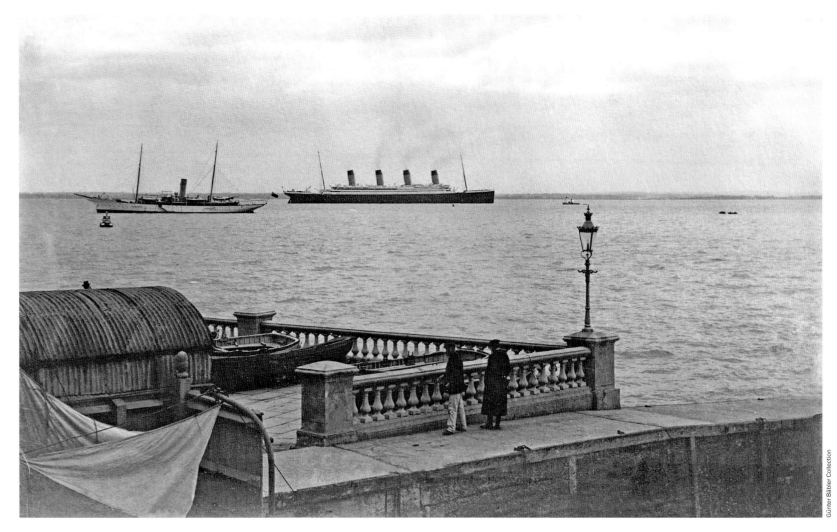

Günter Bäbler Collection

A superb view of *Titanic* passing Cowes as people watch from the Esplanade (above). Behind the corrugated shed a man's head can be seen – this is likely the Debenham photographer in the process of capturing the image below, while one of the small boats seen in the water is likely that of noted marine photographer Frank Beken, who captured the image on the left around the same time. With lunch over, *Titanic*'s decks are again filled with passengers.

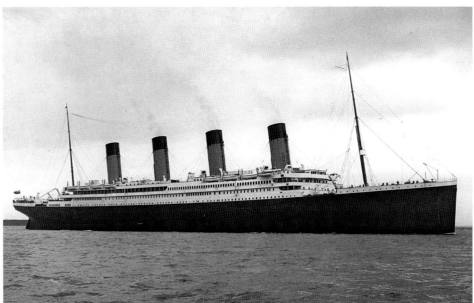

Authors' Collection

Ken Marschall Collection

Looking aft along the port-side rail, Frank Browne photographed what he noted in his album as 'the pilot boat coming to take the pilot'. The ketch about to cross *Titanic*'s wake is one of the Isle of Wight pilot boats, identifiable by the large number on its sail (I.W. No.1). The pilot would have most likely disembarked via the forward E Deck gangway door on the starboard side and would have been picked up by a small rowboat called a boarding punt which, in turn, would have been picked up by the ketch. By the time Browne took this photo the pilot would already be in the punt out of sight to starboard as *Titanic* began increasing speed. Despite the use of steam propulsion for large passenger ships, the Isle of Wight pilots were still in ketches in 1912. The lifeboat in the foreground is Lifeboat No.10 with its company flag plate, home port plate and draft plates clearly visible. Far astern of *Titanic* is No Man's Land fort, one of three built in the Solent between 1867 and 1880 to guard the approach to Portsmouth.

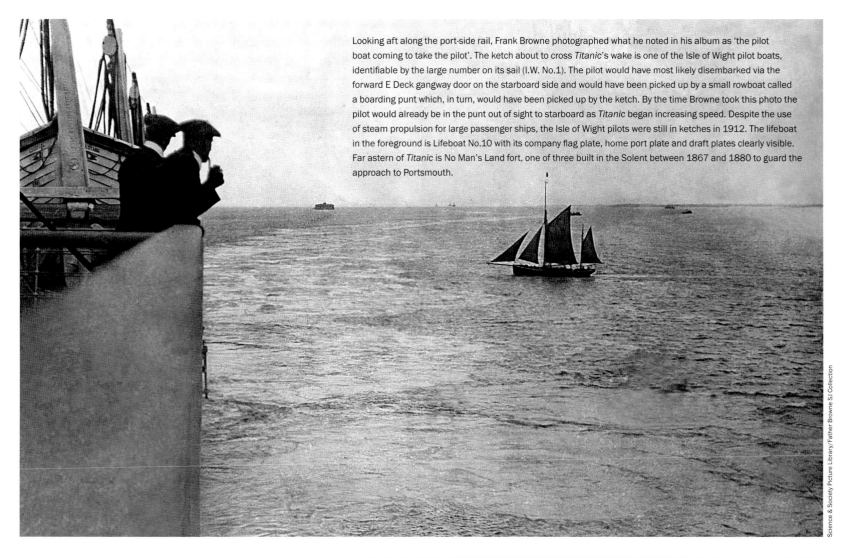

Science & Society Picture Library/Father Browne SJ Collection

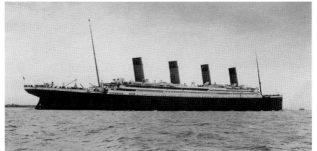

Günter Bäbler Collection

As *Titanic* approaches the open waters of the English Channel, the water is calm and she makes very little wake.

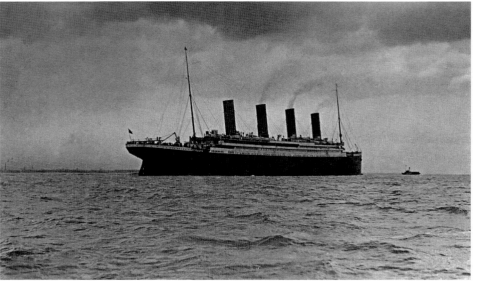

Günter Bäbler Collection

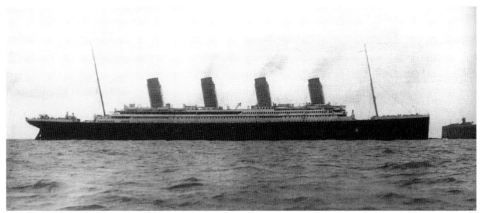

R. Terrell-Wright Collection

Titanic reached Cherbourg just before dusk, with just enough light remaining to photograph her arrival. As night fell, *Titanic* presented a glittering sight with her lights reflecting in the water. In the photo to the left, her E Deck gangway door is open to receive Third-Class passengers and mail which would arrive by the tender *Traffic*. Below, her D Deck gangway door is open to receive First-Class passengers and baggage from the *Nomadic*. These same images were heavily (but inaccurately) retouched in an attempt to illustrate what *Titanic* looked like after dark.

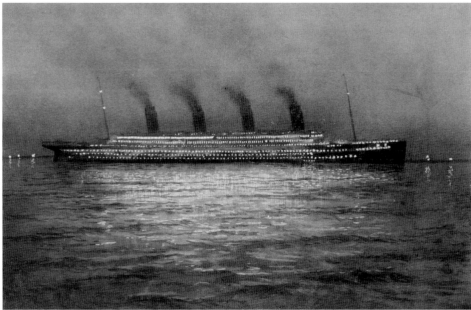

Ioannis Georgiou Collection

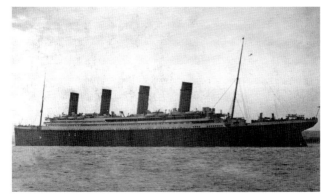

R. Terrell-Wright Collection

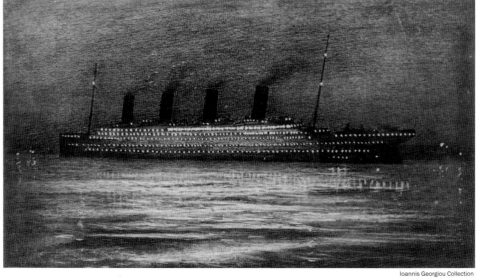

Ioannis Georgiou Collection

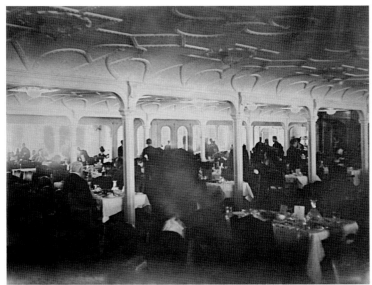

Science & Society Picture Library/Father Browne SJ Collection

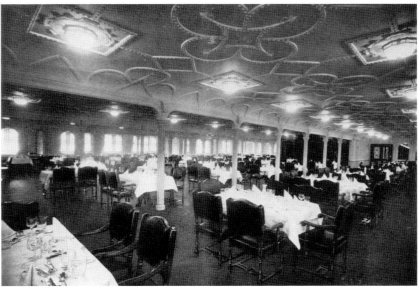

Authors' Collection

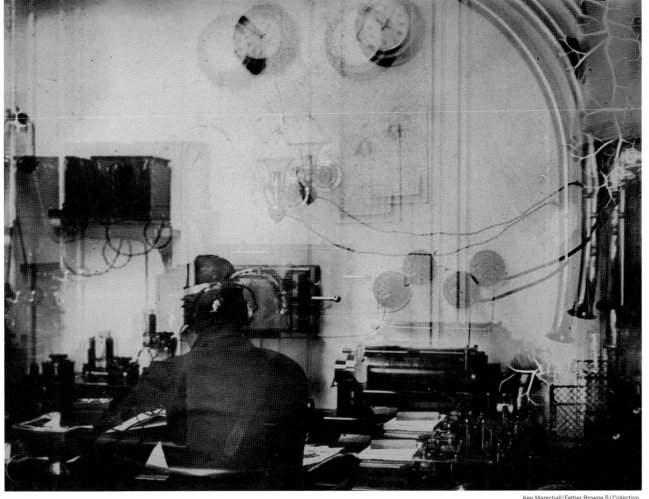

Ken Marschall/Father Browne SJ Collection

The top left image was taken by Frank Browne at breakfast on 11 April 1912 and is the only known photograph of *Titanic*'s First-Class Dining Saloon. The image shows tables set with crystal, fine china, silverware and freshly printed menus. Dining Saloon stewards move about the room while passengers study the menus or await their meals. The image above, taken from an almost identical angle, shows *Olympic*'s Dining Saloon.

This is the only known photo of *Titanic*'s wireless room, taken by Frank Browne in the morning of 11 April 1912 at 10.05a.m. The two Marconi operators, John J. ('Jack') Phillips and Harold Bride, had to work hard to keep up with the huge volume of Marconigrams as passengers took advantage of the still-novel system to send messages to their friends.

As *Titanic* was on her way to Queenstown, Frank Browne took a number of images throughout the morning. On the right, he aimed his camera forward towards the starboard-side Verandah Café as Second-Class passengers look down at him from their promenade area on the Boat Deck.

Science & Society Picture Library/Father Browne SJ Collection

The two passengers seen here aft on the A Deck promenade were merely captioned by Frank Browne as 'First Class'. It is believed this could be cross-Channel passenger Mrs Emily Nichols (who disembarked at Queenstown) and Richard W. Smith, a friend of her husband who was booked through to New York and would have acted as a chaperone to the unaccompanied Mrs Nichols. Smith perished in the sinking.

This is actually an unusual double-exposure image showing traces of the starboard private promenade on B Deck, which Browne probably photographed during the crossing from Southampton to Cherbourg. Unlike on the photo taken by a press photographer before *Titanic* sailed, here the tables can be seen set with flowers. 10 April was Mrs Cardeza's birthday and the flowers are most likely either a thoughtful gesture from the White Star Line or a *bon voyage* gift sent by her friends.

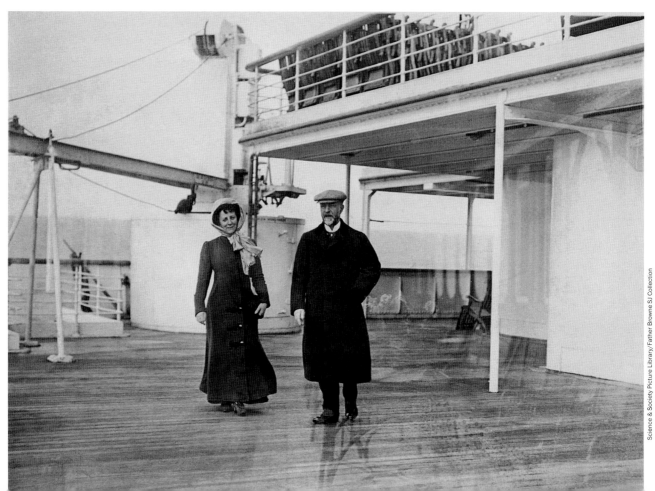

Science & Society Picture Library/Father Browne SJ Collection

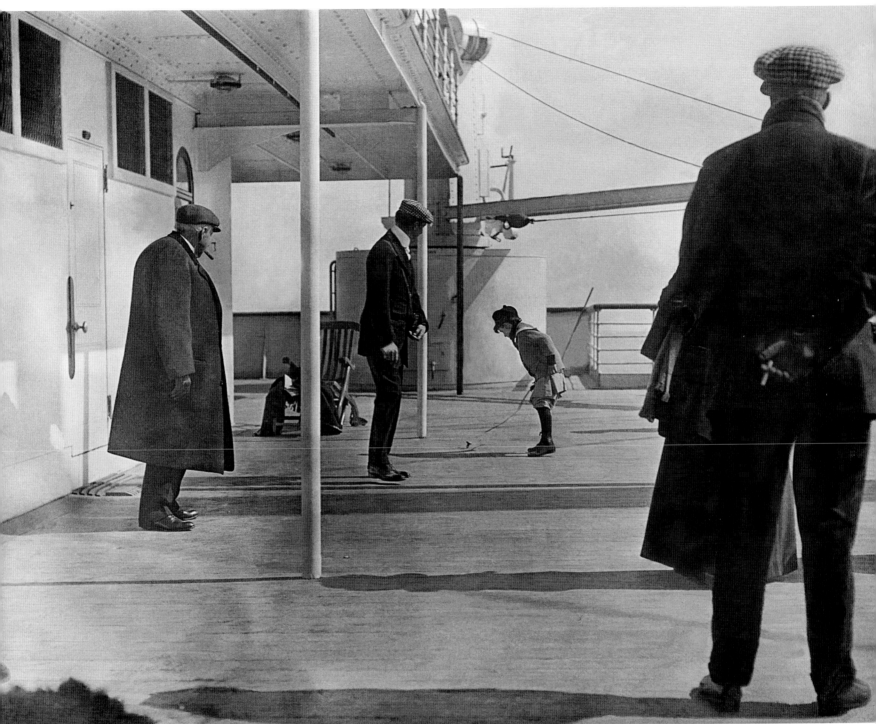

With the sun having emerged from behind the clouds, Frank Browne captured First-Class passenger Frederick Spedden observing his son Robert Douglas spinning a top at the after end of the Promenade Deck while other passengers look on. Three years after this picture was taken, nine-year-old Robert was struck by a car near the family's summer camp in Maine. He later died from injuries sustained in the accident.

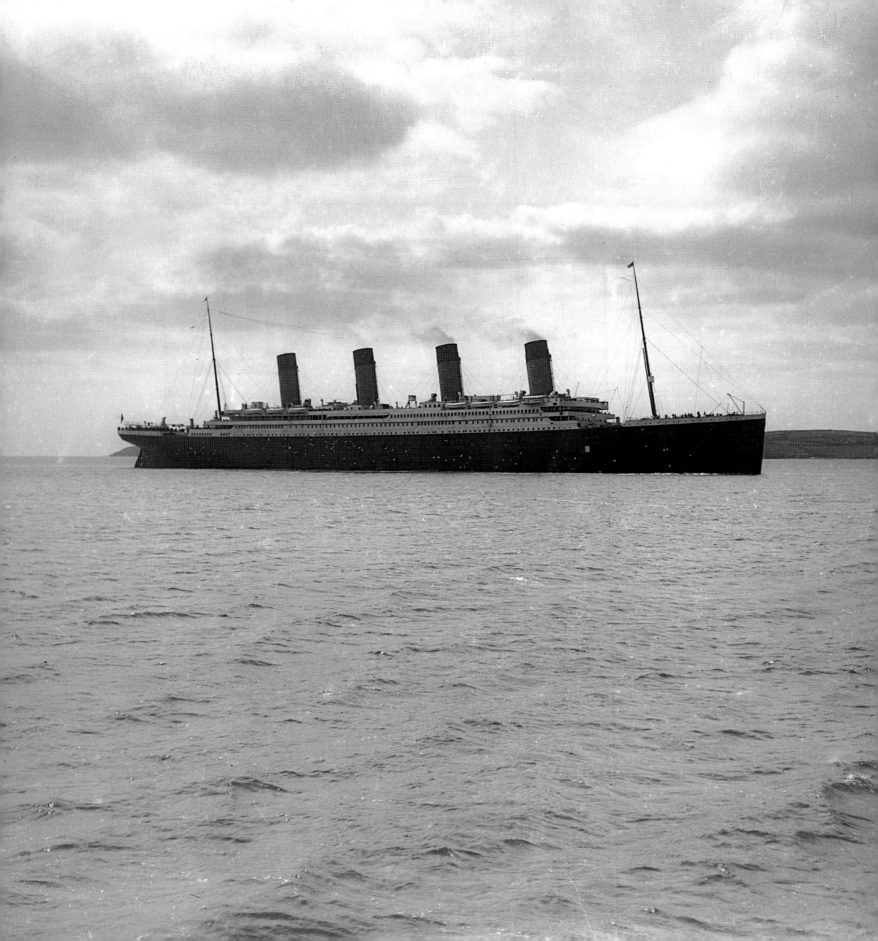

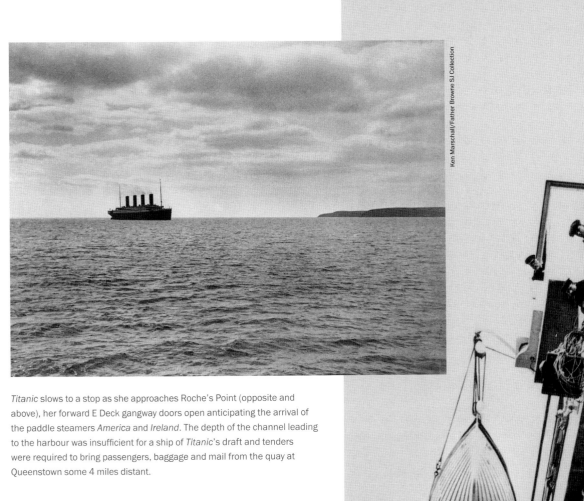

Titanic slows to a stop as she approaches Roche's Point (opposite and above), her forward E Deck gangway doors open anticipating the arrival of the paddle steamers *America* and *Ireland*. The depth of the channel leading to the harbour was insufficient for a ship of *Titanic*'s draft and tenders were required to bring passengers, baggage and mail from the quay at Queenstown some 4 miles distant.

As the tender *Ireland* comes alongside *Titanic*, Captain Smith watches the proceedings from the starboard Bridge wing. Dr William McLean (Sanitary Surveyor of the Board of Trade at Queenstown) captured this image from the deck of the tender. Captain Smith can be seen looking down from the Bridge wing cab, while forward on A Deck are Quartermaster Alfred Olliver and First-Class newlyweds Daniel and Mary Marvin of New York. Below Olliver is the leadsman's platform folded down for use and the lead line for soundings coiled on top of it.

The three large portholes on D Deck belonged to staterooms D7, D11 and the passageway between them that extended out to the side of the ship from the main fore-and-aft corridor on that side. When *Titanic* collided with the iceberg, the porthole at the end of the passageway was still open. Investigating what had happened, First-Class passenger Anna Hogeboom of Hudson, New York (occupying D7) stepped out into the passageway and found that pieces of ice had fallen inside through this open porthole.

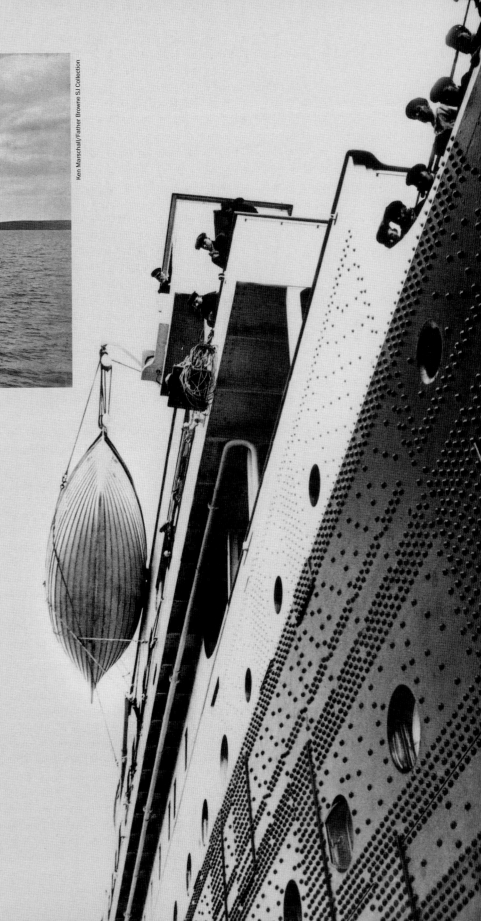

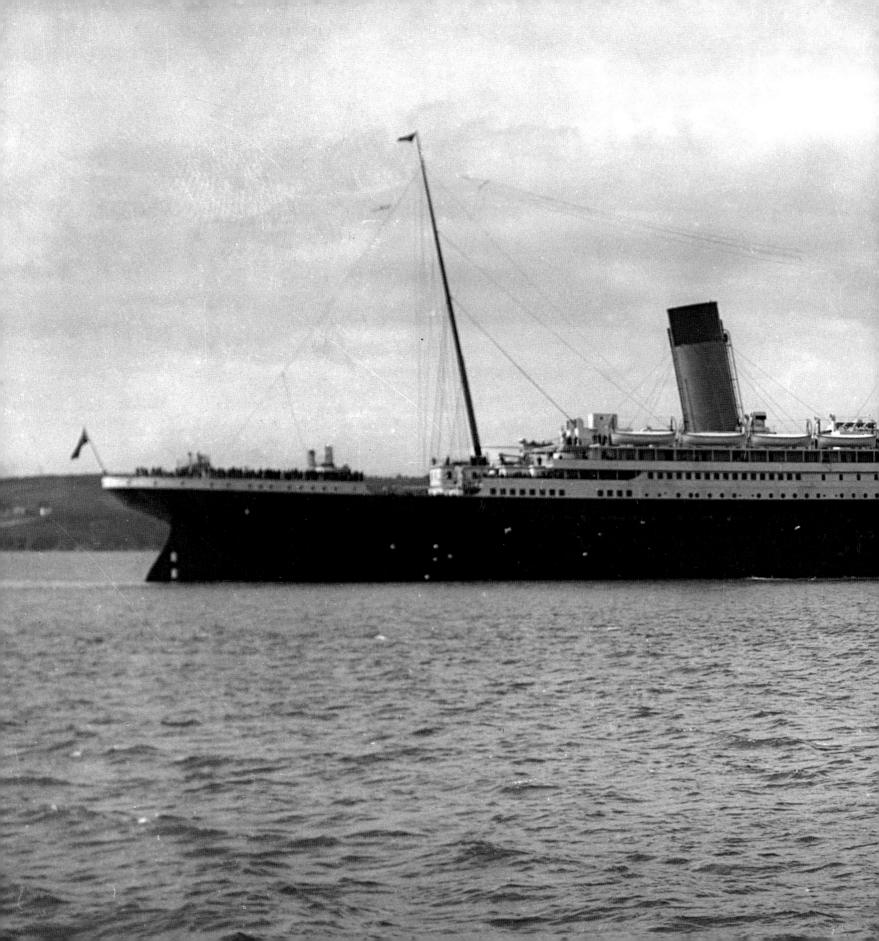

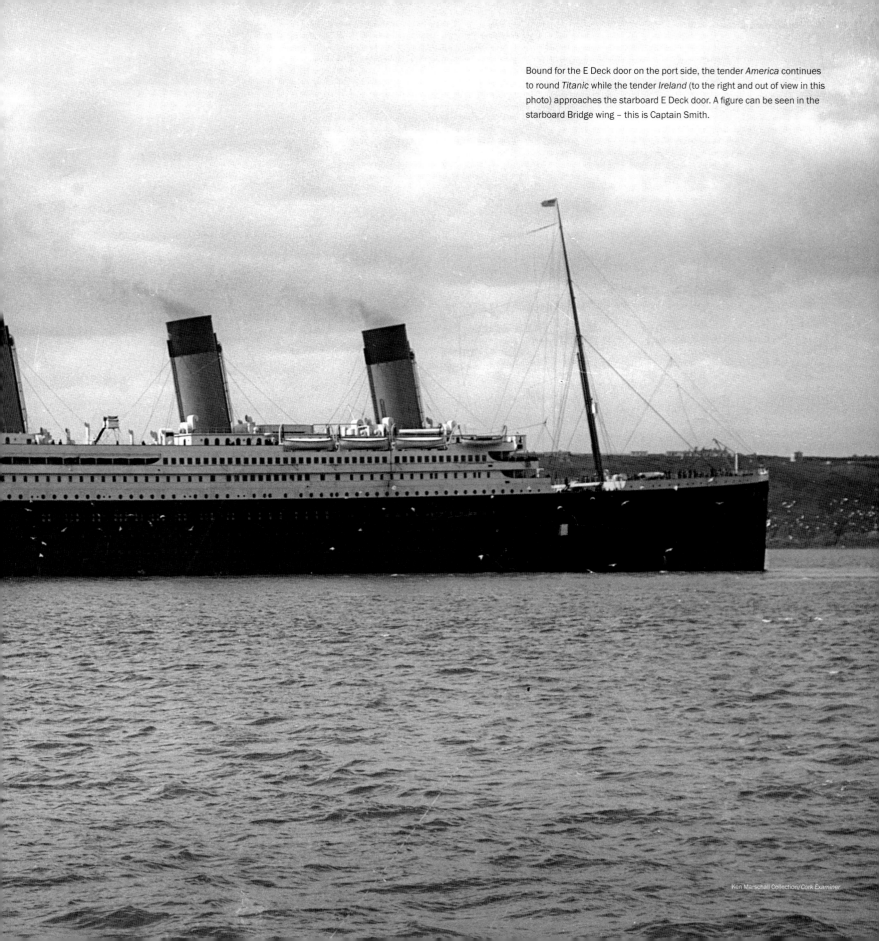

Bound for the E Deck door on the port side, the tender *America* continues to round *Titanic* while the tender *Ireland* (to the right and out of view in this photo) approaches the starboard E Deck door. A figure can be seen in the starboard Bridge wing – this is Captain Smith.

The photo below was taken by a Mr Whyte as *America* rounded *Titanic*'s stern. A blackened figure appeared atop *Titanic*'s fourth funnel and a gasp spread through the crowd. The figure was merely a stoker who climbed the dummy funnel simply for some fresh air or a bird's-eye view of the harbour, but many considered this to be a bad omen. Taken aboard *Olympic* in New York, the image on the right shows the vantage that the stoker would have enjoyed.

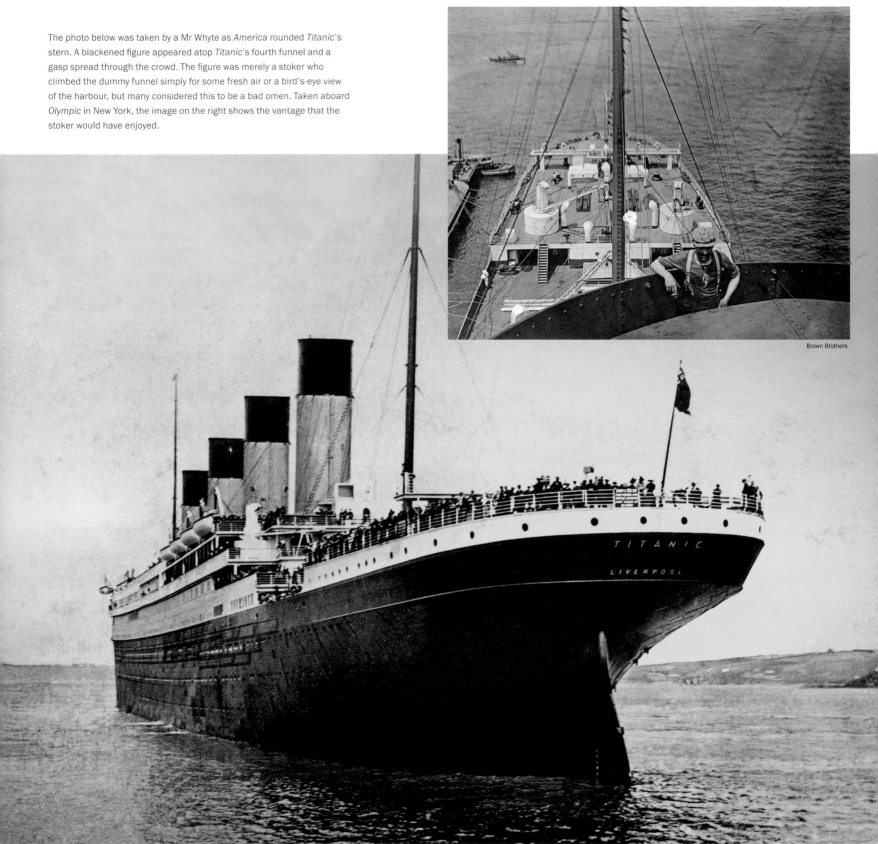

Brown Brothers

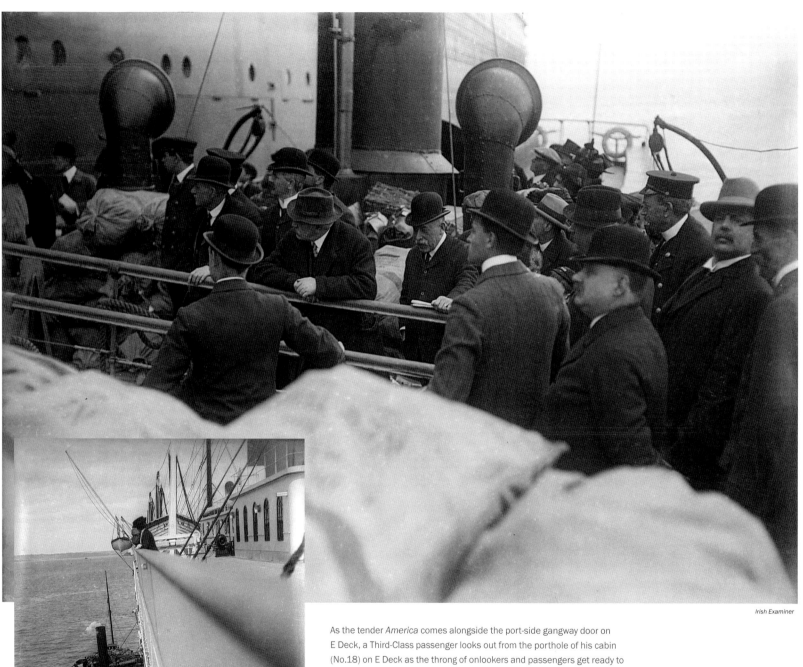

Irish Examiner

As the tender *America* comes alongside the port-side gangway door on E Deck, a Third-Class passenger looks out from the porthole of his cabin (No.18) on E Deck as the throng of onlookers and passengers get ready to board (above). In the foreground are mail bags marked 'New York'. Once on board, photographer Thomas Barker aimed his camera down toward the tender far below *Titanic*'s Boat Deck (left).

Irish Examiner

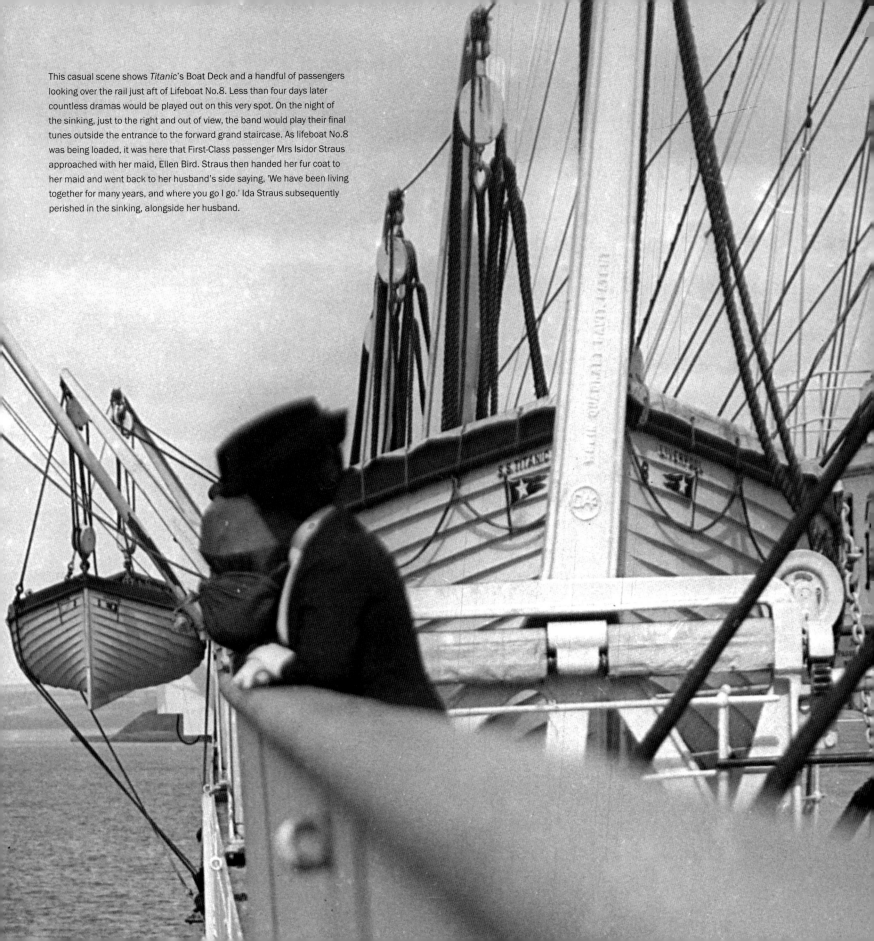

This casual scene shows *Titanic*'s Boat Deck and a handful of passengers looking over the rail just aft of Lifeboat No.8. Less than four days later countless dramas would be played out on this very spot. On the night of the sinking, just to the right and out of view, the band would play their final tunes outside the entrance to the forward grand staircase. As lifeboat No.8 was being loaded, it was here that First-Class passenger Mrs Isidor Straus approached with her maid, Ellen Bird. Straus then handed her fur coat to her maid and went back to her husband's side saying, 'We have been living together for many years, and where you go I go.' Ida Straus subsequently perished in the sinking, alongside her husband.

1ST CLASS ENTRANCE

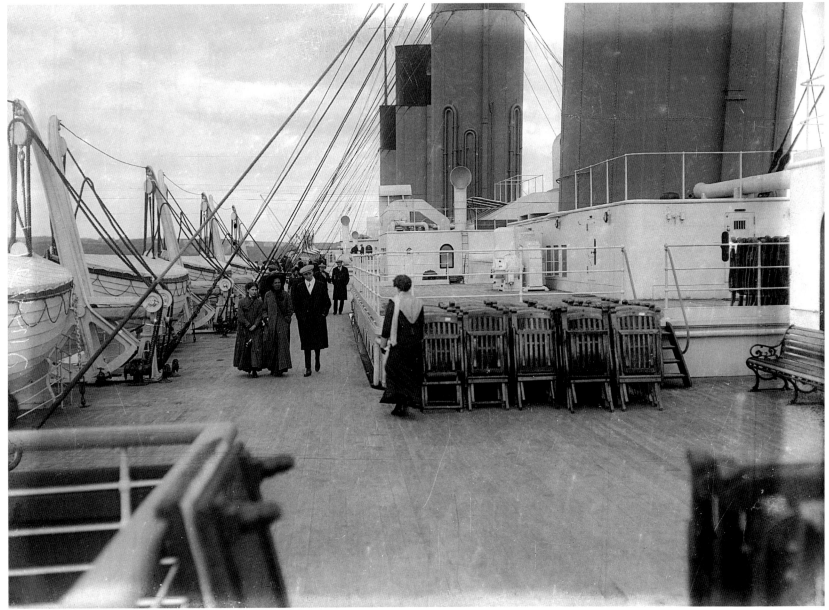

Irish Examiner

Looking forward along the port Boat Deck Second-Class promenade, Thomas Barker captured *Titanic*'s passengers enjoying a stroll. Edwin Wheeler is seen here with Elsie and Ada Doling, while behind him are brothers Leonard and Lewis Hickman. None of the men would survive the sinking. Wheeler was the personal valet of American millionaire G.W. Vanderbilt, who cancelled their booking on *Titanic* but sent their valet along with the bulk of their baggage.

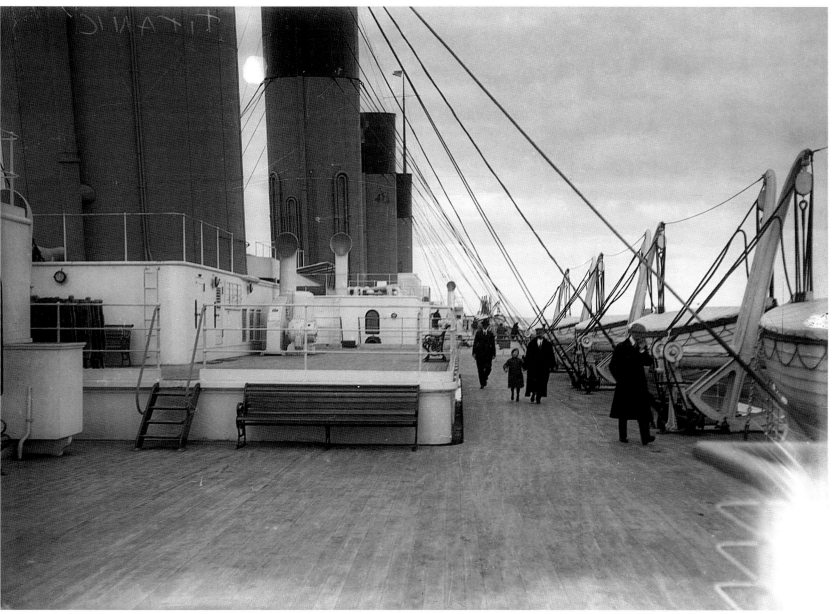

Irish Examiner

On the starboard side, Barker took a similar photo looking forward along the Second-Class promenade. The girl seen here is Annie Jessie (Nina) Harper and holding her hand is her father, the Revd John Harper. Nina would survive in lifeboat No.11, seen here next to the Harpers, while her father would perish in the sinking.

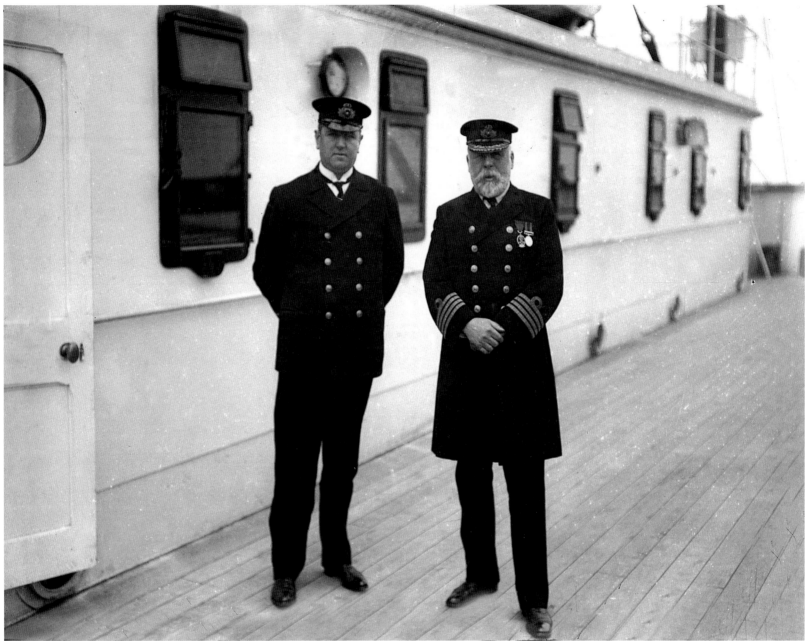

Irish Examiner

Outside the starboard side of the Officers' Quarters, Thomas Barker came across Captain Smith and Chief Purser Hugh McElroy. This is the last known photo ever taken of these men. The window to the left of McElroy is that of the Fourth Officer's cabin while most of the others belong to the Captain's suite.

Ken Marschall Collection/Cork Examiner

Of the twelve glass plates he brought on the day, Thomas Barker exposed the last plate looking aft over *Titanic*'s stern. One deck below, on A Deck, two First-Class ladies can be seen chatting on a deck bench. One of the ladies wears a very similar coat to that which movie star Dorothy Gibson wore on the night of the sinking when she survived in lifeboat No.7.

A poignant view of *Titanic* weighing anchor for the last time. On the night of 14 April 1912, some 21ft below the waterline here, *Titanic* would receive her fatal wound from the iceberg.

Science & Society Picture Library/Father Browne SJ Collection

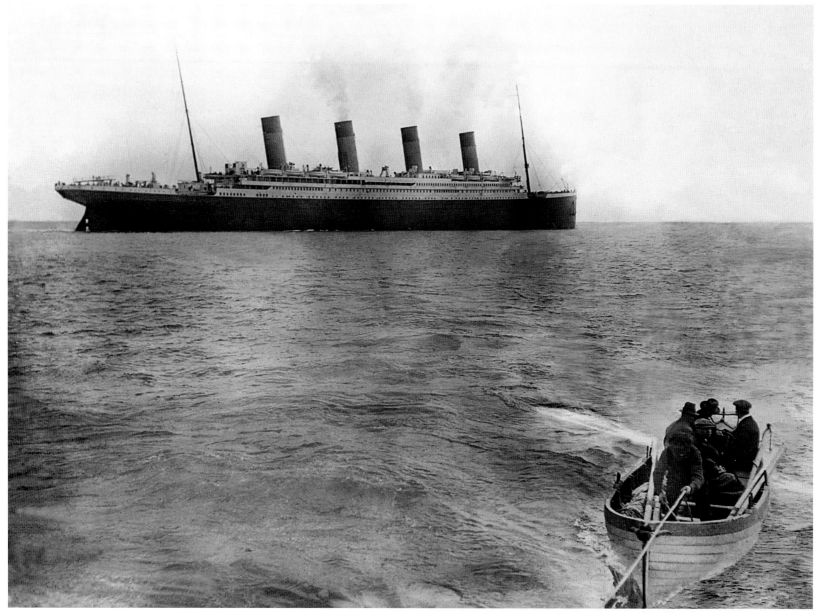

This is the very last image of *Titanic* taken by Frank Browne as she heads out to sea and the tender *Ireland* heads
back to the quay. The time is approximately 2.00p.m. on 11 April 1912.

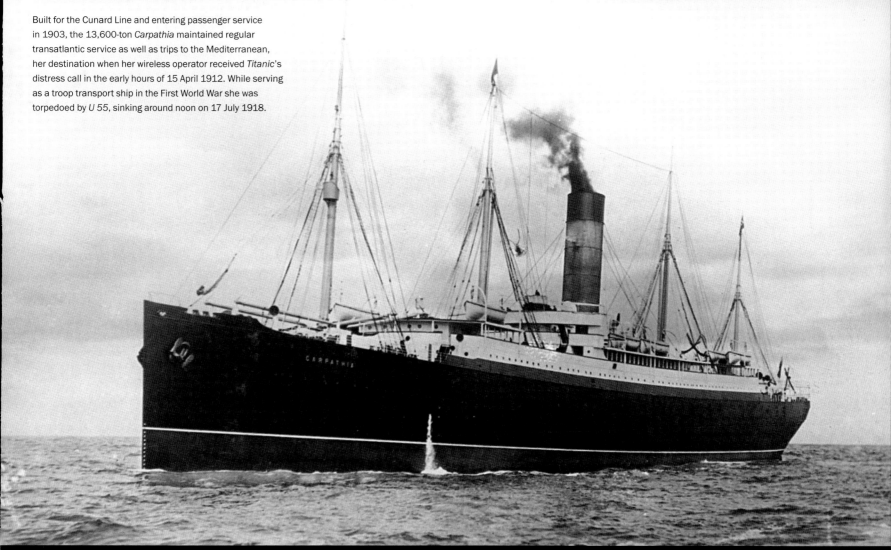

Built for the Cunard Line and entering passenger service in 1903, the 13,600-ton *Carpathia* maintained regular transatlantic service as well as trips to the Mediterranean, her destination when her wireless operator received *Titanic*'s distress call in the early hours of 15 April 1912. While serving as a troop transport ship in the First World War she was torpedoed by *U 55*, sinking around noon on 17 July 1918.

5 ★ TRAGEDY & RESCUE

On 11 April 1912 the Cunard liner *Carpathia* sailed from New York, bound for the warm climates of the Mediterranean. Her first intended stop was Gibraltar, to be followed by Genoa, Naples, Trieste and finally Fiume in Austria-Hungary. Five days later, *Carpathia*'s name would be known to the world and her captain lauded as a hero.

During the night of 14 to 15 April 1912, as soon as the extent of *Titanic*'s flooding became known, Captain Smith directed the Marconi operators to send out a distress call. The first 'CQD' ('CQ' denoting 'attention all stations' and 'D' indicating 'distress') went out at 12.15a.m. local ships time. *Titanic*'s distress call was heard by a number of ships as well as the shore station at Cape Race, Newfoundland. At that time, *Carpathia* was some 50 miles away from *Titanic*. Her wireless operator, Harold Cottam, was awaiting a reply from the *Parisian* and purely by chance, to pass the time, switched over to the Cape Cod frequency just as the shore station was attempting to send messages to *Titanic*. Wanting to assist, he contacted *Titanic*: 'I say, old man, do you know there is a batch of messages coming through to you from Cape Cod?' To his surprise, *Titanic* replied, 'Come at once we have struck a berg'. Cottam responded by asking, 'Shall I tell my captain? Do you require assistance?' *Titanic* replied, 'Yes come quick'. *Carpathia*'s captain Arthur Rostron immediately ordered full speed ahead and issued a series of orders to wake all off-duty crew and make preparations to receive survivors. With her maximum speed being only 14½ knots, Rostron calculated they could not reach *Titanic* for another four hours. (Due to incorrect distress coordinates given by *Titanic* and the shorter time it took to reach the drifting lifeboats, it was wrongly believed that *Carpathia* achieved 17½ knots.)

This is widely believed to be the iceberg with which *Titanic* collided in the late hours of 14 April 1912. The photograph was taken on 20 April 1912 in the vicinity of the wreck site by Stephan Rehorek, a seaman aboard the German liner *Bremen*, en route to New York. Rehorek saw a number of icebergs in the area but this particular berg caught his attention because of some scars and freshly exposed ice. Rehorek's photograph, which showed an iceberg described as having a striking resemblance to the Rock of Gibralter, was later compared to a sketch drawn aboard *Carpathia* by American artist Colin Campbell Cooper based on survivor descriptions of what they had seen. The resemblance was unmistakable.

Throughout the night as *Carpathia* raced towards the stricken liner, she tried to maintain contact with her. Wireless exchanges had been taking place continuously since the first distress call and at 1.30a.m. *Carpathia* overheard *Titanic* report to her sister ship *Olympic*, 'Women and children in boats, can not last much longer'. At 1.45a.m. *Carpathia* also heard 'Engine Room filling up to boilers'. This was the last message Cottam received from *Titanic* directly. Fearing the worst but still hopeful, Rostron maintained his speed. There was much ice about but apprehensive about the consequences of any delay, Rostron doubled the lookout at the bows of the ship and kept watch himself from the Bridge. Reducing speed only to manoeuvre around the ice in their path, it was a harrowing time, as Rostron later recalled:

Icebergs loomed up and fell astern and we never slackened. It was an anxious time with the *Titanic*'s fateful experience very close in our minds. There were 700 souls on *Carpathia* and those lives as well as the survivors of the *Titanic* herself depended on the sudden turn of the wheel ... When day broke, I saw the ice I had steamed through during the night. I shuddered, and could only think that some other hand than mine was on that helm during the night.

Shortly after 3.00a.m. Captain Rostron noticed a faint green light in the distance. Green was the colour of the White Star Line's night signals and Rostron hoped he was seeing one from *Titanic* herself. With nothing heard from her for some time, Rostron sent: 'If you are there we are firing rockets'. Rostron ordered these rockets sent up at fifteen-minute intervals to give hope to *Titanic*'s passengers and crew. Instead, the green light turned out to be a flare from lifeboat No.2 under the command of Fourth Officer Joseph Boxhall. Having been detailed for a time to supervise the firing of distress rockets from the *Titanic*'s Bridge wing during her sinking, he had the foresight to take a box of green flares into the lifeboat with him as he left the ship. Throughout the night he periodically set these off in the hope of attracting help. Just after 4.00a.m., as the *Carpathia* drew near Boxhall's lifeboat, Rostron rang down 'STOP' on both engines, intending to receive the boat's survivors on his port side. Suddenly an iceberg loomed directly in front of *Carpathia*'s bows and he ordered a hard turn to starboard. The iceberg was successfully avoided but as a consequence *Carpathia* drifted past the lifeboat. Someone from the lifeboat then called up that they did not have enough sailors and had difficulty handling the boat. Rostron ran his engines astern to meet them and a short

Günter Bäbler Collection

time later, around 4.10a.m., lifeboat No.2 was alongside. First-Class passenger Miss Elisabeth Allen was the first survivor to be taken aboard, crying out to the officer who received her that *Titanic* had gone down.

Having followed the occasional green glow that appeared throughout the night from Boxhall's flares, lifeboat No.1 was the second boat to reach *Carpathia* some thirty minutes later as the sky began to lighten. Ironically, the morning was almost breathtaking in its beauty. A pink haze of colour on the horizon reflected off the icebergs, and the sea glittered from the sun's first rays. The growing light revealed the sea dotted with icebergs and a handful of lifeboats, scattered over an area of 4 to 5 square miles, making their way towards *Carpathia*. Lifeboats No.5 and 7 were next to reach the rescue ship almost simultaneously around 5.00a.m. No.5 was under command of Third Officer Herbert Pitman, together with Quartermaster Alfred Olliver. Lifeboat No.7, with three crewmen but no officer aboard, was the first to be launched.

Most of *Carpathia*'s passengers remained asleep throughout the night despite the increased engine vibrations and the noise from preparations to receive survivors. As they began to wake in the early morning of 15 April 1912, they realised that the engines were silent. On deck, instead of the more moderate temperatures expected as she headed south-east, passengers woke up to a chilly Monday morning and soon realised they were surrounded by icebergs – and an occasional lifeboat arriving at the ship's side.

Between 5.00 and 6.00a.m. lifeboats No.3, 9 and collapsible C also reached *Carpathia* and boats No.13 and 15 arrived shortly after 6.00a.m. In the first light, as lifeboat No.3 neared *Carpathia*, six-year-old First-Class passenger Robert Douglas Spedden was mesmerised by the scene around him and exclaimed to his nurse (Elizabeth Margaret Burns), 'Oh Muddie, look at the beautiful North Pole with no Santa Claus on it'. One of Robert's favourite toys was a Steiff polar bear and his parents no doubt told him stories of the North Pole. Robert survived along with his nurse, his parents, and their maid. Also aboard lifeboat No.3 was Charlotte Cardeza and her son, their palatial promenade suite now at the bottom of the ocean along with her fourteen steamer trunks and four suitcases. Collapsible C brought White Star Line's owner and managing director, Bruce Ismay. Having helped *Titanic*'s crew load several lifeboats, he stepped aboard collapsible C at the last moment as it was being lowered. Ismay's was the last lifeboat launched from the starboard side. Arriving aboard lifeboat No.13 was Second-Class passenger Lawrence Beesley. In lifeboat No.15 was five-year-old Third-Class passenger Lillian Asplund. Of the seven Asplund family

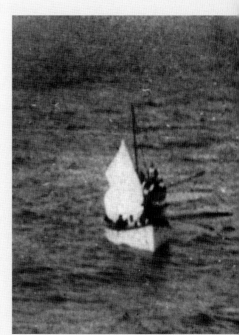

members, only Lillian, her mother and younger brother boarded the lifeboat; her father and three other brothers all perished in the sinking. Lillian passed away in May 2006 and was the last *Titanic* survivor who had actual memories of the disaster.

Each lifeboat brought a varying amount of survivors and as each boatload was taken aboard, *Carpathia* became increasingly crowded and noisy. With the sun fully up, more and more of *Carpathia*'s passengers began to wake and make their way to the upper decks to see what was going on. As they stepped out on deck, among the first sights that greeted many of the bewildered passengers some time around 6.30a.m. was a small white sail in the distance. As it grew larger, it became evident that one of *Titanic*'s lifeboats had its mast stepped and was under sail. This was lifeboat No.14, with collapsible D in tow. At least three of *Carpathia*'s passengers – a Mrs Fenwick, a Mr Ogden and a Mr Skidmore – had thought of bringing their cameras as they went up on deck. Photographs they took of these two lifeboats arriving were the first taken of all that remained of *Titanic*. By 7.00a.m. both boats would be alongside *Carpathia* and her survivors being brought aboard.

Shortly after *Titanic* sank, port-side boats No.4, 10, 12, 14 and collapsible D, under the direction of Fifth Officer Harold Lowe, were gathered together and tied to each other. Occupants of boat No.14 were redistributed among the other lifeboats and 14, under Lowe's command, went back to search for survivors in the water. The other boats stayed together for some time but eventually began to disperse one by one. As the sun came up the occupants

As the winds picked up with the rising sun in the early morning of 15 April 1912, Fifth Officer Harold Lowe, in command of lifeboat No.14, hoisted a sail and used the wind to his advantage. While all boats were provided with a mast and sail, this is the only boat known to have utilised it. In tow behind No.14 is collapsible D. These are the earliest photographs known to have been taken of *Titanic*'s lifeboats approaching *Carpathia*.

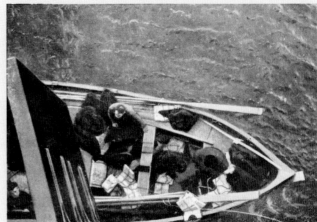

Ioannis Georgiou Collection

This photo is most likely of the nearly empty lifeboat No.14. Blankets, heavy clothing and life jackets are seen strewn around the boat, likely discarded as they were wet and heavy and would have impeded the survivors' ascent up and into *Carpathia*.

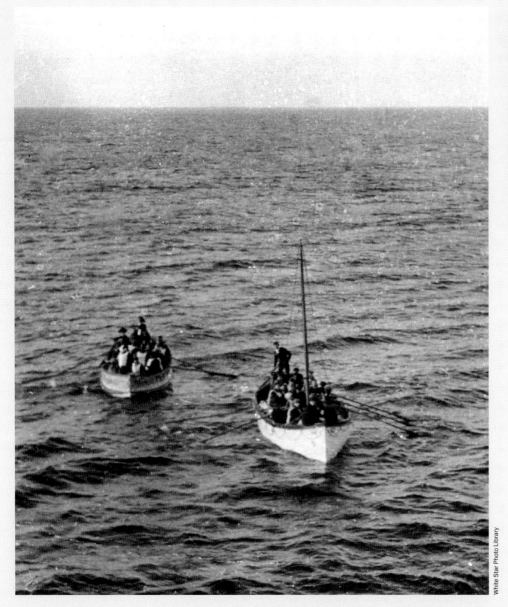

White Star Photo Library

Earlier in the night, Fifth Officer Harold Lowe had transferred all occupants from his boat (No.14) into lifeboats Nos 4, 10, 12 and collapsible D and returned to the wreck scene to pick up survivors. He rescued four people from the water, one of whom later died. After sighting *Carpathia* in the morning and making for her, he came upon collapsible D with her crew and passengers attempted to row toward the ship they had sighted. Lowe took the collapsible in tow, subsequently coming upon another boat – the waterlogged collapsible A – and took all its occupants into his boat. Among them was only one woman, Third-Class passenger Rhoda Abbott. Collapsible A was the last boat rigged for launch under *Titanic*'s davits but there was no time to lower it as the water came over the deck during *Titanic*'s final plunge.

of boats No.4 and 12 heard an officer's whistle and rowed in that direction. They came upon collapsible B, overturned, with almost thirty men balancing on top and trying not to tip the boat to one side or the other. Having taken as many men off as they could, the survivors in No.4 left and rowed towards *Carpathia*. Boat No.12 took the remaining twenty or so men, one of whom was Second Officer Charles Lightoller. Among the other survivors aboard the now-crowded boat was Second-Class passenger Lillian Bentham who was travelling in a large party of nine, of whom only the three women survived. Once the men from the overturned collapsible B had been taken on board, Lillian took off one of her coats and gave it to one of the men.

Heavily overloaded, boat No.12 began to row towards the rescue ship, rejoined by boat No.10. Aboard No.10 was First-Class passenger Mary Marvin. During the sinking, her husband of less than two months escorted her to the boat and convinced her to go, saying, 'It's alright little girl. You go. I will stay.' It is also believed that this is the lifeboat in which Third-Class passenger Georgetta Dean survived with her eight-week-old daughter Elizabeth (later known as Millvina) and one-year-old son Bertram. Millvina Dean was *Titanic*'s youngest passenger, and would eventually have the distinction of being the last survivor, passing away on 31 May 2009. Lifeboats No.10 and No.12 were the last to reach *Carpathia* and the last to come aboard was Second Officer Lightoller, who was also the most senior surviving officer from *Titanic*.

With their compliment of 712 survivors, Captain Rostron quickly made up his mind to return to New York and informed

Bruce Ismay of this decision. Ismay was by now sequestered in the cabin of *Carpathia*'s surgeon, Dr McGee, where he was administered opiates. He quickly penned a telegram for the White Star Line office in New York, which read: 'Deeply regret advise you *Titanic* sank this morning fifteenth after collision iceberg resulting serious loss life further particulars later.' For a time, the option of transferring *Titanic*'s survivors to her sister ship *Olympic* was considered, and for this reason *Olympic* was still steaming full speed ahead toward *Carpathia*'s position. Upon further consideration the idea was dismissed as it was thought the sight of *Titanic*'s sister ship, nearly identical in appearance, would distress the surviving passengers. Consequently, Rostron wired *Olympic* and advised her to keep out of sight.

After briefly steaming through the area to ensure there were no more survivors, *Carpathia* changed course and made for New York. To the north, a massive ice field now visible in the daylight stretched beyond the horizon. *Carpathia* passenger Dr Frank Blackmarr of Chicago later wrote that it was afternoon before they finally 'passed the mass of ice, having run nearly 75 miles to get around. We steamed within 2 or 3 hundred yards of part of this ice floe and at dusk we could see in [the] distance only a few straggling icebergs'. In the days that followed, the weather changed drastically, almost reflecting the mood that befell the *Carpathia*. The trip was decidedly unpleasant. Second-Class *Titanic* passenger Lawrence Beesley remembered: 'cold winds most of the time; fogs every morning and during a good part of one day, with the foghorn blowing constantly; rain; choppy sea with the spray blowing overboard and coming in through the saloon windows.' One night there was thunder and lightning, and so closely did the peal follow the flash that some frightened and already shaken survivors thought that rockets were being fired again.

On Thursday morning, 18 April 1912, the Nantucket Lightship was sighted and by the evening *Carpathia* finally entered New York harbour. As the 'Ship of Sorrow' (the nickname attributed to her by the American press) steamed up the Hudson River, she was mobbed by tugs and small boats chartered by various newspapers, all eager to get the first 'scoop'. Describing the arrival, the *New York Herald* reported:

The *Carpathia*, with the red funnel and black band, the distinguishing mark of the Cunard Line, was seen off the Sandy Hook lightship just before seven o'clock. There she took her pilot aboard and steamed up the channel toward the pier, where the anxious thousands were awaiting some details of the

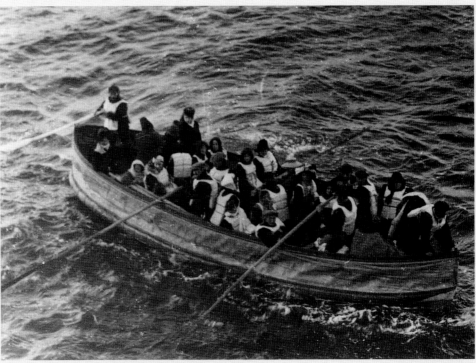

National Archives, New York

(Above) Once lifeboat No.14 and D were sufficiently close to *Carpathia*, the tow rope was cast off and collapsible D rowed the remaining distance. It is seen here nearing *Carpathia*'s side. Collapsible D was the very last lifeboat lowered from *Titanic*'s davits. To prevent remaining passengers from swarming the boat, a line of men locked arm-in-arm had stood at the rail and let only women and children through. It was here that First-Class passengers Henry B. Harris, Jaques Futrelle and Frederick Hoyt finally convinced their wives to board a lifeboat; where Michel Navratil – failing to board a boat elsewhere – finally placed his two young sons in the custody of other passengers; and it was here where First-Class passenger Edith Evans turned to her companion, Caroline Brown, and told her 'You go first, you have children waiting at home'. Evans would be one of only four First-Class female passengers not to survive. Seen here at the bow are First-Class passengers Hugh Woolner and Mauritz Björnström-Steffansson. After assisting other passengers into the boats until all were gone, they ran down and climbed into collapsible D as it was being lowered past A Deck.

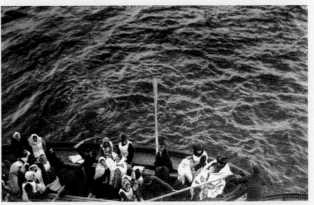

Heritage Images

(Left) Lifeboat No.16 is seen here having just arrived at *Carpathia*'s side shortly after 7.00a.m. *Carpathia*'s passengers were shocked to see just how empty some of the lifeboats were. With so few people in this boat, it was obvious to all that there would have been room for many more. A member of *Titanic*'s crew is seen assisting from collapsible D as No.16 is secured. At the bow of the lifeboat, First-Class stewardess Violet Jessop is seen holding a baby which was handed to her by Sixth Officer James Moody. Next to her is her cabin mate and fellow stewardess Elizabeth Leather. Jessop would be one of the very few crew members who would serve on all three *Olympic*-class ships.

Unlike the lifeboats on *Titanic*'s port side, the starboard boats were, on average, lowered with more people per boat. Among the officers and crew, there was some uncertainty as to whether the rule of 'women and children first' meant 'women and children only', or 'women and children before anyone else'. First Officer William Murdoch, in charge of lowering the starboard boats, allowed men to board once all women in the immediate vicinity had been loaded. In this photo, lifeboat No.11 is seen at *Carpathia*'s side with a nearly full complement of survivors. Somewhere among the crowd is First-Class passenger Edith Rosenbaum, carrying a musical pig given to her by her mother. Turning the tail the pig played the jovial Spanish tune of *Maxixe* which Edith used to calm the children in the lifeboat. Elsewhere in the boat is six-year-old Second-Class passenger Nina Harper together with her aunt, Jessie Leitch. Nina's father, the Revd John Harper, placed them in the boat but stood back even though men were allowed to board.

White Star Photo Library

great catastrophe ... Off the Cunard Line pier the great rescue ship stoped her engines and several tugs attached lines to her bow and stern. She was about midstream. It was half past eight o'clock when this position was reached.

Carpathia had steamed past the Cunard Line Pier 54 and approached the entrance to White Star Line Piers 58 and 59 where she stopped midstream. The crowds watching the rescue ship were initially confused by *Carpathia*'s movements but the reasoning soon became apparent. The *New York Herald* continued:

The reason for the long delay was seen about nine o'clock, when seamen had gathered at the port side on the upper deck. The ropes holding the lifeboats to the davits were unfastened, the boats swung over the side of the *Carpathia* and slowly the men began to lower them ... As the 'Herald' tug drifted in towards *Carpathia* the name *Titanic* was plainly discerned on the bow of the little craft. Seamen were in the boats as they were being lowered to the river. The tug *John Nichols* in charge of Captain Richard Wray, towed the life craft to the south end of the White Star pier, where they were moored.

Dropping *Titanic*'s lifeboats, *Carpathia* finally docked at Pier 54 around 9.30p.m. The *Montreal Daily Star* later reported:

Carpathia had arrived opposite her dock. It was a wild night outside the harbour and a heavy fog hung over the bay as the rescue ship hurried up the channel. It was raining drearily, and at intervals lightning lit up the big vessel with vivid flashes ... Relatives of the survivors gathered on the pier early. By direction of the Customs men, they arranged themselves in alphabetical sections so that there would be no confusion ... At 9.55 the first passenger walked down the gang plank.

Throughout the night, *Titanic*'s survivors disembarked and dispersed, many met by friends and family. Those who had nowhere to go were met by Salvation Army representatives and other charity and hospital personnel. Those Third-Class passengers detained aboard *Carpathia* for immigration formalities finally disembarked the next day. At White Star Line's Pier 59, instead of *Titanic* proudly dominating the docks, thirteen lifeboats sat bobbing in one corner – a sad reminder of the disaster and all that remained of the once great ship.

In the aftermath of the disaster, demand for lifeboats was at a premium and it was intended that *Titanic*'s boats would be

returned to Southampton as soon as possible and refitted aboard other White Star Line ships. This was not to be, and the lifeboats – as far as can be determined – remained in New York. On 17 May 1912, collapsible A, which was recovered by the White Star liner *Oceanic* on 13 May while en route to New York, was later added to the group. Earlier in April, during the body recovery operation, the *Mackay Bennett* had come across collapsible B, but with all available space being utilised to store bodies, the lifeboat was not taken aboard. The remaining lifeboats (Nos 4, 14, 15 and collapsibles C and D) were permitted to float away after *Carpathia* recovered their passengers and were never seen again.

In December 1912 the boats were examined one last time by marine surveyors for the Limitations of Liability case against the Oceanic Steam Navigation Company in the matter of the loss of the Steamship *Titanic*, giving the value of the boats as $4,972 and their remaining contents as $474.31. This amount would be added to the total sum available for compensation. Hearings and legal proceedings would continue until at least 1917, by which stage records no longer seem to mention *Titanic*'s last relics.

Whatever eventually happened to *Titanic*'s fourteen lifeboats still remains a mystery. ★

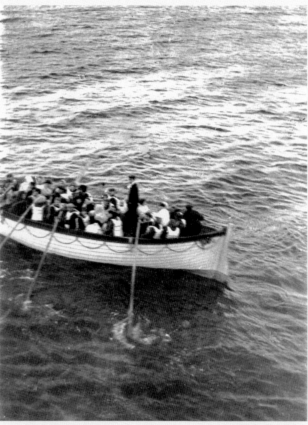

White Star Photo Library

Lifeboat No.4 approaching *Carpathia*. This was the first boat made ready for launching on the port side, some time around 12:30a.m. The lifeboat was lowered to A Deck where the crew soon realised it could not be loaded from there due to the screen of windows fitted aboard the forward end of the deck. These windows could be opened, but the handle required to lower them could not be located. The situation was eventually rectified and passengers were assisted into the boat one by one. Perhaps by coincidence, lifeboat No.4 ended up carrying *Titanic*'s wealthiest survivors. John Jacob Astor escorted his pregnant wife to the boat and asked whether he could go with her in order to look after her, but was told to stand aside. Other occupants among the group seen in this boat are Lucile Carter, Marian Thayer, Eleanor Widener and Emily Ryerson. When No.4 was finally launched, it rowed along *Titanic*'s side and several men climbed down the falls of the other boats and were taken aboard. An additional seven or eight men were rescued from the water, two of whom later died.

As lifeboat No.6 nears *Carpathia*, the number of empty seats are immediately noticeable (left). With her survivors safely aboard the rescue ship, lifeboat No.4 is seen here being relocated to make room for other boats approaching the open gangway doors. Lifeboat No.6 is visible to the left (below).

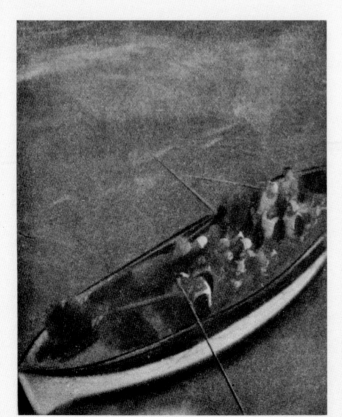

Ioannis Georgiou Collection

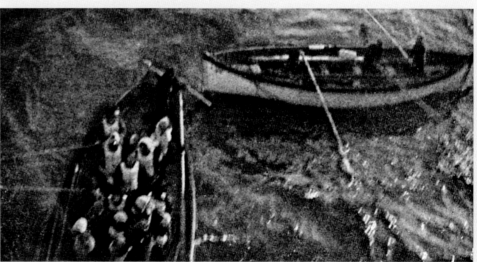

Günter Bäbler Collection

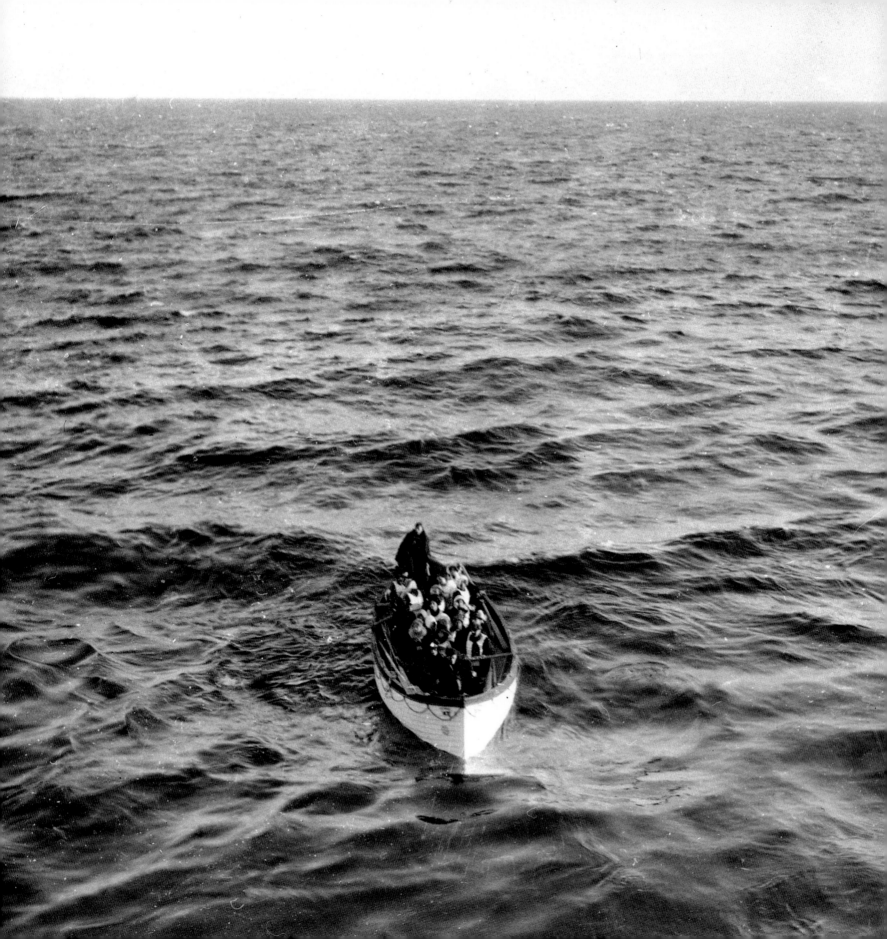

The arrival of lifeboat No.6 is the most photographed. The story of this boat is perhaps the most famous, due in no small part to the presence of First-Class passenger Margaret Brown. After helping a number of women into the lifeboat, she began walking away to see what was happening elsewhere. At that moment, a crew member lifted her up and put her in the lifeboat, saying 'you're going too'. During the night Brown helped boost morale to counter the gloomy mood instilled by the emotional Quartermaster Robert Hichens, seen sitting up at the back of the boat. Hichens was at the helm when *Titanic* struck the iceberg, and this may have accounted for his mental state. Lookout Frederick Fleet, who first sighted the iceberg, can be seen at the bow, while First-Class passenger Arthur Peuchen (behind Fleet and to the right) helps to row.

Günter Bäbler Collection

Some of the female passengers were too cold and exhausted to climb the boarding ladder up and into *Carpathia*. One of them is seen here being hoisted aboard from lifeboat No.6 (above).

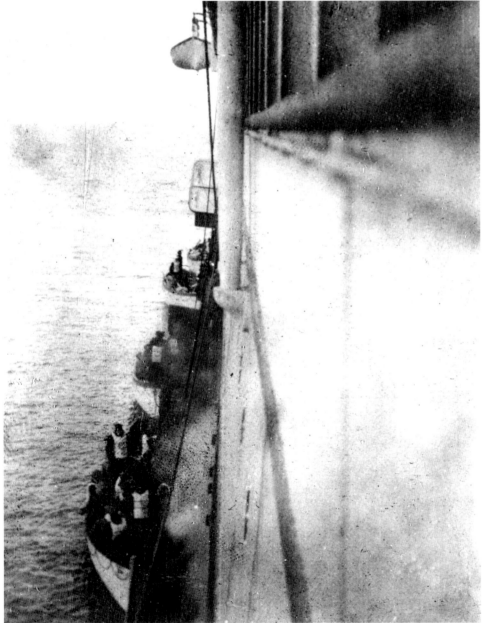

White Star Photo Library

Heritage Images

Four of *Titanic*'s lifeboats at *Carpathia*'s side (above). The two closest to the camera are filled with survivors and may be boats Nos 10 and 12 which arrived almost simultaneously around 8.00a.m. After more than six hours adrift in the ocean, a survivor from one of these boats finally boards the rescue ship (left).

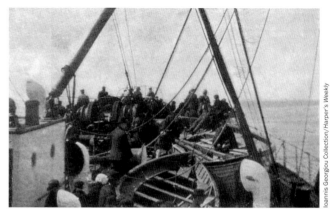

Ioannis Georgiou Collection/*Harper's Weekly*

Carpathia's forecastle deck crowded with survivors, some seen here sitting in *Titanic*'s lifeboats. In the foreground is lifeboat No.2 and two others are stowed in front.

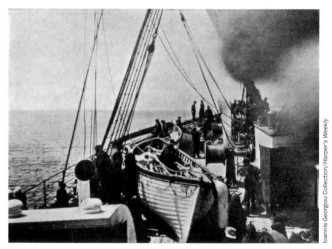

Ioannis Georgiou Collection/*Harper's Weekly*

In this view of the other side of *Carpathia*'s forecastle deck, lifeboat No.9 is in the foreground, with another 30ft boat and emergency cutter No.1 in front.

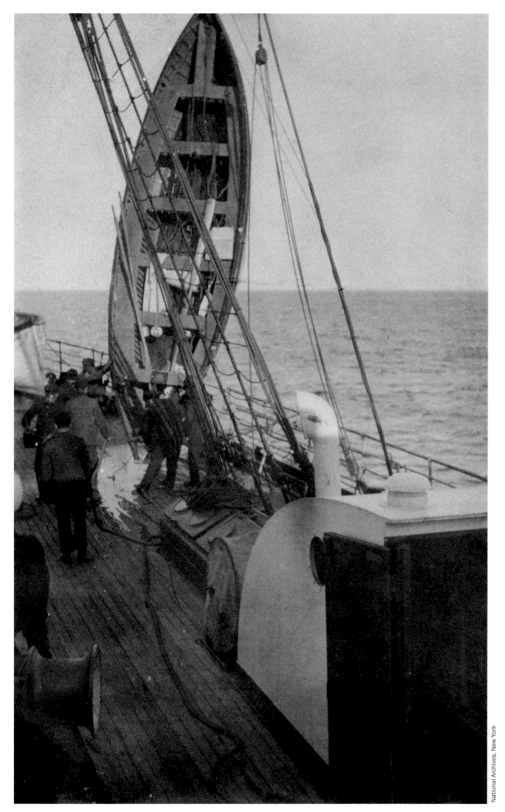

National Archives, New York

Lifeboat No.2 is seen here being hoisted aboard *Carpathia* after all of *Titanic*'s 712 survivors had been taken aboard.

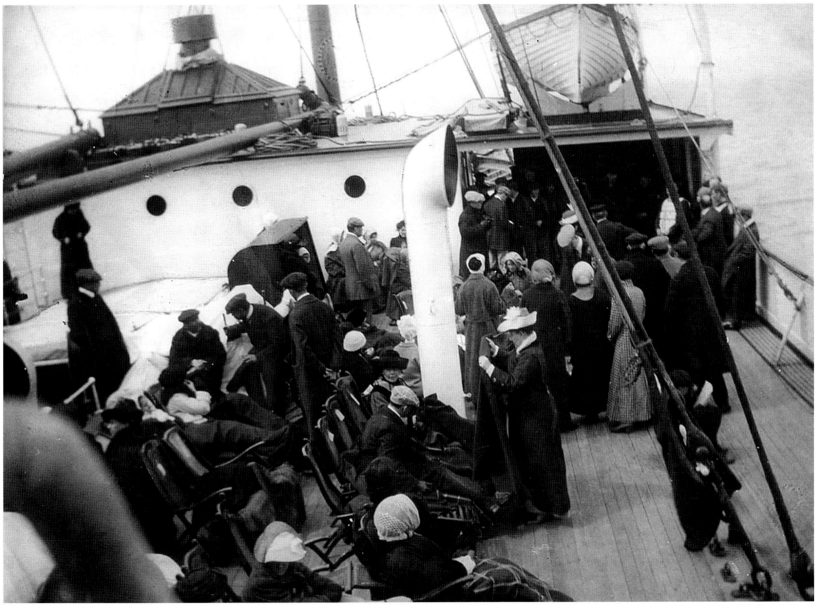

White Star Photo Library

This scene aboard *Carpathia* (above) shows the small group of survivors who were rescued in lifeboat No.1, gathering near the rail while a man waits to take a photo. One of the greatest controversies associated with *Titanic*'s sinking is how lifeboat No.1, built to carry over forty people, left the ship with only twelve occupants. This number included seven crewmen and five First-Class passengers, among them Sir Cosmo and Lady Duff Gordon. As a gesture of recompense for what they had lost, Sir Cosmo gave each of the crew £5 to replace their personal gear that went down with the ship. The couple were later ridiculed in the press when this gesture was made to seem like a bribe for Sir Cosmo and Lady Duff Gordon to have exclusive use of the boat.

Ioannis Georgiou Collection/*The Sphere*

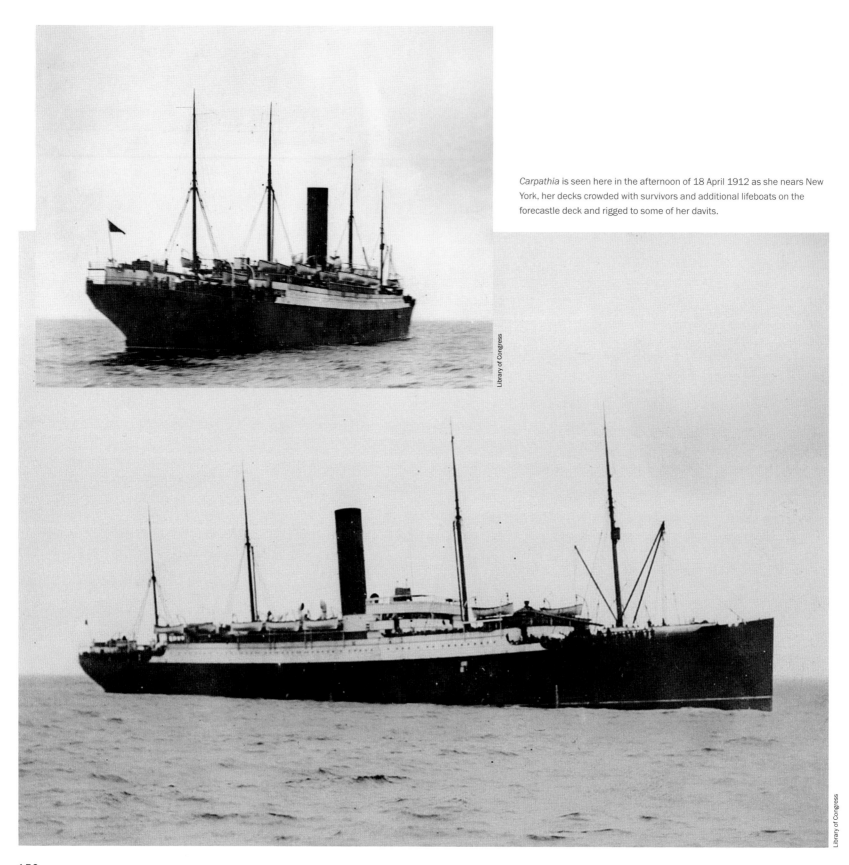

Carpathia is seen here in the afternoon of 18 April 1912 as she nears New York, her decks crowded with survivors and additional lifeboats on the forecastle deck and rigged to some of her davits.

Library of Congress

Library of Congress

Crowds wait outside Cunard Line Pier 54 and White Star Line Pier 59 in the evening of 18 April 1912, unsure of where *Carpathia* would disembark survivors (above and overleaf, top).

Library of Congress

Steaming up the Hudson River, *Carpathia* passes Cunard Line Pier 54 and
proceeds further up the river to White Star Line Pier 59.

Ioannis Georgiou Collection/*The Sphere*

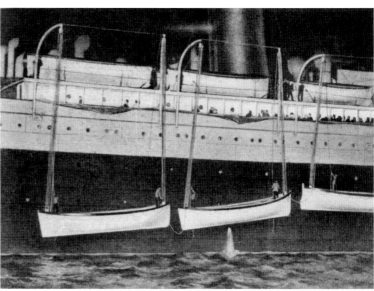

Ioannis Georgiou Collection/*Popular Mechanics*

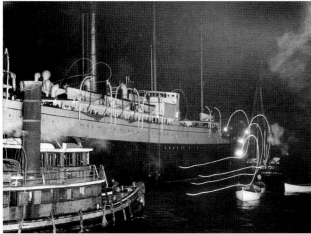

White Star Photo Library

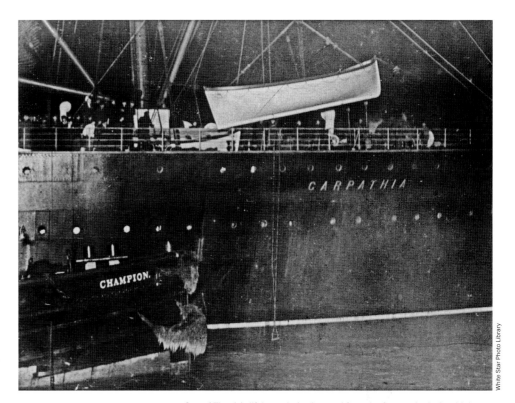

White Star Photo Library

One of *Titanic*'s lifeboats being lowered from the forecastle deck, with boat No.2 still in place.

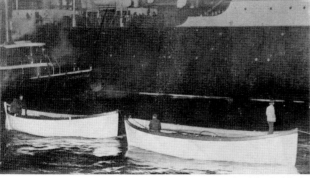

Ioannis Georgiou Collection

Carpathia stopped outside the entrance to Pier 59 and dropped off *Titanic*'s thirteen lifeboats – all that remained of the once grand ship.

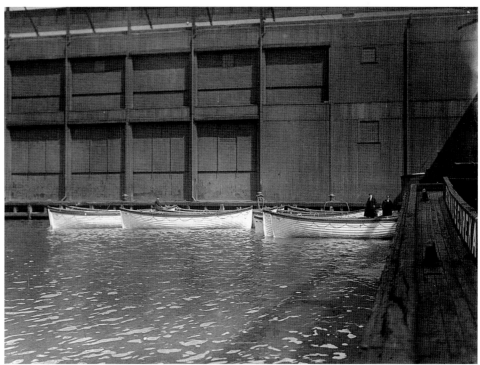

On 19 April 1912, a photographer visits Pier 59. Instead of the giant *Titanic* which was meant to dock two days prior, thirteen lifeboats occupy a small amount of space along the pier.

Brown Brothers

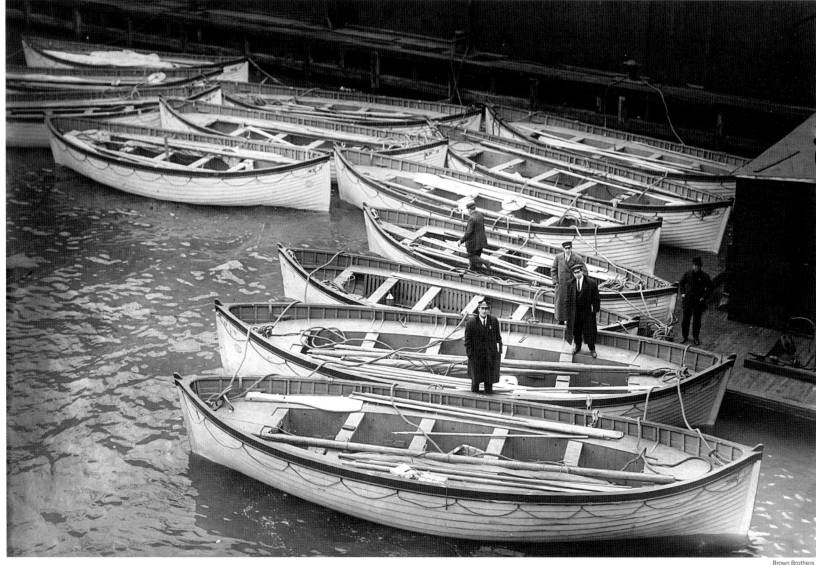

Brown Brothers

Even as *Carpathia* steamed towards New York, the various flags, numbers, name and port plaques began to disappear from *Titanic*'s lifeboats. Some were given to survivors as mementos of their escape while others were removed by souvenir-hunters in New York. On 20 April 1912, all of the boats' contents were assessed by the C.M. Lane Lifeboat Company of Brooklyn, New York, and the following items were found to be missing:

No.1
2 numbers
4 flags
Draft plate

No.2
3 numbers
4 flags
2 *Titanic* name plates
2 *Liverpool* name plates
Draft plate

No.3
4 numbers
4 flags
2 *Titanic* name plates
2 *Liverpool* name plates
Draft plate

No.5
3 numbers
4 flags
2 *Titanic* name plates
2 *Liverpool* name plates

No.6
1 *Titanic* name plate

No.7
1 number
1 flag
2 *Titanic* name plates

No.8
4 numbers
3 flags
2 *Titanic* name plates

No.9
4 numbers
4 flags
2 *Titanic* name plates
Draft plate

No.10
3 flags
2 *Titanic* name plates
1 *Liverpool* name plate

No.11
2 flags
2 *Titanic* name plates

No.12
2 *Titanic* name plates

No.13
4 flags
2 *Titanic* name plates
2 *Liverpool* name plates
Draft plate

No.16
1 number
4 flags
2 *Titanic* name plates
1 *Liverpool* name plate
Draft plate

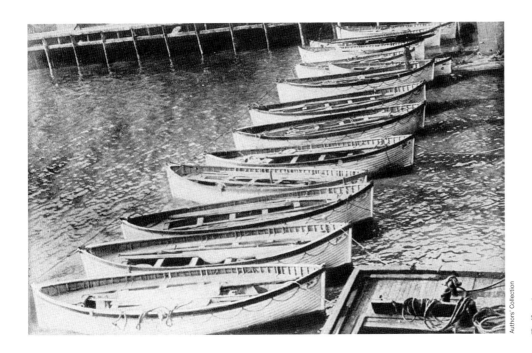

Titanic's thirteen lifeboats are arranged in a row prior to being hoisted to the second-floor loft between White Star Line piers 58 and 59. They remained there until at least December 1912.

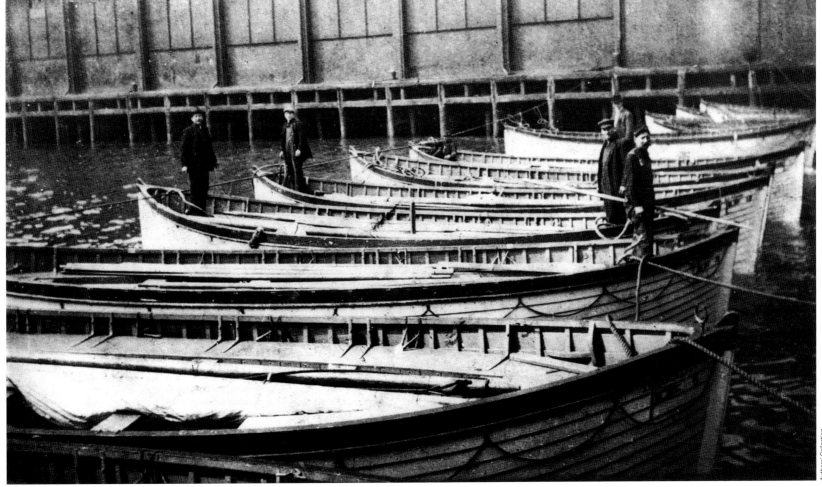

AFTERWORD

Following the sinking, two major governmental inquiries – one American, one British – attempted to find a cause or a scapegoat to explain such an unbelievable event. Society expressed indignation that a disaster of this scale had been allowed to occur, while taking comfort in how stoically those aboard confronted their fate. Such sentiment was not limited to the British side of the Atlantic. The *New York Sun* commented that, 'From an age that has been decried as material and sordid, heroism has not departed. When the call comes, men and women are as brave and willing to die for others and for principle as in the days of old.' The momentary setting aside of class differences also drew praise: 'Millionaire and deckhand,' said the *Times-Union*, 'stood on terms of perfect equality.'

Titanic's sinking is arguably the most famous sea tragedy of all time. Her loss was a profound shock to the maritime world and Edwardian society. Suddenly man and his technology were not as invincible as they seemed. Some saw the event as the inevitable consequence of arrogant overconfidence in what they had created – 'a monument and warning to human presumption', railed the Bishop of Winchester. Decades later, some accuse *Titanic*'s officers of recklessness and lay charges of poor material quality and workmanship against her builders.

But any look backwards at *Titanic* must be with an understanding of the standards and practices of her time. The *Olympic*-class ships were built to the most rigorous standards of the industry by one of the leading shipyards in the world, overseen by inspections performed by one of the most demanding governmental agencies in the country. The advanced safety features built into *Titanic* at the time – automatic watertight doors, backup generators higher up in the ship, an independent emergency lighting system – made her one of the safest ships afloat. A combination of unique circumstances never before seen and perhaps which never would have occurred again conspired to seal her fate. Indeed, her elder sister *Olympic* would go on to serve for a quarter of a century as one of the most popular, reliable and successful passenger ships in history. She could not have done so

had her design been flawed. Even *Titanic*'s captain could not be faulted, except in retrospect. As Lord Mersey opined at the British inquiry, 'He was only doing that which other skilled men would have done in the same position.'

Had *Titanic* reached New York, she would have been treated to a tumultuous welcome as she came up the North River. Her crew would have dressed ship, and she would have hosted dignitaries and notables anxious to associate their names with the latest jewel in White Star's crown. She would have settled down to become *Olympic*'s running mate, eventually joined by the third *Olympic*-class ship to permit weekly service in each direction across the Atlantic. Almost certainly, *Titanic* would have seen wartime service with her sisters as either a hospital ship or a troop transport, returning – if she survived – to ten years or more of passenger service before her retirement. Her initial fame when she entered service would have been fleeting – ironically, it would be her tragic sinking that would give her lasting notoriety.

Titanic's story reads like a Greek tragedy – the millionaire's captain, proud and confident, master of a ship that was a microcosm of British and American society and the very best that man could create, all lost in a matter of hours to circumstances utterly unimaginable and due as much to the fates as anything else.

Titanic's wreck is slowly but inexorably settling onto the ocean floor and will ultimately disappear with the passage of time. Yet interest in her and her history continues. Few other ships are as 'alive' today as when they sailed. *Titanic*'s story is told and retold and lives through the iconic photographs taken when the ship and the era in which she was built was filled with wonder and promise. Periodically, a newly discovered photograph surfaces. Similar though it may be to existing images, taken at a different angle, on a different day, it yields a new piece of information and a new perspective. The wreck of *Titanic*, rapidly disintegrating on the ocean floor, is merely the remains of what once was. It is her photographs that keep her alive and give us the opportunity to look back at her or stand on her decks and think of what once was and what might have been. ★

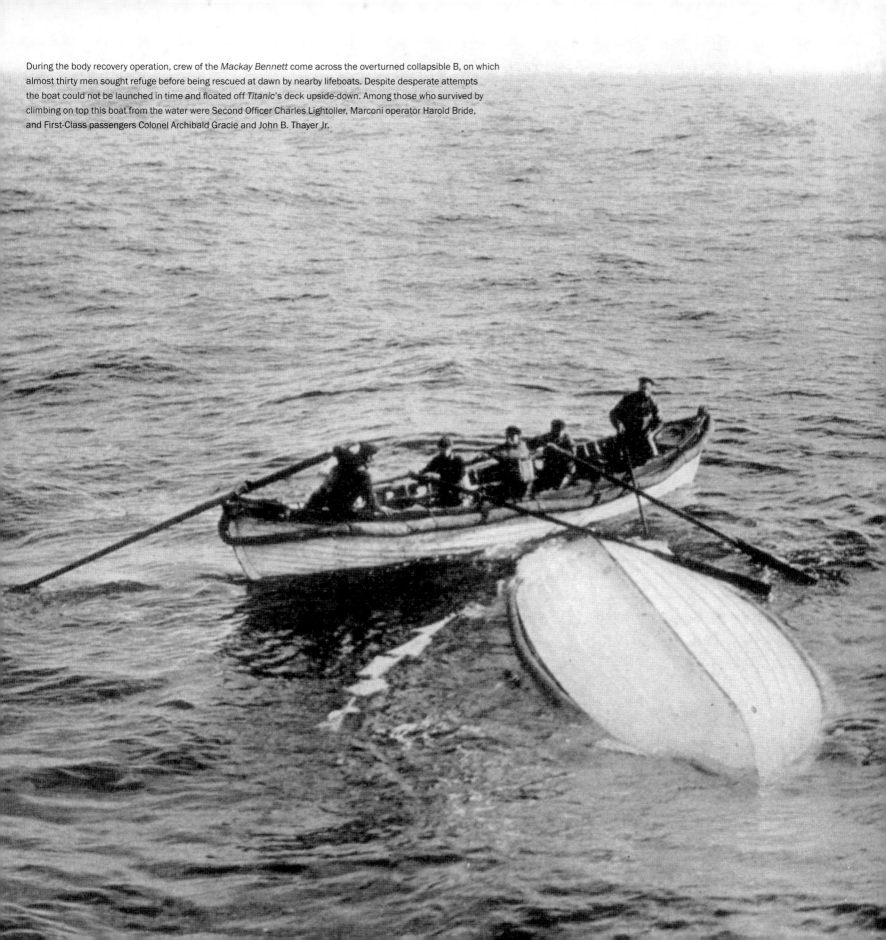

During the body recovery operation, crew of the *Mackay Bennett* come across the overturned collapsible B, on which almost thirty men sought refuge before being rescued at dawn by nearby lifeboats. Despite desperate attempts the boat could not be launched in time and floated off *Titanic*'s deck upside-down. Among those who survived by climbing on top this boat from the water were Second Officer Charles Lightoller, Marconi operator Harold Bride, and First-Class passengers Colonel Archibald Gracie and John B. Thayer Jr.